STANLEY SPENCER
An English Vision

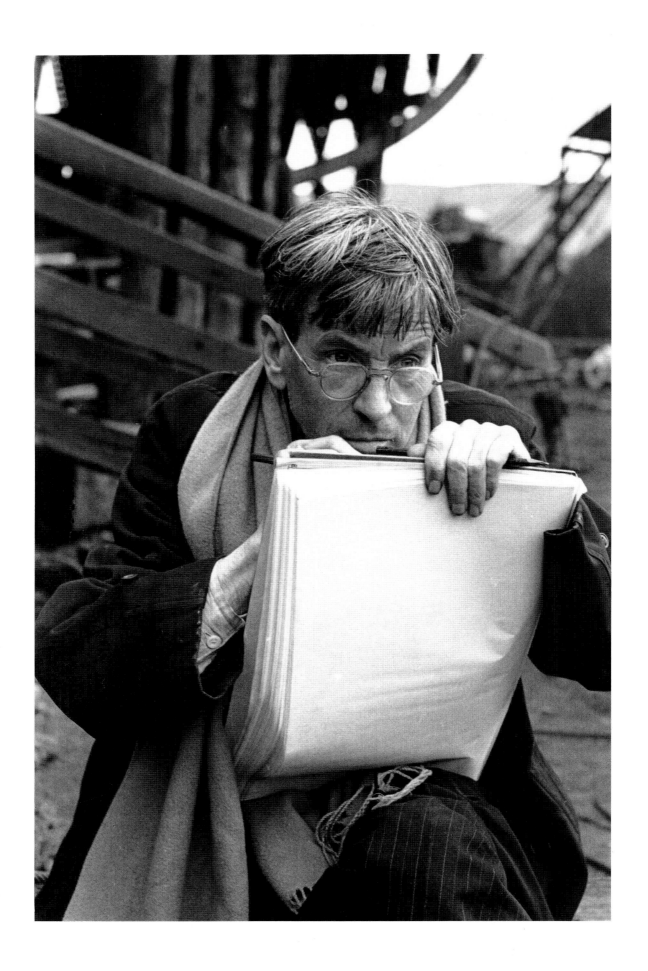

STANLEY SPENCER
An English Vision

Yale University Press
in association with The British Council *and*
The Hirshhorn Museum and Sculpture Garden,
Smithsonian Institution, Washington DC 1997

The British Council and the Hirshhorn Museum and Sculpture Garden gratefully acknowledge support for the exhibition from

HOWARD AND ROBERTA AHMANSON
FIELDSTEAD AND COMPANY

Exhibition organised by The British Council and the Hirshhorn Museum and Sculpture Garden in association with Centro Cultural/Arte Contemporáneo, Mexico City and the Fine Arts Museums of San Francisco

Hirshhorn Museum and Sculpture Garden, Smithsonian Institution, Washington DC
9 October 1997 – 11 January 1998

Centro Cultural/Arte Contemporáneo, Mexico City
19 February – 10 May 1998

California Palace of the Legion of Honor, Fine Arts Museums of San Francisco
8 June – 6 September 1998

Exhibition selected by James T. Demetrion and Andrea Rose
Exhibition Organiser (London): Andrew Dempsey
Exhibition Assistant (London): Jules Breeze
Exhibition Co-ordinator (Washington): Maureen Grove Turman

Produced and published by Yale University Press
Designed by Kate Gallimore
Set in Walbaum MT by Servis Filmsetting Ltd, Manchester
Printed in Singapore

ISBN: paperback 0 300 07426 3; hardback 0 300 07337 2
LOC number 97-61407

COVER/JACKET ILLUSTRATIONS: Front: detail from *Hilda, Unity and Dolls*, 1937 (no. 35). Leeds Museums and Galleries, City Art Gallery. Back: *Self-portrait*, 1959 (no. 64). Tate Gallery, London.

FRONTISPIECE: Stanley Spencer drawing in the Lithgow Yard, Port Glasgow 1943. Photograph by Cecil Beaton. Getty Images.

CONTENTS

PREFACE AND ACKNOWLEDGEMENTS

Within the last ten years the Hirshhorn Museum and Sculpture Garden has been privileged to host important exhibitions of Francis Bacon and Lucian Freud, considered by many critics in England and elsewhere to be Britain's most significant painters since Turner. Although Bacon's work has been well known in the United States since his emergence as a mature artist over half a century ago, Lucian Freud's exhibition at the Hirshhorn in 1987, curated and organised by the British Council, marked a first for museums in the United States. Both exhibitions revealed a vitality and strength in the depiction of the human figure that is almost without parallel in our time.

It is appropriate, therefore, that the Hirshhorn Museum in collaboration with the British Council should introduce a third British figurative painter, Stanley Spencer, to a broader American public than has hitherto been the case. (The artist's only other museum show in the United States took place at the Yale Center for British Art in 1981.)

Of the three, Spencer – the least known outside Britain – is, compositionally at least, the most ambitious. While it is extremely rare to find more than half a dozen figures in a given work by one of the two younger artists (even in Bacon's triptychs), Spencer's paintings are frequently crammed, à la Brueghel, with people engaged in all manner of activity. The recurring portrayal of biblical themes – nearly always from the New Testament – further sets Spencer apart not only from Freud and Bacon but from the grand parade of artists in the twentieth century. Although Biblical imagery appears sporadically in the work of more than a few serious artists of our time, those who have made such subject matter an important focus of their work, like Spencer, are few and far between. Georges Rouault (1871–1958) in Europe and Henry Ossawa Tanner (1859–1937) in the United States are examples, but there are not many.

It is, of course, not simply the religious component that has drawn renewed attention to Spencer's work in recent times but, in this sex-engrossed century, his astonishing nudes. This is all the more remarkable when one considers that he painted fewer than a dozen nudes during the course of his career. Nearly always these paintings (which were rarely exhibited during his lifetime) are of Patricia Preece, his second wife. Although these portrayals verge on idolisation, particularly in the double portraits in which he includes himself as worshipper, the figures are represented without idealisation. Like an altar, Preece's raw but voluptuous form stretches horizontally across the canvas in front of the artist for his adoration. Even so, it is still shocking to learn that Spencer envisioned these nudes displayed in a chapel-like setting, brought together for veneration. For him, sex was virtually a sacrament, a vital force essential for humankind's spiritual well-being.

This obsession with and intermingling of religion and sex appears to have struck a chord in the spirit of our times and it is this contemporaneity that has in

large part created the growing interest in his work during the final two decades of the century.

Spencer's desire for assimilation – of sex with religion, the natural with the supernatural, man with woman, man with plant and animal life as well as with every kind of imaginative experience, lies behind his frequent talk of marriage. Marriage was a means of getting closer to things; not an institutional tie, but the integration of himself with everything outside of his self. When he describes not lying, but sitting like a bird on a groundsheet; not watching but crawling like an ant up the stalk of a leaf, his peculiarly centrifugal vision becomes palpable. The suggestion that his almost hallucinatory powers of description make him 'too English' (i.e. too local) has often been made, but Spencer was a radical in the most fundamental sense. Like Constable a century before, the intensity of his attachment to a particular region carried him ever deeper into it. For Constable it was the landscape of the river Stour near Dedham in Suffolk. For Spencer it was the village of Cookham on the river Thames. In both cases the urgency led to possession, and it is this rootedness, this exclusivity, that has sometimes been an impediment to wider appreciation. Yet within the province that he claimed as his own, Spencer dug deeper, and more adventurously, than anyone before him. It is to his credit that he has taken 'Englishness' to include some of the most direct and outspoken images of this century.

When, four years ago, the Hirshhorn Museum decided to explore the feasibility of mounting an exhibition of Spencer's paintings in the United States, it contacted the British Council for possible assistance only to learn that the Council itself had decided to organise a show of the artist's work for North America or for Europe. As a result, our collaboration was born; and the early interest of Harry S. Parker III and Steven A. Nash, Director and Associate Director respectively of the Fine Arts Museums of San Francisco, was instrumental in bringing the exhibition to the West Coast, thus ensuring that Spencer's work would be seen across the country.

At a later stage in our planning than we would have wished, we approached the Centro Cultural/Arte Contemporáneo in Mexico City to ask if the exhibition might be shown there. We would like to thank the Director of the centre, Robert R. Littman, for responding so quickly and favourably; and also to thank the British Council's Cultural Officer in Mexico, Marcela Ramirez, for her help in bringing this about. A Mexican showing in such an important venue seemed to us to be very desirable and we are delighted it has come about.

All of us, in London, Washington, Mexico City and San Francisco, are deeply indebted to Howard and Roberta Ahmanson and Fieldstead and Company for their wholehearted and generous support of this exhibition from its inception.

Rather than construct an orthodox retrospective, which would have included interesting student work and a selection of the artist's fine drawings, we decided to introduce Spencer to a new audience through the paintings which most completely embody his vision and his ideas. Our selection is in effect framed by the self-portraits of 1914, at the beginning of his independent life as an artist, and 1959, the

year of his death. It is our hope that we have fully demonstrated Spencer's very considerable achievement.

Although we reproduce them in this catalogue, Spencer's paintings in the Sandham Memorial Chapel at Burghclere – *The Resurrection of the Soldiers*, 1928–9, is surely one of the greatest works of art of the twentieth century – could not be removed from their architectural setting, and the condition of another major painting, *The Resurrection, Cookham*, 1924–7, also precluded its inclusion.

We would like to express our gratitude to all the lenders to the exhibition, both public and private, who readily understood the importance of the occasion and agreed loans for an inevitably lengthy period. Private lenders have been especially generous in this respect. There are a number of museums whose holdings of Spencer's work meant that we wished to borrow several paintings. The collaboration of the Tate Gallery in London has been especially crucial to the success of our project and we would like to express our thanks to its Director, Nicholas Serota, whose encouragement at an early stage was of paramount importance. Many other key collections have been exceptionally generous including the Imperial War Museum in London; Leeds Museums and Galleries; the Fitzwilliam Museum in Cambridge; the Stanley Spencer Gallery at Cookham; Aberdeen Art Gallery; and the Ferens Art Gallery in Kingston upon Hull. But this is far from a full list of the many generous lenders, which is given on succeeding pages of this catalogue.

The artist's daughters, Shirin and Unity, have helped us considerably and we are particularly grateful to Unity Spencer for her sympathetic advice, for patiently answering our enquiries and for making available to us many of the documentary photographs of the artist and his family and friends which are a feature of this catalogue.

An exhibition of this kind comes together with the help of many people. Richard Francis, former James W. Alsdorf Curator at the Museum of Contemporary Art in Chicago, has made significant contributions throughout the planning process; Timothy Potts, Director of the National Gallery of Victoria, Melbourne, Australia, magnanimously stepped aside to allow a work from an important period of Spencer's life to be available for this landmark US exhibition and tour; also helpful in this way were Alan Dodge and Gary Dufour, Director and Director of Curatorial Programmes respectively, at the Art Gallery of Western Australia in Perth; Ivor Braka, Richard Nagy, Massimo Martino, Thomas Gibson, Anthony d'Offay and Bernard Jacobson were all instrumental in locating important examples of Spencer's work in private collections; Tom Toperzer and Hugh Davies also lent their knowledge and expertise at critical points.

The organisation of the exhibition has benefitted especially from the help and advice of Duncan Robinson, Director of the Fitzwilliam Museum in Cambridge; Keith Bell, whose catalogue raisonné has been indispensable; Kenneth Pople, the artist's biographer; Alec Gardner-Medwin and Richard Hurley of the Stanley Spencer Gallery, Cookham; Susannah Pollen, Director for Modern British Paintings at Sotheby's in London; and Jane Alison of the Barbican Art Gallery in London.

In addition, we should like to acknowledge the help of the following individuals during the preparation of the exhibition: Matthew Teitelbaum; David Thomson; Sylvester Bone; Evelyn Silber, Director, and Corinne Miller and Alex Robertson, Keepers, at the City Art Gallery in Leeds; Jennifer Melville, Keeper at Aberdeen Art Gallery; Rob Colwell and Naomi Williams, Carrick Hill, Springfield, South Australia; Ron Radford, Director of the Art Gallery of South Australia in Adelaide; Edmund Capon, Director of the Art Gallery of New South Wales, Sydney; Angela Weight and Roger Tolson, Keeper and Collections Manager respectively at the Imperial War Museum, London; Gillian Spencer; Jim Moyes; Dr Stephen P. Kane; Catherine Clement, Registrar at the Tate Gallery, London; Pauline Allwright; Jennifer Booth; Chris Webster; Janet Tod; Patricia Eaton; and Adrienne Corner.

In London, the work of organising the exhibition was begun by Robert McPherson and Sarah Walker at the British Council and continued by Andrew Dempsey and Jules Breeze, to whom we are most indebted for their thoroughness and tenacity in pursuing the detailed arrangements for both the loan of paintings and the production of the accompanying exhibition catalogue. We should also like to thank Craig Henderson, the British Council's Workshop Manager, and his staff, for undertaking all the technical preparations for transport, including the case-making.

At the Hirshhorn, Maureen Turman was instrumental in coordinating the oftentimes complicated details of bringing this exhibition to Washington; Acting Chief Registrar Brian Kavanagh and Assistant Registrar Barbara Freund were involved in ensuring safe and efficient transport; Assistant Director for Administration Beverly Pierce and Assistant Director for Art and Public Programs Neal Benezra provided important insights throughout the exhibition planning process; Sidney Lawrence, the Museum's Head of Public Affairs, enthusiastically promoted the exhibition to the public; Ed Schiesser and his staff in the Department of Exhibits and Design ably hung the exhibition and designed the accompanying graphic material.

This publication, produced in collaboration with Yale University Press, has two main authors, the critic and biographer Fiona MacCarthy, whose narrative of the artist's life is so accessible and illuminating, and the artist himself, for Spencer was almost as prodigious a writer as he was a painter. The task of selecting and editing the painter's words has been undertaken by Judith Collins, Curator of twentieth-century British art at the Tate Gallery, with help from her colleague Michela Parkin and from Adrian Glew of the Tate Gallery Archive, the repository of Spencer's vast collection of papers.

James T. Demetrion
Director, Hirshhorn Museum and Sculpture Garden

Andrea Rose
Head of Visual Arts, The British Council

LENDERS TO THE EXHIBITION

AUSTRALIA

Adelaide
Art Gallery of South Australia 57

Perth
Art Gallery of Western Australia 42, 43

Springfield, South Australia
The Carrick Hill Trust 40

Sydney
Art Gallery of New South Wales 46, 56

SWITZERLAND

Castagnola-Lugano
Thyssen-Bornemisza Collection 53

UNITED KINGDOM

City of Aberdeen Art Gallery & Museums Collections 10, 36, 47

The Executors of Mary Adshead's Estate 1

Belfast
Ulster Museum 12, 54

Birmingham Museum and Art Gallery 49

Cambridge
Syndics of the Fitzwilliam Museum 14, 24, 32, 37

Carlisle
Tullie House, City Museum & Art Gallery 3

Cookham-on-Thames
Stanley Spencer Gallery 8, 39

The Collection of the late W.A. Evill 22

Glasgow Museums: Art Gallery and Museum, Kelvingrove 41

Kingston upon Hull City Museums & Galleries, Ferens Art Gallery 25, 34

Leeds Museums and Galleries, City Art Gallery 11, 17, 29, 35

London
British Council Collection 51
Imperial War Museum 7, 44, 45
Tate Gallery 2, 4, 5, 6, 9, 13, 33, 64
Ivor Braka Ltd 26

Newcastle upon Tyne
Tyne and Wear Museums, Laing Art Gallery 19

Rochdale Art Gallery 28

Cdr L.M.M. Saunders Watson, Rockingham Castle 20

Southampton City Art Gallery 18, 50

Swansea
Glynn Vivian Art Gallery, City and County of Swansea 58

UNITED STATES OF AMERICA

Chicago
Museum of Contemporary Art 61

New Haven
Yale University Art Gallery 21

New York
Museum of Modern Art 30

PRIVATE COLLECTIONS 15, 16, 23, 27, 31, 38, 48, 52, 55, 59, 60, 62, 63

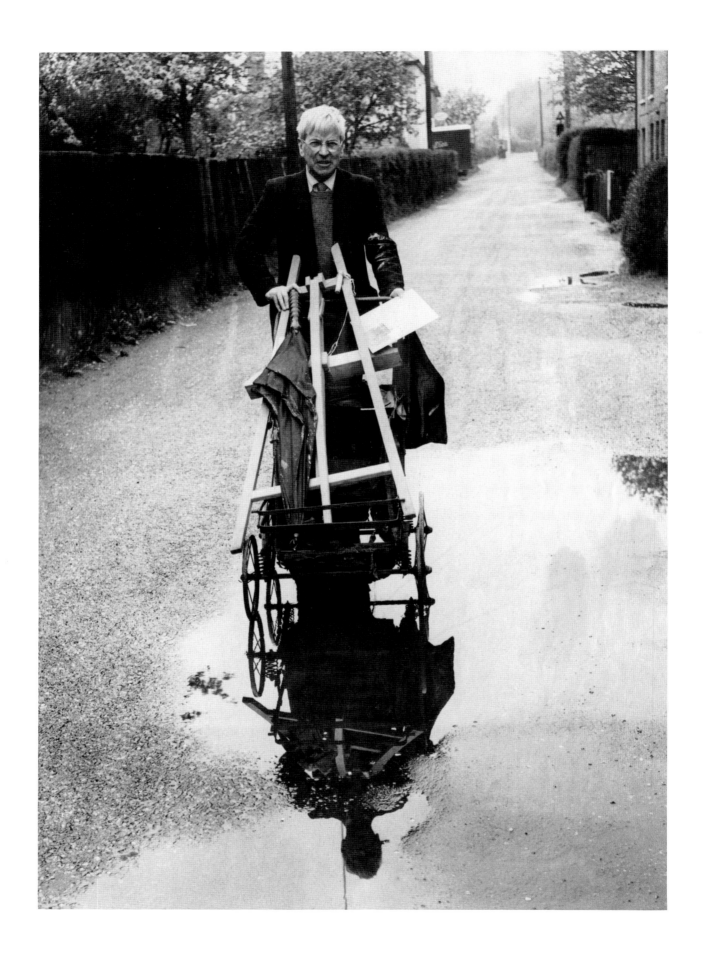

STANLEY SPENCER, ENGLISH VISIONARY

Fiona MacCarthy

I

Cookham is a demure brick-built village in the county of Berkshire, thirty miles west of London. It lies along the River Thames and part of its charm is the juxtaposition of water and marshy meadows, the bridge and the boathouses, the church and the churchyard, the reedy river banks, the preponderance of swans. The painter Stanley Spencer was born there on 30 June 1891 and lived there, with few absences, until his death in 1959. His identification with the village was so total that there was a sense in which Spencer became Cookham, and indeed as a student at the Slade School in London he acquired the nickname 'Cookham'. Spencer's immense sequence of visionary paintings transformed the local scene into the epic with an ambitiousness and weird intensity unparalleled in British twentieth-century art.

At the hour of his birth a rook descended from the chimney at Fernlea, the Spencers' villa in the High Street, and flapped around the living room. Stanley Spencer would later claim this as a portent, with his genius for finding the miraculous in the domestic events of village life. This hypersensitivity aligns him with earlier visionary artists rooted in England: Henry Fuseli, William Blake and Samuel Palmer, Richard Dadd. Like Blake, Stanley Spencer was attuned to hearing angelic voices speaking in the next room. He himself experienced 'visitations' and his painting *Sarah Tubb and the Heavenly Visitors* (fig. 1) shows white-robed angel figures delivering presents – souvenirs and knick-knacks – to a Cookham backyard.

In Stanley Spencer's Cookham, Jesus Christ himself is a familiar village character, preaching among the punts at the annual Regatta, being baptised in the local bathing pool. Spencer took over John Donne's description of a churchyard as 'a holy suburb of Heaven' and applied it to Cookham.[1] Like Donne, whose metaphysical complexities Spencer was always to adore, he sought the means of fusing the religious and erotic and found it in the intimacies of village life. The sheer physical proximity of life in a community of forty or so houses side by side along the High Street. Low-key local gatherings. Muttered village gossip. The small events of Cookham, with their seasonal rhythms and their repetitions, provided Spencer with his immense themes of the human life cycle: birth and copulation, death and transfiguration.

Out of Cookham came a body of work that is not remotely like any other painter's. Spencer was by no means a primitive recluse. As we shall see, he was

Stanley Spencer pushing his painting equipment around Cookham in a dilapidated pram, 1950s. Getty Images.

Fig. 1 *Sarah Tubb and the Heavenly Visitors*, 1933.
Stanley Spencer Gallery / The Barbara Karmel Bequest.

professionally trained and he had friends and many contacts in the London art world and connections with the Bloomsbury Group. But in his painting as well as in his writing Spencer was evolving what was almost his own language. In his auto-biographical notebooks he argues against the restrictiveness of 'thoughts logically following each other' in the conventional way. Spencer maintains that this 'limits the capacity of thought and cuts it off from something which in its undisturbed condition it can deal with and perform'.[2] The style of writing he prefers is free flowing and James Joycean, and in his huge visionary figurative scenes, the paintings referred to by Spencer as his 'queer ones', a similar stream-of-consciousness

prevails. He plays with simultaneity. Event crowds in upon event, unconnected yet related. These *mouvementé* panoramas are touchingly human yet unnervingly peculiar. They have a grand, mysterious inner logic of their own.

In fact all Stanley Spencer's paintings have their overtones of 'queerness'. His hundreds of landscapes and flower paintings bristle with endeavour. Their rare sense of physical immediacy repays the effort of Spencer's detailed observation. Like the Pre-Raphaelites (a reproduction of Millais' *Ophelia* hung in the house at Cookham) Spencer was a ravager and pillager, the artist taking possession of the landscape. A friend once watched, astonished, as Spencer flung himself into a meadow, writhing with pleasure, burying his face ecstatically in the grass. In the 1930s and early 1940s he painted a series of nude portraits of himself and his two wives which are ruthless in their honesty. There is an uncanniness in the sheer sense of concentration, the cool determination with which the artist lays his claim on such an acreage of undefended flesh. These portraits are as powerful as anything being painted in Europe at that time.

Spencer looked like an English eccentric. He was not one. There was nothing of the amateur or dilettante in him. His spiritual and personal struggles were in some ways as painful as Van Gogh's. Spencer's sense of himself was solemn, and he could be hard and even violent in the pursuit of his creative impulses, as an entry in one of his voluminous autograph notebooks shows:

> An artist is not used to having to put a name to his feelings, but for myself it seems inseparable from such experiences as Love, desire, Faith, passion, intimacy, God, spiritual consciousness, curiosity, adventure, ingenuity. An artist wishes to absorb everything into himself; to commit a kind of spiritual rape on every thing.[3]

The most impressive of his paintings have the innate gravity that comes from deeply absorbed experience.

II

Spencer was a Victorian child. He and his brother Gilbert, as small boys, led the village procession to celebrate Queen Victoria's Diamond Jubilee in 1897. He grew up in a world grounded in the securities and conventions of the Victorian English middle classes but was of a generation that challenged those connections with a sometimes shocking courage. There is often a fascinating tension between the static and dynamic in his work. Spencer was born within a decade of the artist Eric Gill (born in 1882 in Brighton) and the writer D.H. Lawrence (born in 1885 in Eastwood, Nottingham) and he too was committed to exploring the relationship between the personal and cosmic, the spiritual and the erotic, crossing permitted boundaries of sexual explicitness.

It was a large, close family. Stanley, known to his intimates as Stan, was the eighth of nine surviving Spencer children. Two more children – twins – had died

Fig. 2 Study for the month of April: *Cutting the Hedge*, for Chatto & Windus Almanack, 1926. Stanley Spencer Gallery/Barbara Karmel Bequest.

in infancy. His small size made him especially well protected: he was never to grow taller than 5 ft 2 in. Fernlea, the yellow brick villa in which the Spencers lived, was one of a pair of semi-detached houses in the High Street (fig. 2). It was modest in size and, when most of the children were in residence, was crowded. But, as Stanley's brother Gilbert describes it in his memoir *Stanley Spencer by his Brother*, 'At home we all found our niches about the house.'[4]

Even by Victorian standards the household was unusually self-contained. Stanley never spent a night away from home till he was twenty. The inwardness of

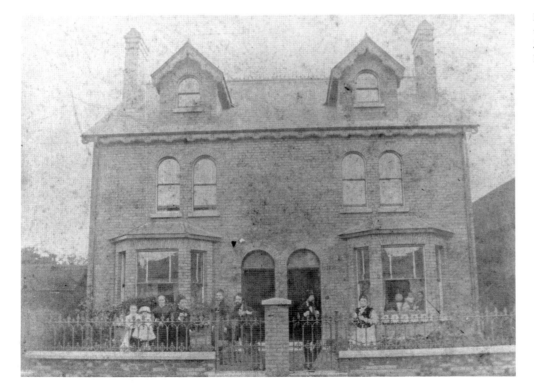

Fernlea, right, *c.* 1880 with William Spencer and his wife Annie in the garden. William Spencer's brother Julius and his wife and family are in the garden of Belmont, left. Estate of Stanley Spencer.

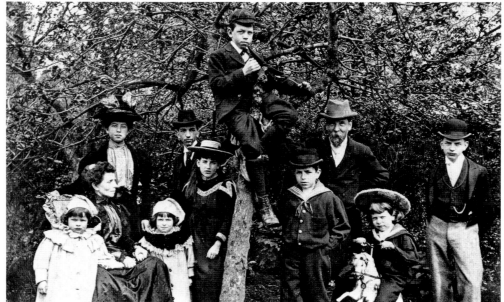

Gilbert, Florence and Stanley (left to right), 1895.
Estate of Stanley Spencer.

The whole family (from left to right): Gilbert, 'Ma'
Spencer, Annie, Stanley, Will (behind), Florence, Percy
(in the tree), Horace, 'Pa' Spencer, Sydney and Harold.
Estate of Stanley Spencer.

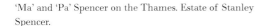

'Ma' and 'Pa' Spencer on the Thames. Estate of Stanley
Spencer.

family life was paralleled by the isolation of a village so settled in its habits as to be almost immune to the coming of the railway. Flooding would sometimes cut it off completely in the winter. The hidden Cookham of Stanley's childhood could seem as 'remote as the Milky Way'.[5] From his childhood containments and contentments arose Stanley Spencer's concept of the cosy, which had to do with round and comfortable shapes, large bosoms and fat buttocks, the plump and squashy cushions that appear in so many of his paintings. To be cosy was to be on the side of the angels, and indeed his heavenly visitors are rubicund and ample. To him the term 'uncosy' or 'unhomely', applicable equally to works of art and people, were pejorative words.

Stanley Spencer's father, 'Pa', was serious and energetic, an upright, wiry man with a full beard described by an acquaintance as 'a patriarchal figure who cycled round Cookham reciting Ruskin aloud'.[6] He habitually wore a black frock-coat. William Spencer is recognisable in many of Spencer's crowd scene paintings. He is

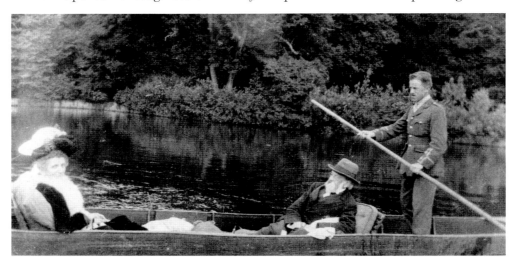

there in the background of *The Dustman* or *The Lovers* (cat. 19); Pa lies in the coffin in *The Temptation of St Anthony* (cat. 48); there are several variations on Professor William Spencer, as he (not entirely accurately) liked to term himself, in Stanley Spencer's *Adoration of Old Men*, a painting now in the Leicester City Art Gallery.

William Spencer was the organist of the parish church in Hedsor, a village close to Cookham, and he earned a precarious living teaching the piano at home to private pupils. He had the multifarious interests and proselytising spirit of the Victorian self-made man, opening a public lending library, the Cookham Free Library, in his own front room. He was an aspirant poet, having published his collected poetry in a two-shilling volume entitled *Verses Grave and Gay*. These poems show an intense consciousness of nature and of landscape; in one he ascends to an almost painterly description of a gorse bush with 'fingers of fire and heart of gloom'. William Spencer lived a life of solemn purposefulness, allowing no excuses for idleness, and there is much of his father in Stanley's own unremitting dedication to work. He also absorbed his father's curiosity, his semi-scientific and partly religious amazement at the universe. Pa Spencer's infectious interest in astronomy was well described by Gilbert: 'Father was a devoted star-gazer; he would stand with his hands on his hips looking at the sky in wonderment. And he passed this sense of wonder on to us.'[7]

Map of Cookham. From *Stanley Spencer* by Maurice Collis, London 1962.

There was an ever present sense of the odd-ball in that household. Pa Spencer could become alarmingly excitable, so much so that he could cause his young children to have nightmares. Stanley himself was prone to sudden violent rages. He was known as a 'little spitfire' and called 'tiger' out in the village, and had once appalled the family by covering the face of his brother in the family photograph album with a pig's head. His mother, Annie Spencer, had her own form of exuberance. The children remembered how, hearing Schumann's *Papillons*, *opus 2*, being played on the piano in the dining room at Fernlea, she was so carried away she 'almost danced'.[8] After 'Ma' became ill, with acute bronchitis, in the years just before the First World War, Stanley wheeled her round the neighbourhood in a bath chair, precursor of so many curious, comfortable seats − chintzy armchairs and gently curving punt backs − in his paintings. He felt her early death, in 1922, as a great grief and an abandonment, the loss of that special mother-and-son domesticity:

> I wish all my life I could have been tied to my mother's apron strings. It would have suited me, mostly in the kitchen or the bedroom or just on a visit in the locality, a long talk and plenty of cups of tea.[9]

Fernlea was exactly in the centre of the village, in the string of shops and houses running up from the Maidenhead road to Cookham Moor. Opposite was Ovey's Farm, from which, in summer, the smell of manure wafted in through the open windows of the Spencers' house. The family had its own direct connection with the fabric of Cookham since Stanley's grandfather had been a master builder in the

village. His grandfather had actually built Fernlea for Stanley's father on his marriage, and the adjoining villa, Belmont, for Stanley's uncle Julius. Stanley himself was intensely aware of, almost proprietorial about the architectural make-up of the village, the way that one building impinged upon another, linked by mysterious alleyways and yards.

When he painted it was with the child's slightly skewed vision of gardens half-revealed through tall gates usually closed, as he had glimpsed them as a child out walking with his sister Annie, or neighbours' secret views only vouchsafed from the tops of Cookham fir trees. Stanley Spencer was always the voyeur. His art is all about the making of connections: the adult vision recapturing the child's one, the twentieth-century sensibility finding a new meaning in the ancient traditions of Biblical communities. His words in one of the autobiographical fragments on 'Life, Bible and Cookham' are significant: 'Remote things join in me.'[10]

Spencer once compared the instinct of Moses in casting off his shoes when he saw the burning bush to his own feelings about Cookham, where he found burning bushes by the dozen: 'I could see the richness that underlies the Bible in Cookham in the hedges in the yew trees.'[11] He used the locations around Cookham like a library, drawing on the familiar juxtapositions of natural and man-made landscape all his life, from the shimmering early painting *Cookham* (cat. 3) to the marvellous and dreadful *Crucifixion* (cat. 62) of 1958, enacted on the rooftops of the village, a cramped, familiar setting. Such stark proximities create a special terror. Gilbert Spencer has described the way in which his brother would wander through the village 'peopling it with his thoughts and ideas'.[12] People, of course, were essential to his vision: 'A person is a place's fulfilment, as a place is a person's.'[13] He was used

Cookham early in the century. Estate of Stanley Spencer.

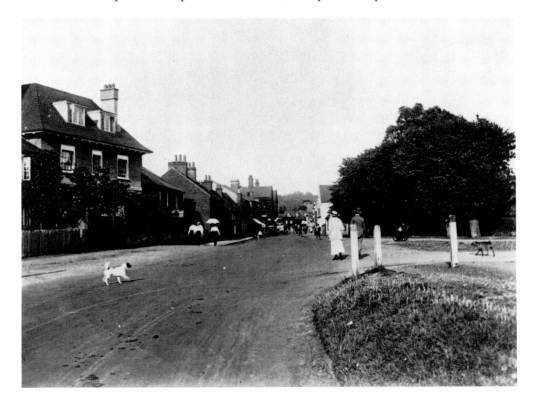

to, and depended on, close daily human contact, interchange between gardens across the privet hedge.

Spencer clung to the remembered objects of his childhood. Few artists have sustained so involved a relationship with the domestic. Spencer's paintings and drawings are awash with *things*, artefacts of deep significance, associated with particular situations and rituals. Village ironmongers' merchandise: brooms, brushes, kettles, saucepans. Fernlea furniture: the bentwood chairs upturned in the dining room for March spring-cleaning appear in one of Spencer's most lovely mid-1920s drawings, made for the Chatto & Windus *Almanack*. The children would rummage for treasure in a dark dank cupboard at the bottom of the stairs containing discarded household bric-à-brac, a mangle, a piano-trolley, even – once – an unexpected pair of policeman's handcuffs. Spencer related such childhood explorations to his later sexual urges: 'My physical desires [and] longings are a part of my artistic vision, just as curiosity was one of the strongest aids as a child to the fulfilment of my artistic creative needs.'[14]

Stanley Spencer's curiosity extended to almost everything. It included the things that other people had, in his view, unperceptively discarded. As a child he would pick his way through Farmer Hatch's rubbish heap to find 'beads, pieces of old china with all sorts of painted flowers on them, old books with engravings'.[15] An intensive visual toleration ruled him. Spencer found redeemable what conventional canons of taste judged ugly, unfashionable, meagre, tawdry, squalid. He placed himself smugly 'on the side of the angels and of dirt'.[16]

'God is Love' was the text in woolwork lettering, threaded through the cardboard with the punched-out holes, that hung framed at Fernlea. The 'Bible life', in the sense of daily habit rather than externally imposed discipline, permeated the house and Spencer as a boy accepted it unquestioningly: 'Somehow religion was something to do with me, and I was to do with religion. It came into my vision quite naturally, like the sky and rain.'[17] He absorbed this religiousness into the bloodstream. It affected his language; Spencer wrote, as he spoke, in a curious mixture of the Biblical and slangy. 'Do you know what good art is?', he once asked his friend and director of the Tate Gallery, John Rothenstein. 'It's just saying "ta" to God.'[18] His perception of Christ was of an Almighty Artist, creating works of charity and faith and love.

Stanley's father, as church organist, had close connections with the Church of England. But his mother attended the more socially lowly Wesleyan chapel in the village, the building which now houses the Stanley Spencer Gallery. It was to this more literal and emotional form of worship that Spencer, as a boy, felt most attuned. Central to the service was the public experience of religious transportations. What he saw in the chapel was of extreme importance to Spencer as an artist, as he explained in 1942:

The comfortable atmosphere of this chapel stimulated me as a painter. Being 'sanctified' was the way they had of expressing themselves. When they felt in

that state, they would go and flop down just under the auditorium. I felt I should not look, but though my eyes were down I was trying to imagine what shape they were on the sacred piece of ground where they were 'coming to the Lord'. It was a patch of hard linoleum with only room for one man at a time. It seemed to me the taking off place for the Wesleyan heaven. When I heard someone pass by my pew and get down there I felt it was a sort of apotheosis of the grocer or confectioner or whoever it was.[19]

Already the possibilities of human transformation were enthralling Stanley Spencer. The local grocer would become 'more intensely a grocer' as he lay there 'crumpled, his face turned up in a wonderful ecstacy'.

Besides the pervasive religion in the household, a dominant influence at Fernlea was music. Grandpa Spencer, the builder, had founded a choir in Cookham that developed a considerable local reputation, eventually travelling far and wide through the Home Counties. According to Gilbert, listening to music was as much a part of the Spencer children's lives as breathing, and he maintained that Stan, as he grew older, was 'the best listener to music of us all'.[20] He could play Bach by ear and was always a compulsive hummer, to the irritation of his friends. He revered his eldest brother Will, a child prodigy who had impressed the Duke of Westminster with his playing of Beethoven at the age of seven. The Duke later supported him through the Royal College of Music in London. Will became piano master at Cologne Conservatoire and eventually a Professor in the Bern Music Institute. When Stanley was a child at Fernlea, Will was absorbed in an ambitious and apparently interminable composition referred to as 'the Theme'. In that house of high endeavour the music and the painting worked together on Stanley Spencer's mind. Listening to Bach played after breakfast at Cookham used to give him 'such a desire to paint great pictures'.[21] He was conscious of a close relationship between musical forms and the way he composed paintings, explaining the *Resurrection of the Soldiers* (fig. 8), the climactic painting of the Burghclere murals, in terms of the structure of the fugue.

Spencer came from a background that was optimistic, cultured. In spite of such an emphasis on music, the visual arts had their place in Fernlea life. Family taste in pictures was by no means radical: of the two pictures hanging in Stanley and Gilbert's nursery one was a reproduction of *The Bengal Lancer*, the other a sentimental genre painting of a sailor and his sweetheart sitting on a wall looking out to a rough sea. But Pa Spencer would take the children to the annual Summer Exhibition at the Royal Academy in London. A reproduction of Fred Walker's painting *Geese in Cookham Village* hung in their own house, arousing the boys' interest in the artistic potential of local scenes. They were all in touch with William Bailey, a local builder and accomplished 'Sunday painter', who specialised in willow trees in sepia wash. Two paintings by Bailey – *Willow Trees* and *Cookham Church and River* – were placed in the Spencers' dining room, one on either side of an engraving from Turner of the approach to Venice. Long before

Stanley, William Bailey painted an atmospheric oil of Cookham Bridge. He would talk to the susceptible Stanley and Gilbert Spencer of 'the lost-and-foundnes of things'.[22]

There was no resistance from the family to both the boys' eventual decisions to be painters. Early on they had been sent for lessons from William Bailey's daughter Dorothy, herself an artist and designer. These lessons were 'very simple and direct'.[23] It was Stanley's mother who first drew Pa's attention to the illustrations Stanley had done of John Bunyan's Vanity Fair. For a family of builders, so imbued with the mediaevalist ideas of John Ruskin and William Morris, there was nothing outré in the idea of the artist. Stanley Spencer agreed instinctively with Eric Gill and indeed with Ananda Coomaraswamy that 'An artist is not a special kind of man, but every man is a special kind of artist.' The doing of drawings, the painting of pictures, was a functional, sociable activity, part of the sub-structure of normal village life. Though Stanley Spencer's paintings are so striking in their oddness, they are also deeply rooted in community affections. His genesis in Cookham, circumscribed and yet resplendent, defined the special kind of artist Stanley Spencer would become.

Fig. 3 *The Gladiator*, or *Recollection of 1907/8*, from Scrapbook Drawings, *c*.1932. Tate Gallery Archive.

III

In 1907, aged sixteen, Spencer began his training as an artist at the Technical School at Maidenhead, the small town three miles from Cookham. The school was part of a whole network of provincial English art schools established in the aftermath of the Great Exhibition of 1851 and Stanley had been sent there at the instigation of a local benefactress, Lady Boston. Until then his education had been totally home-based since his father disapproved of the system of state schooling and the younger Spencer children had attended their sister Annie's classes in a corrugated iron shed at the bottom of the garden.

The effect of this change of scene on Stanley can be gauged from a drawing he did years later, in the 1930s, showing the young art students at their drawing boards surrounding a plaster cast of the classical statue of the *Gladiator* (fig. 3). It is a crowded picture, a scene of great activity. At Maidenhead, Spencer was aware of a sudden opening out of artistic possibility. As he noted, in his caption to this drawing: 'Casts are on shelves and hanging on the wall. And like the comic postcard I saw of two tramps saying to each other about a cow in the field, "Just think everywhere it looks it sees something to eat", so here everywhere one looked there was something to draw or being drawn.'[24] His brother Gilbert remembered him being neither especially happy nor unhappy at the Technical School. 'His mood was one of serious application and concentration' as he followed the classically-based curriculum in force in the English art schools of the time, drawing casts and heads from life.[25] His more imaginative 'notion' works were in abeyance while he was studiously acquiring his technique.

A year later Spencer moved on to the Slade School, the leading London art school

of the period. He spent the next four years there, winning two important prizes and the admiration of an extraordinary peer group. Spencer's generation of Slade students included Eric Wadsworth, Paul Nash, Christopher Nevinson, David Bomberg, William Roberts, Mark Gertler and John Currie. Gertler and Currie were said to have admired 'Cookham' more than anybody else. But although Spencer's work made so glowing an impression, personally he stood out as an oddity, the small and owlish student, still looking almost childlike with his boyish haircut and Eton collar. He could be irascible and unpredictable, veering between the arrogant and shy. His regular routine of arriving each day on the 8.50 train from Cookham to Paddington, returning on the 5.08, made a strange contrast to the quasi-Bohemian lifestyle of the Slade students of the day and there were stories of bullying. The 'Goering-like' Wadsworth, John Fothergill and Nevinson, for instance, once put Spencer upside-down in a sack.[26] At times he felt terrified of going to the school and once had an attack of hysteria on the premises. His recurring self-portraits as small man of pathos may reflect this phase of victimisation at the Slade.

In those years just before the First World War the ethos at the Slade School was high-minded. Spencer's mentor, the famous Professor Henry Tonks, would lecture the students on the privilege of being an artist, impressing upon them 'that to do a bad drawing was like living with a lie'.[27] The emphasis in training was on drawing from life rather than on painting, with minimal instruction on colour. Tonks's own ideal of draughtsmanship was based on that of Ingres. Slade priorities are clear in Spencer's early drawing *The Fairy on the Waterlily Leaf* (fig. 4). Though Spencer so

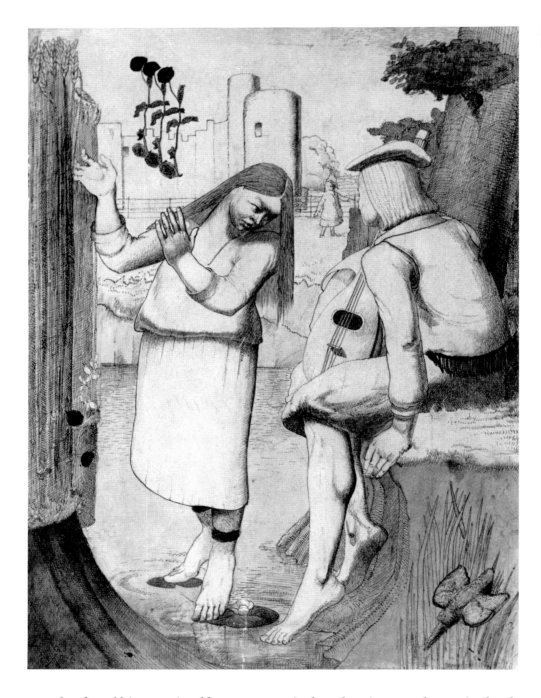

Fig. 4 *The Fairy on the Waterlily Leaf, c.*1909. Stanley Spencer Gallery.

soon developed his own visual language, meticulous drawing was always absolutely central to his work. The drawing was his starting point in giving form to the ideas for a painting already in his head. It was during the actual processes of drawing that Spencer's real creative activity occurred. His paintings were confirmations of decisions made at the preliminary drawing stage. As if acknowledging the great importance that they had for him, Spencer would hoard his drawings. He referred to them as 'knitting', a gently creative routine and reassuring pleasure, comparing himself at the easel to an old lady purling and plaining by the fire.[28]

Spencer at the Slade became more and more immersed in the work of the Old Masters. He had a peculiar ability to absorb another artist's work from reproduction,

sometimes appearing to prefer this indirect approach, and devoured the little Gowans and Gray Art Books, easily accessible and costing sixpence each, with their monochrome plates of Masaccio, Giotto, Donatello, Fra Angelico, Botticelli, Duccio and so on. He loved the scale, the directness and the purity of vision of pre-Renaissance Italian painters with their almost nonchalant approach to the miraculous. Masaccio's composition of *St Peter Healing the Cripple* was the first painting he pointed out to Gilbert in a Gowans and Gray monograph. He hung a Pisanello reproduction beside his bed at home, ready to look at as soon as he woke up.

A group of Slade contemporaries shared Stanley Spencer's mania for the work of the early Italians, calling themselves the 'Neo-Primitives'. Gilbert identified the Slade's importance in giving Stanley Spencer a sense of historical context. 'The Slade held a mirror in front of him, the like of which did not exist at home, and he saw himself among the forbears of his art in all their glory.'[29] Interestingly, until well into the 1930s, he described himself in official publications as a 'muralist'. In his own mind, he was still firmly linked to the early fresco painters. The idea of art for buildings, and of paintings accessible to a whole community, stayed with him all his life.

At the same time Stanley Spencer opened himself out to European influences. Part of his originality lay in a deep-seated imaginative fusion of the Old Masters and contemporary art. There is no direct evidence that he attended Roger Fry's important exhibition *Manet and the Post-Impressionists* of 1910, in which the work of Cézanne, Gauguin and Van Gogh was introduced to a largely unreceptive British public. But it seems unlikely that the promising Slade student stayed away. His own work was represented in the sequel, the *Second Post-Impressionist Exhibition* at the Grafton Galleries in London in 1912. Spencer's early paintings had impressed Clive Bell, co-selector of the exhibition with Roger Fry, and his oil painting *John Donne Arriving in Heaven* (fig. 5) and two drawings were included in the British section, with Wyndham Lewis, Vanessa Bell and Duncan Grant. The European selection was a very strong one, and Spencer's work was shown alongside paintings by Matisse, Picasso, Cézanne, Derain, Vlaminck and Friesz.

The influence of continental Post-Impressionist painters, and especially Gauguin, can be seen in some of Spencer's paintings of that period, such as his *Apple Gatherers* (fig. 6) of 1912. But Spencer was in no sense an imitative painter. He took only those things he wanted and he needed. Professor Tonks, in a letter to his parents, said that Spencer showed signs of having the most original mind of anyone he could remember as a student at the Slade. A draft for one of Spencer's later lectures, on the subject of the inspiration of the artist, is headed characteristically and uncompromisingly 'One's own way'.[30]

When he left the Slade Spencer returned full-time to Cookham in a mood of ebullience. Using the image so dear to William Morris he felt he had entered 'a kind of earthly paradise. Everything seemed fresh and to belong to the morning.'[31] He was working more-or-less in the bosom of his family. One of the earliest of Spencer's post-Slade pictures, *Zacharias and Elizabeth* (cat. 1), was begun in

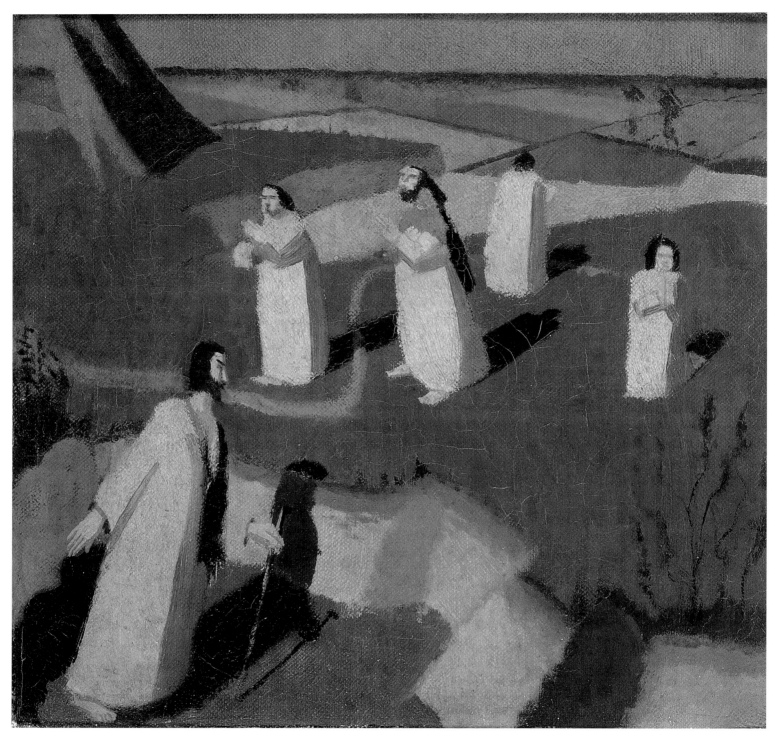

December 1913 in the dining room at Fernlea, with the dining table tipped up to form an easel. In the same room Pa Spencer would be giving piano lessons on the upright piano. Children waiting for their lessons lined up along the wall with its dark, patterned paper. In Spencer's mind the gestation of this painting, a scene based on the view across the garden of St George's Lodge in Cookham, was forever entwined with the memory of Pa Spencer practising his Beethoven and Joachim Raff.[32] Raff, the self-taught musician who worked his way up from penury to

Fig. 5 *John Donne Arriving in Heaven*, 1911. Private Collection, on loan to the Fitzwilliam Museum, Cambridge.

become one of the leading mid-nineteenth-century composers in Germany, was something of a role model for the family.

In alighting on the subject for a painting Spencer would only consider a particular moment or incident of 'special significance' to him. This intensive personal involvement, what he liked to describe as the 'me-myselfness' of a subject, is almost overwhelmingly obvious in another of the Cookham paintings of this period, *The Centurion's Servant* (cat. 4). The painting illustrates the episode of Christ and the centurion recounted in St Luke 7, 1–10, in which the centurion sends a message asking Christ to heal his much-loved servant, who is dying. Jesus heals him, conscious of finding greater faith in the centurion, a Gentile, than in any of the Jews.

Fig. 6 *Apple Gatherers*, 1912–13. Tate Gallery, London.

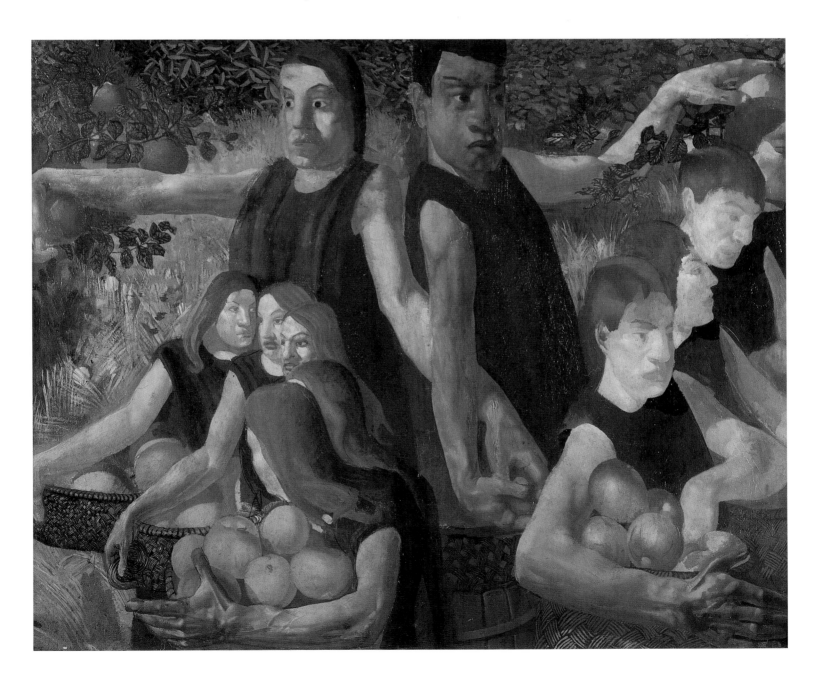

Spencer illustrates the Bible story in a way that is both truthful and extremely esoteric. In the centre of the picture Spencer places a curly iron bedstead with round white china knobs, the very bed that dominated his own childhood nursery, an attic room now taken over by the servant at Fernlea. The sprawling boy on the bed edge is Stanley as the servant. The praying figures round the bed are all portraits of other Spencer children. Spencer always loved the other-worldliness of bed life, and in this painting and later ones – *Going to Bed* of 1933, *The Nursery*, or *Christmas Stockings* (cat. 30) of 1936 – he gravely extrapolates upon a common human experience of pleasure and compatibility. In his life with his wife Hilda the moment at which she joined him in bed was of extreme significance. Tea in bed was, for Spencer, the ultimate in cosiness. Bed was a thing of yearning. Spencer was to write in 1940, 'Mentally I have been bedridden all my life.'[33]

Those three years back in Cookham were enormously productive. Of Spencer's visionary 'queer' works he completed *Mending Cowls, Cookham* (cat. 5) and started on *Swan Upping* (cat. 6). In the attic of Ship Cottage in the village he also finished the first of his holy Resurrection pictures, *The Resurrection of the Good and the Bad*. He painted one of his first pure landscapes, *Cookham* (cat. 3), a rapturous picture which is almost Emersonian in the freshness with which Spencer looks upon the land.

Technically Spencer approached landscapes differently from the way in which he painted his visionary narratives, dispensing with preliminary drawing, standing out in the open, painting direct from nature like his Victorian Pre-Raphaelite predecessors Dante Gabriel Rossetti and Holman Hunt. He found the immobility tedious and frustrating, feeling like a wooden post embedded in the soil. He would often decry his landscape painting as a secondary occupation, missing out on the 'me-myselfness' element that he found essential. This was a sweeping statement that needs looking at again. Sometimes his landscapes, with their depth of observation, almost prickle with Spencerian peculiarity, and we should remember Spencer once told his wife Hilda (with a blatant tactlessness) that the only really significant love affairs he had ever had had been with places rather than with human beings.

In 1914 Stanley Spencer painted a remarkable *Self-Portrait* (cat. 2), an oil which in its qualities of modelling and painting could be counted as a twentieth-century Old Master. It is a candid portrait, as truthful as a Holbein or a Rembrandt, marking the beginning of Spencer's pitiless confrontation with the human face. Spencer's self-obsessiveness was, of course, remarkable. To himself he was 'Treasure Island', maintaining that the most exciting thing he ever saw was Stanley Spencer. He evolved a self-justifying view of himself as 'a new kind of Adam . . . joy is the means by which I name things; that is, define my wishes through a knowing it as part of God'.[34] Spencer's creative bumptiousness shines out from this portrait. This is the man with a sure sense of inner logic who looks for the most intelligent person he can find and discovers unsurprisingly that it is himself.

The *Self-Portrait* was purchased straightaway for £18, by Edward Marsh, the well-known London connoisseur. Spencer was by now acquiring patrons and

influential friends and his social circle widened. Henry Lamb bought work from Spencer as did his Slade friend, the painter and engraver Gwen Raverat. The poet Rupert Brooke proposed a theatrical collaboration. Stanley, Gilbert and their parents, improbably dressed-up, were taken to the opera in London by Lady Ottoline Morrell. Spencer responded to his growing success with an insouciance that always proved a safeguard: a friend made the true comment that he loved the sound of praise but did not bother to listen to the content. From 1914 these auspicious beginnings were shattered by Spencer's involvement in the First World War.

IV

Once war on Germany had been declared in August 1914 and the wave of jingoism swept through England, Spencer had been eager to be called up. Because of his small size and poor physique his mother persuaded him to opt for ambulance work rather than for service in the infantry and, after some camp training in first aid and drill, Spencer was ordered to report for service in July 1915 as a hospital orderly in the Royal Medical Corps at Beaufort War Hospital in Bristol. This large grim Victorian gothic building was the former Bristol Lunatic Asylum. Though most of the 1600 pre-war inmates had been dispersed to other institutions, about eighty were kept on for domestic duties. There was a sense of makeshift, even desperation, as the First World War wounded began arriving in their convoys from France or from the Dardanelles.

The Spencer family had no military tradition. As Gilbert comments in his memoir of his brother, 'the army was entirely out of our sphere . . . and the sinister nature of war was something that we had not thought about at all'.[35] For Stanley, the regime at Beaufort War Hospital was a considerable culture shock, only mitigated by the fact that his brother Gilbert had been posted there as well. But for all his nervy inwardness Spencer had a surprising resilience and adaptability, enabling him to turn the privations and sufferings of war to his advantage. From his own point of view, war was to some degree a prison, but as he told the students at the Ruskin School of Drawing in 1922, 'The first place an artist should find himself is in prison. The moment he realises he is a prisoner, he is an artist, and the moment he is an artist, he starts to free himself.'[36] Spencer's dignified and tender sequences of paintings based on his years of military service first in Beaufort War Hospital and then in Macedonia are amongst the most original of any European artistic responses to the First World War.

Spencer underwent the shock of the menial at Beaufort. He had an almost impossibly full day, 'full of every kind of job you can think of'. But as he told his sister Florence, 'I felt very deeply the stimulating influence "doing" had upon me. Every act so perfect in its necessity seemed like anointing oil on my head.' He found it actually 'wonderful' to wash up, to scrub the floors and 'to dress nearly every wound in the ward'.[37] He was especially affected by attending surgical operations. As a boy he had been gruesomely fascinated by the shedding of human

'Pa' Spencer, Stanley (centre) and Sydney (on the right), 1915. Estate of Stanley Spencer.

blood. He had always longed to see some of the internal organs. An account Spencer gives in a letter to Florence of an operation carried out in summer 1916 at Beaufort Hospital is almost unbearably intense:

> Operations had a terrible influence over me. I remember when it was eventually decided that they would have to operate on a patient named Hawthorn – an elderly man with a sweet nature … The abscess, which was a big one, had burst and flooded his body … He went in at 10. 30 and came out at one o'clock and all that time was a strain … Dr Reynolds, while Dr Morton was scrubbing his hands, sat on a high chair and to anyone who went by would say: 'Fetch so and so; don't touch me; do so and so.' He is so complete, so compact. I wish I could draw [him] sitting on a chair in a perfect state of sterility. I saw other operations, but none so exciting.[38]

Spencer found something 'very classical' about this operation, intensely aware as he was of the 'wonderful' stillness in the theatre in contrast to the sounds made by staff scurrying along the corridors outside.

Spencer believed instinctively that the activity of making was essential to any creative person. This philosophy was strengthened through the friendship he made while in Bristol with a young Catholic intellectual, Desmond Macready Chute.

Chute, relatively well-bred and sophisticated, came from a Bristol theatrical dynasty of famous actor-managers. He was soon to attach himself to the Catholic craft community in Sussex established by the patriarch and sculptor Eric Gill. Chute's visits to Beaufort made a lasting impression on Spencer who describes a radiant figure 'like Christ visiting Hell' walking towards him along a passage in the hospital with stained glass windows all down one side. Spencer, at the time, was

swathed in sacking, the approved uniform for floor scrubbing. Chute was a 'youth in a beautiful civilian suit'.[39]

In the course of this highly charged romantic friendship Chute gave Spencer a copy of the *Confessions of St Augustine* and frequently quoted Augustinian precepts in his letters. Spencer fixed upon the phrase about God 'fetching and carrying'. He wrote 'I am always thinking of these words. It makes me want to do pictures. The bas reliefs in Giotto's Campanile give me the same feelings.'[40] Spencer's ideas about art as necessary service became imbued with the perfectionist humility of St Augustine, as indeed did Eric Gill's.

Stanley Spencer went to war with his Fra Angelico, his Giotto and Masaccio, the small Gowans and Gray volumes of Old Master reproductions, stuffed into the pockets of his military uniform. In summer 1916, after thirteen months at Beaufort, he was transferred abroad. The destination was secret. On board ship he believed he might be en route for India. But in fact the troop ship landed in the northern Greek port of Salonika, and Spencer spent the next two-and-a-half years with the British army fighting the Bulgarians and Germans in Macedonia. At first he served with the Field Ambulance divisions but in August 1917, wanting more active participation in the fighting, he volunteered for the infantry, finishing the war as Private Spencer in the 7th Battalion, the Royal Berkshires. He spent several months in the front line.

There were times in his war service when Spencer felt as truly happy as he had ever felt – 'in fact happier'.[41] He had never been abroad. The landscape in Macedonia worked in on his imagination until he found there 'something equal in degree of intensity' to Cookham. He responded to the 'merciless wildness' of the country which struck him as just like being in Purgatory.[42] His letters back home are filled with descriptions and sketches of the haunting landscape of blue lakes, great trees and shrubs and 'Mysterious unknown Mountains'.[43] He was excited by the bird life: the storks and the wild geese; the way the Balkan sky would suddenly be solid with thousands of starlings massed together in flight. His childhood love of churchyards revived in foreign places and he was delighted, when walking one day in what seemed to be an overgrown park, to discover a Turkish Macedonian cemetery. He explained in a letter to his sister that the Turks would 'put brush wood round the nearly made graves and extra special dedders have tombstones like this (sketch attached) very oriental and wicked'.[44]

Spencer, still with his father's self-improvement instinct, read hard on foreign service, 'gorging' himself on Shakespeare's history plays. He asserted chirpily that Shakespeare 'beats the best bread ever baked'.[45] He read Marlowe and Milton and begged his sister Florence to send him a Dickens novel (as well as some biscuits and cakes in air-tight tins). He continued with what he called the 'nightmare' of reading Dostoievsky – 'dreadful but you can't stop'.[46] On 17 July 1917 he reported he was doing 'something very interesting'.[47] He was reading Keats and Blake at the same time. Spencer especially admired Blake's mellifluous lyrics: 'My silks and fine array' and 'How sweet I roamed from field to field', while noting that Blake was

accounted a madman – a description that would soon be applied by his detractors to Spencer himself. Spencer sensed he was like Blake in his purity and clarity, his vivid combinings of the visual and verbal. They shared a blazing integrity, a dangerously complicated English innocence.

In Macedonia Spencer learned the camaraderie of armies. The life was full of 'wonderful and beautiful experiences', many of them arising from military team-work, such as the giant exercise of shifting camp.[48] Like the interactions he watched in Cookham Village, the routines and interdependencies of soldiery were important to Spencer in arriving at the heart of what he wanted to express. The shy and awkward artist found acceptance amongst men whom, in other circumstances, he would have found antipathetic. 'They like cigarettes: I hate them. They like beer and rum: I hate it. They like sports: I loathe them in the spirit in which they are engaged.'[49] The exigencies of war enlarged his sense of human possibility. His always acute feel for transformation and transcendence excels itself in his descrip-tion of the scheme for the painting of *Dug-Out* (fig. 9) in Sandham Chapel, con-ceived in the horrors of the Macedonian War:

> The idea . . . occurred to me in thinking how marvellous it would be if one
> morning, when we came out of our dug-outs, we found that somehow every-
> thing was peace and that war was no more. That was one thing – the thought of
> how we would behave.[50]

Stanley Spencer completed very little work in wartime. He did some drawings of the inmates at Beaufort Hospital. The studies he made in Macedonia were left behind and lost when the Berkshire Regiment made the last big offensive of the war. The official offer of a commission to become a British War Artist, which Stanley Spencer welcomed when it was first suggested in May 1918, did not materialise until the war was at an end. He was wary of embarking on any large-scale painting, feeling that he could only do it 'in a rather slipshod way', and that

this, as his friend Jacques Raverat expressed it, 'would be "meddling with the Holy Ghost"'.[51] Sometimes he was calm about the lack of output, believing that the experience of war had improved his work more than if he had been actually painting. At other times, towards the end, as fighting intensified, he felt panic-stricken, dreading being snatched away with so much work that he wanted to complete before he died. Stanley's brother Sydney was killed in France, after being awarded the Military Cross, in the last month of the war.

Spencer came home to Cookham in December 1918. A recurrence of the malaria from which he had suffered intermittently in Macedonia allowed him to be invalided out. *Swan Upping* (cat. 6), the painting left unfinished when he enlisted in 1915, was still at Fernlea. He went to find it in the bedroom and described the reunion in terms of rediscovery of a loved person: 'I walked round the bed & laid my hands on it once more. Well there we were looking at each other; it seemed unbelievable but it was a fact.'[52]

The First World War had a profound effect upon the work of Spencer's contemporary British artists. Paul Nash painted a revelatory series of war landscapes, showing how the fighting had created great new deserts within Europe. Christopher Nevinson's paintings emphasised the growing brutality of war technology. Painters fighting on the other side – for instance, Max Beckmann and Otto Dix – also found the war a powerful stimulus. Beckmann, as a medical orderly, insisted 'For me, the war is a miracle. My art can gorge itself here.'[53] The Great War, as a traumatic and terrifying image, loomed over the next two decades of European art. But no other artist depicted it as Spencer did, in such grand-scale yet finally such warmly human terms. Spencer brings out the realities of what it was like to actually be there, in an almost humdrum every-day contact with battle and with death.

After Macedonia, Spencer started work on *Travoys Arriving with Wounded at a Dressing Station, Smol, Macedonia 1916* (cat. 7). This was an official war commission from the Ministry of Information, and Spencer painted it in his bedroom in Fernlea, later moving to Lambert's Stables in the village which were larger and better lit. The painting shows wounded men being brought in to an improvised dressing station during an attack on what was known as Machine Gun Hill in the Doiran Vardar section in mid-1916. Spencer recreated the incident from memory in one of a series of preliminary wash drawings showing scenes from the front. The splayed out composition was a favourite of his. Interestingly he planned a much closer-in depiction of a wartime operation with an incision in the belly in the centre of the painting and the surgical instruments radiating out.

The war had affected Spencer's equilibrium. The years of his Cookham earthly paradise were over: the village was now reorientated by political events and so was he. The literal Christian faith of his childhood had been shaken and, he told John Rothenstein, he had now 'got the wind up about Hell'.[54] At his worst, he clung obsessively to his belief that the War Office owed him compensation for what he had suffered in the war. His Cookham paintings of the early 1920s – among them

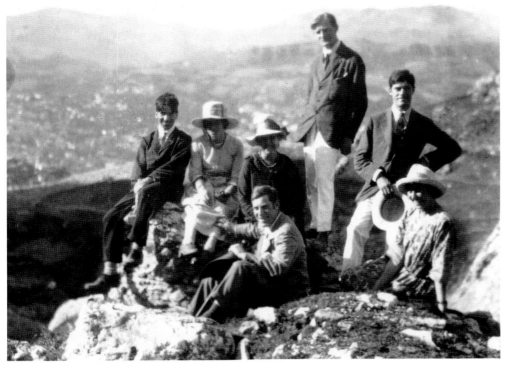

Christ Carrying the Cross (cat. 9), *The Last Supper* (cat. 8), *Christ's Entry into Jerusalem* (cat. 11) – are ominous and edgy evocations of Christ's passion. The memories of Macedonia still enter everything. When Spencer paints *The Cruxifixion* (cat. 10) the three crosses are set in a wilderness ravine beneath the range of mountains that divided Macedonia from Bulgaria. In 1922 Spencer went on a painting holiday in what was then Yugoslavia, spending a month in Sarajevo. He had wanted to return as close as possible to the remembered contours of the Macedonian hills.

V

'What Ho, Giotto!'[55] This was Spencer's response to the commission from Mr and Mrs J. L. Behrend for his most substantial post-First World War commission, the Sandham Memorial Chapel at Burghclere (figs 7–16). He was very familiar, through his careful study of the early Italian masters, with the idea of the chapel specifically-designed to house an artist's work, the ultimate example of which is the 'Arena' (or Scrovegni) Chapel in Padua, with its early fourteenth-century cycle of frescos by Giotto telling the story of the life and death of Christ. To Spencer, the builder's grandson, the idea of a 'home' for his work was irresistible, linking him back to the *modus operandi* not only of Giotto but also Fra Angelico, Masolino and Masaccio and other Italian artists whom he loved.

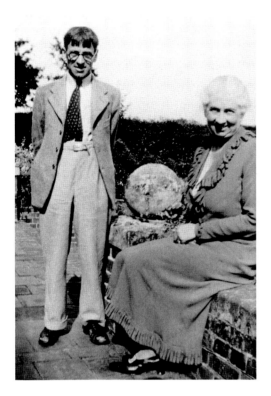

The concept of a war memorial chapel had been in his mind already, before he met the Behrends. In Macedonia he had been planning to acquire fresco techniques himself, when he returned to England. A scheme for a War Memorial Hall at Street in Hampshire had been proposed but had fallen through. When the Behrends, old acquaintances, came to visit Stanley in 1923 he had already drawn out a whole architectural scheme for a building to take his sequence of Great War paintings. They commissioned the chapel as a memorial to Mary Behrend's brother who had died in 1919 after an illness contracted in wartime. Like Spencer, Lieutenant Henry Willoughby Sandham had served in Macedonia, albeit more exalted in the military hierarchy. Spencer was remarkably lucky in his patrons. The Behrends bought a site for the chapel near their home in Hampshire, instructing their architect, Lionel Pearson, to construct the building exactly in the way Stanley Spencer had envisaged it. The artist had complete freedom with his subject matter too.

Spencer discarded the idea of fresco, reverting to his usual oil painting on canvas for the very large-scale scheme, which occupied him almost continuously from 1926 to 1932. He went to live in a cottage near the chapel, then still under construction in the village of Burghclere, thirty-six miles south-west of Cookham. Like his

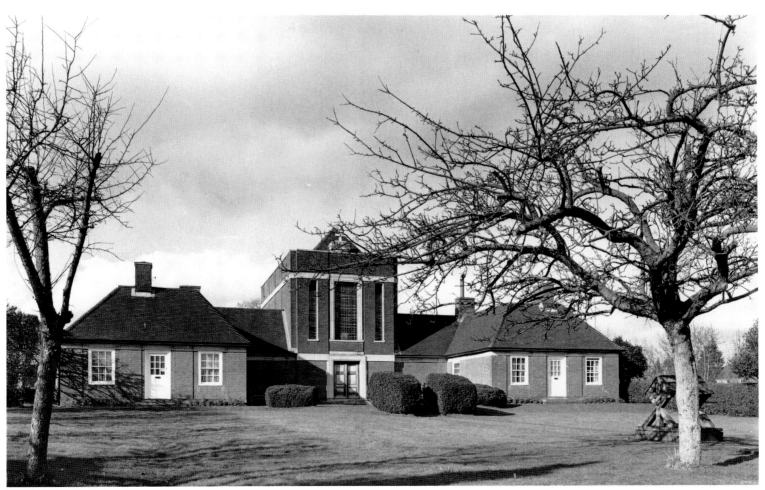

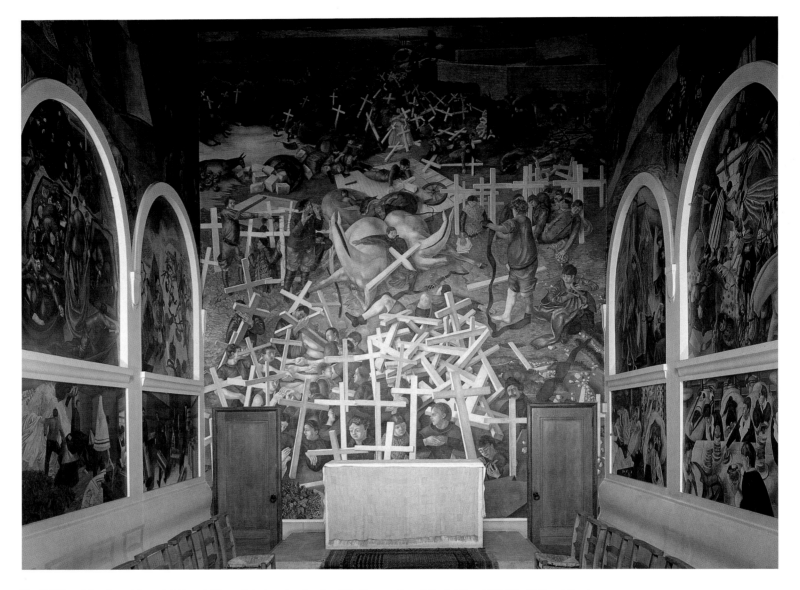

Fig. 7 (Above) Sandham Memorial Chapel: View of the interior showing *The Resurrection of the Soldiers*, 1932. The National Trust.

Fig. 8 (Opposite) Sandham Memorial Chapel: *The Resurrection of the Soldiers* (detail). The National Trust.

Fig. 9 Sandham Memorial Chapel: *Dug-out (or Stand-to)*. The National Trust.

Fig. 10 Sandham Memorial Chapel: *Filling Tea Urns*. The National Trust.

Fig. 11 Sandham Memorial Chapel: *Reveille*. The National Trust.

Fig. 12 Sandham Memorial Chapel: *Frostbite*. The National Trust.

Fig. 13 Sandham Memorial Chapel: *Filling Waterbottles*. The National Trust.

Fig. 14 Sandham Memorial Chapel: *Tea In the Hospital Ward*. The National Trust.

Fig. 15 Sandham Memorial Chapel: *Map Reading*. The National Trust.

Fig. 16 Sandham Memorial Chapel: *Bedmaking*. The National Trust.

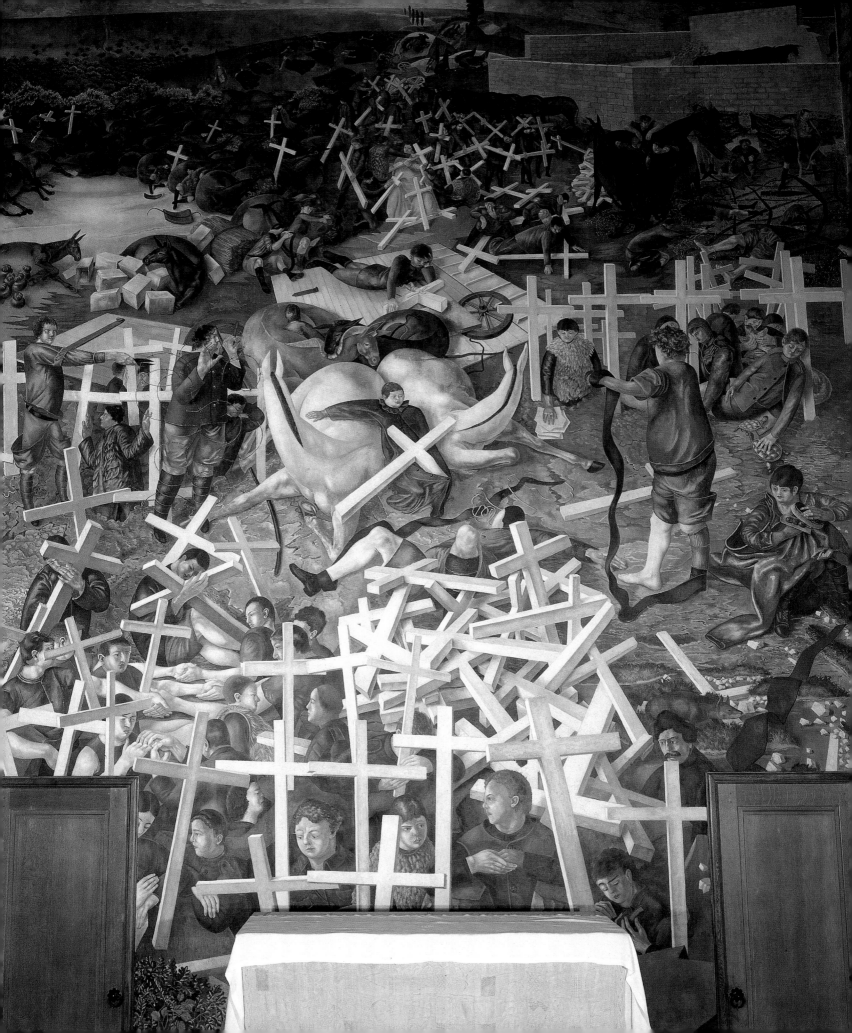

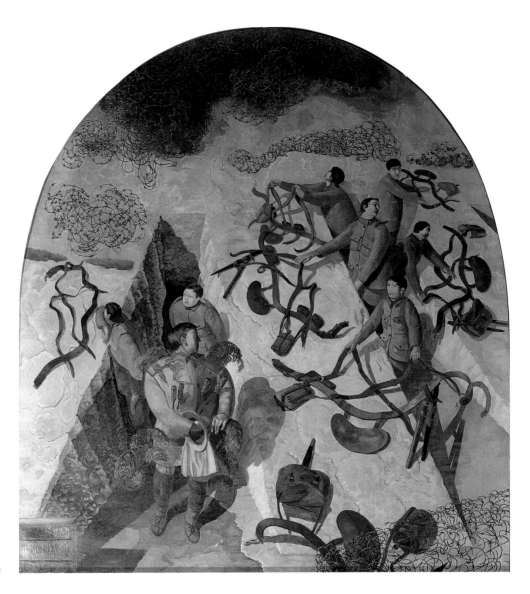

9

10

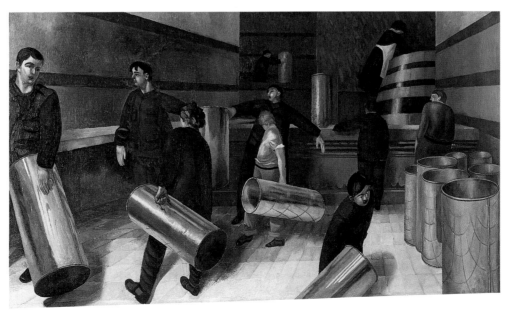

11

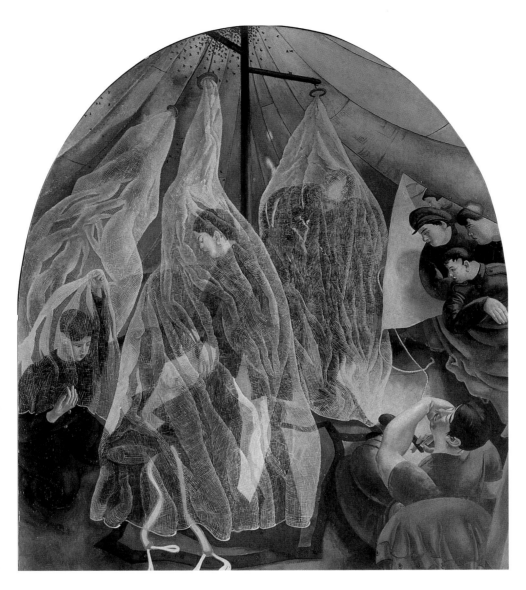

12

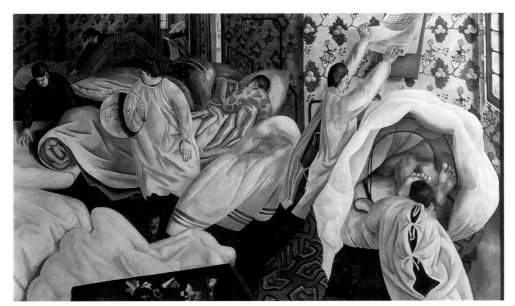

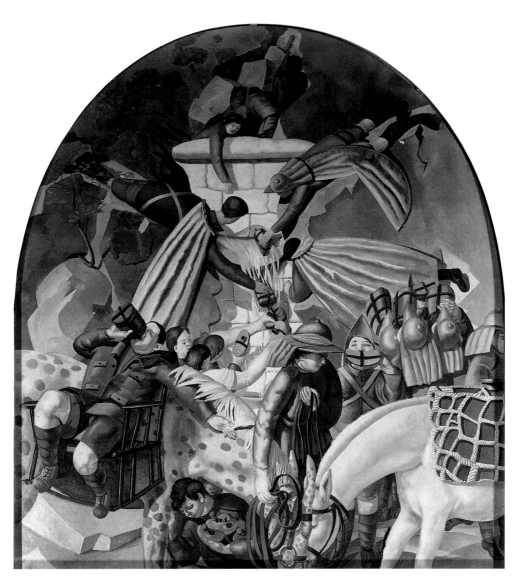

13

14

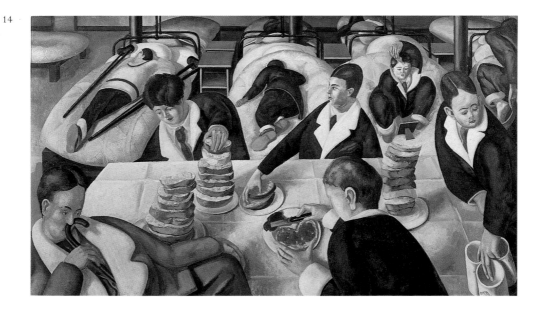

15

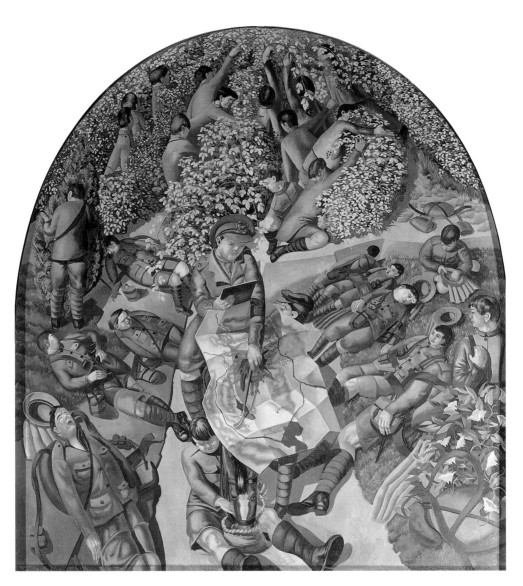

16

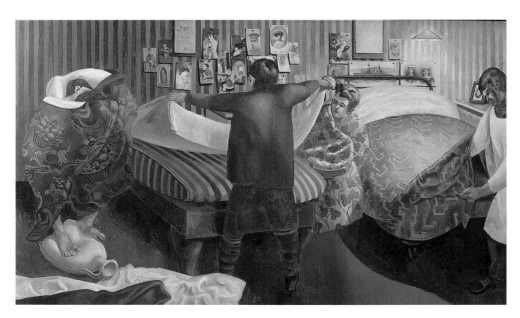

Italian forbears, the painting of the cycle became his way of life. Although some of the compositions were treated as easel paintings, much of the work was carried out *in situ* on wide bolts of canvas stretched across the walls. The walls had first been lined with asbestos cloth to which the lengths of canvas were then glued. Spencer spent about four years at work within the chapel, not minding the interruptions of visitors, one of whom was surprised to find the artist perched high on the scaffold reading Mark Twain.

Spencer's narrative of war winds itself around three of the four walls of Sandham Chapel. The north and south walls follow the same pattern: four tall panels with arched tops surmounting four much smaller rectangular 'predellas', and one large high-level painting extending down the wall. Each niche holds a scene concentrated with activity. Spencer has reached back into his memories of Beaufort War Hospital: the wounded arriving through cranking iron gates; the rituals of washing and medical inspections; the mundane tasks he found so curiously satisfying, such as making tea and scraping the frostbitten soldiers' feet. In another painting he returns to kit inspection at the military camp at Tweseldown, near Farnham in Surrey, where Spencer was sent for training before service overseas. In scenes set in Macedonia, soldiers are filling water bottles (wearing topees and regulation army mackintoshes); dressing and shaving, shrouded by mosquito nets; making beds in the temporary hospital in Salonika where Spencer was taken to recover from malaria. The large wall-paintings north and south show men in a Macedonian military camp.

These are crowded canvases but, as always in Spencer's more ambitious compositions, every group and each small incident stands out with its own clarity. Spencer liked to isolate these subsidiary groupings, using a canvas-stretcher, when he explained his work (he was a voluble explainer). The dynamic of his painting is that of the ant heap: myriad fragments of activity amassed to make a purposeful and pullulating whole.

Spencer's war is one in which the violence is understated. Superficially this is a very cosy war with British soldiers obediently carrying out tasks in the spirit of St Augustine's God 'ever busy yet ever at rest, gathering yet never needing; bearing; filling; guarding; creating; nourishing; perfecting'.[56] The unlikeliness, and bitterness, arises from the context. These are people, and actions, wrenched out of domesticity into a world of inhuman confrontations, in a trans-European war more mechanistic and brutally destructive than any war before. The political message is a deeply personal one, arising from Spencer's own faith in the strength of the human spirit to surmount the worst imaginable scenario.

Spencer's cycle at Burghclere is dominated by *The Resurrection of the Soldiers* (fig. 8). This central composition covers the whole east wall of Sandham Chapel and took Spencer almost a year to complete. The great scene is of recovery: the ending of the battle, the surrender of rifles, the handing in of crosses, the reunion with dead comrades, newly resurrected. In the background the soldiers mob Christ risen, as though he were a rock star. At the top of the canvas, as in an Italian fresco,

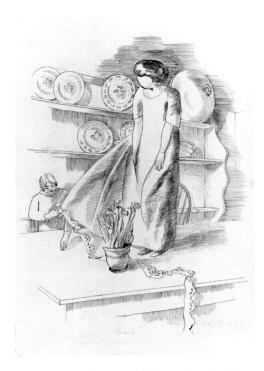

the composition drifts away with cypress groves and hills. This enormous, highly detailed and ineffably strange painting sees the twentieth century in terms of the epic, the miraculous, the culmination of long arduous spiritual journeyings. Spencer is a modern artist who believed that true modernity necessitated reclamation of the past.

Spencer's work at Burghclere is by far the most impressive to emanate from any British painter of the inter-war period. The only real comparison is with Picasso's *Guernica*. The effect on the spectator of seeing Spencer's cycle *in toto* in the chapel is almost overwhelming. The prevailing feeling is of an intensive physicality. Where the disciplines of military life discouraged the visible expression of emotion, peace brings a return of touching, hugging, joyful gesticulation. Spencer's view of resurrection involves the recognition and restoration of the necessary human rhythms of uninhibited physical expressiveness.

Spencer, in his writings, would be eloquent about the proximity of resurrection and sexual unity. In his painting of *The Resurrection of the Soldiers* there is a sense of triumphantly orgasmic relief as men rising from the grave exchange great handclasps, human flesh and mule flesh become strangely jumbled up and, on the right edge of the painting, a small soldier, looking drowsy, stretches his hand caressingly over a tortoise's hard shell. As Spencer wrote:

> During the war, I felt the only way to end the ghastly experience would be if everyone suddenly decided to indulge in every degree or form of sexual love, carnal love, bestiality, anything you like to call it. These are the joyful inheritances of mankind.[57]

Spencer's concept of 'Sex Peace' was to revive in the 'Make Love not War' slogans of the later 1960s. Something of the spirit of the Sandham Chapel murals resonated into later twentieth-century pacifist agendas, in particular the anti-Vietnam protests in the United States. At Burghclere Stanley Spencer had begun his explorations of the themes of human intimacy that came to dominate his painting as the 1930s progressed.

VI

Through the years of his work on Sandham Memorial Chapel Spencer was undergoing his personal resurrection. In 1925 he married Hilda Carline who was also a painter trained at the Slade. A drawing made soon after shows her standing on the table being fitted for her wedding dress (fig. 17). Hilda came from a well-connected sociable family of north London artists and intellectuals. Spencer always gravitated towards semi-establishment bohemians. His farouchness must be seen within a context of the highly civilised and relatively well-heeled. The Carlines lived in a substantial house at 47 Downshire Hill in Hampstead. It was here he first saw Hilda, with her auburn hair and rapt intelligent expression, in the family dining room, bringing round the soup.

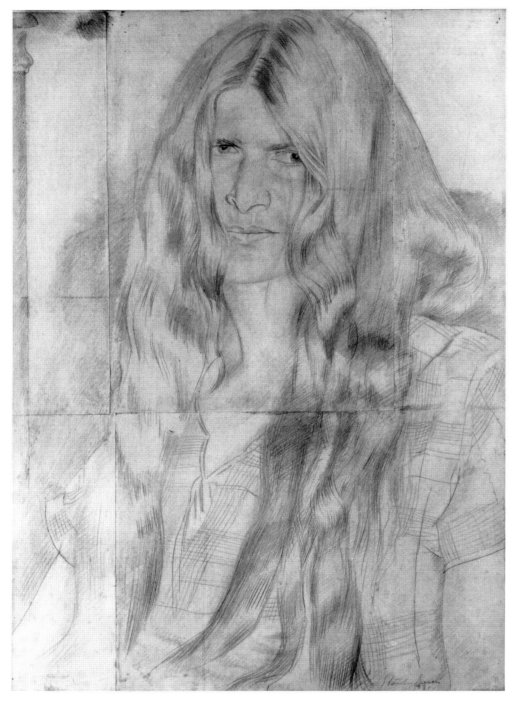

Fig. 18 *Hilda with her Hair Down*, 1931. Present ownership unknown: photograph Courtauld Institute of Art.

Stanley and Hilda at Burghclere, late 1920s. Estate of Stanley Spencer.

'How I would love to do a drawing of you with your hair down,' he wrote to Hilda later, 'not because I think it suits you, although it gives you one special look I love, but because it would be such fun to do.'[58] Long hair gave him a wonderful feeling of infiniteness and endlessness. Spencer's study *Hilda with her Hair Down* (fig. 18), made in the early years of marriage, is one of the most beautiful of all his portrait drawings.

Sexually Stanley Spencer was a very late developer. When he first met Hilda Carline, at the age of twenty-nine, he was in a condition of almost total innocence

Fig. 19 Letter to Henry Lamb, 2 February 1922 , including *Resurrection* sketch. Tate Gallery Archive.

Stanley Spencer painting *Resurrection, Cookham*, 1924–7. Estate of Stanley Spencer.

and saw the event in terms of a momentous separation from his old self: 'from that day onward what I had always understood as being Stan Spencer was now no longer so – a whole heap of stuff lust or what you will was sweeping me along helpless'.[59] The first time he deliberately touched a woman he had realised that here was a 'miracle' he could perform. In later years, when lust had swept him in too many other incompatible directions, he was still returning in his imagination to the blissful beginnings of his sexual life with Hilda, in bed with her or strolling nude around the studio: 'We groped our way peacefully about each other. The overflowing and puddle of you and me met and joined and were lost in each.'[60] His erotic recapitulations have some of the flamboyant intensity of his revered poet, the seventeenth-century metaphysical, John Donne.

Spencer went into marriage knowing that he needed a secure domestic framework in which to work. In a revealing passage in his autograph notebooks, dated 1949, he explained: 'At Fernlea as a child I consummaged [sic] all through Pa and Ma and Home Life.' This combination gave him the 'lived-in-element' that he required. Working away from home, he realised he was drifting and that in order to be able to achieve the things he wanted he needed to be married: 'If I wanted the Fernlea lived-in feeling I must create a new thing that provides it: a new Pa and Ma.'[61]

Marriage to Hilda gave him, to begin with, the domestic security he craved. Sex and work. An alert and sympathetic critic. To Stanley's brother Gilbert the Hilda-Stanley ménage looked like an easy-going Impressionist marriage: he instances Pissarro, painting with wife, children and chickens milling contentedly around. Stanley himself, in an egocentric drawing *Me painting*, made his own comparison with Gustave Courbet's self-portrait *Bonjour Monsieur Courbet!*, adding the explanation 'the Deity and Hilda inspire the artist to work'.[62]

Spencer's home-based resurrection, *The Resurrection, Cookham*, (cat. 13) was painted in these early years of marriage, between 1924 and 1926. It was sandwiched in between his original conception of the Sandham Memorial Chapel and the actual painting of the murals at Burghclere. *The Resurrection, Cookham*, is another very large-scale, complex, symphonic work, by far the most ambitious of four Resurrection subjects painted by Spencer from 1912 on. It was painted in Hampstead, in a studio lent by Spencer's friend and early patron Henry Lamb, and early plans for it are illustrated in a letter written to Lamb in 1922 (fig. 19).

The painting is many things: a thanksgiving for Cookham, being set in Cookham Churchyard; a testament of friendship, with many recognisable Cookham and Hampstead figures, including the nude portrait of Hilda's brother Richard, kneeling beside Stanley, his arm resting on a tomb. *The Resurrection, Cookham* meditates upon the nature of contentment, the relationship of sex and repetitive activity. Spencer wrote, in relation to his painting:

> In this life we experience a kind of resurrection when we arrive at a state of awareness, a state of being in love, and at such times we like to do again what we have done many times in the past, because now we do it anew in Heaven.[63]

Most of all, of course, *The Resurrection, Cookham* is homage to Hilda who appears in three permutations in the picture: lying on a tomb covered with ivy; climbing over a stile on her way to the river; and smelling a flower by the path on the left. Spencer writes with great *tendresse* about Hilda and the flower. 'She wonders about its scent and pushes it against her face. She wears a jumper I liked, one that had been pulled into being very flopped from much washing of it.'[64] Spencer is a painter for whom domestic textures hold an erotic connotation.

The Resurrection, Cookham was the painting that established Stanley Spencer's reputation. The critic of *The Times* was not alone at the time in thinking it 'The most important picture painted by any English artist in the present century.' He added that 'What makes it so astonishing is the combination in it of careful detail with modern freedom of form. It is as if a Pre-Raphaelite had shaken hands with a Cubist.'[65] The comparison he makes is perhaps a little strained: Cubist forms in Spencer's painting are very tentative. But it is interesting in the light it sheds on the way in which Spencer was at the time perceived, not in isolation but in the perspective of Continental developments in art. Even more to the point perhaps is the inclusion of Spencer in the list of world-class works of art compiled in 1928 by his fellow artist Eric Gill. Here *The Resurrection, Cookham* is cited as a work of lasting aesthetic and intellectual substance, alongside the Pyramids, the Forth Bridge, Karl Moser's new ferro-concrete church in Basle, Matisse's *Turkish Girl*, Cézanne's landscapes, the Cave Paintings of Ajanta, the *Song of Solomon*, *Morte d'Arthur* and James Joyce's *Ulysses*.[66]

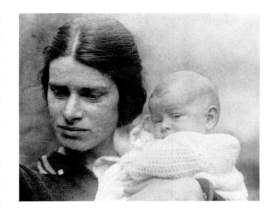

Hilda and Shirin, 1926. Estate of Stanley Spencer.

Stanley holding Shirin with Hilda looking on. Estate of Stanley Spencer.

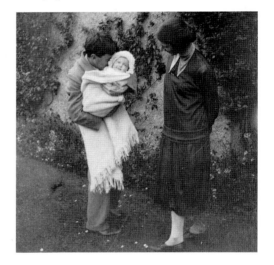

VII

Stanley and Hilda. Stanley and Patricia. Spencer's work is nothing if not autobiographical. The tenor of it changed from the early 1930s when he embarked on a tortuous and often tormented relationship with Patricia Preece, the woman who became his second wife.

During the painting of the Sandham Memorial Chapel Spencer had been living in Hampshire with Hilda and their two small daughters, Shirin and Unity. In December 1931 the family moved back to Cookham, establishing themselves at Lindworth, a large house with a garden just off Cookham High Street. Hilda in fact was absent a good deal at this time, back at the Carline home in Hampstead where her eldest brother George was seriously ill.

The marriage had in any case been developing its tensions. Hilda, a strong-minded woman and a feminist, was not domesticated to the degree that Stanley had expected. A trained artist of much talent, as he himself acknowledged, she now found herself frustratingly unable to work. Her fervent Christian Science principles induced her to refrain from sex for considerable periods. Stanley resented this. Hilda was moody and was later to develop mental illness. Stanley, also unstable, was still debilitated by the malaria contracted in Macedonia, and was prone to bad attacks of renal colic from 1930 on.

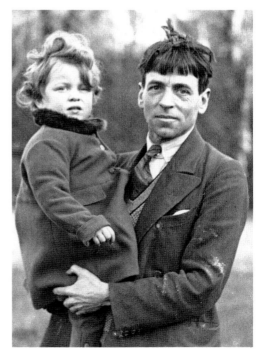

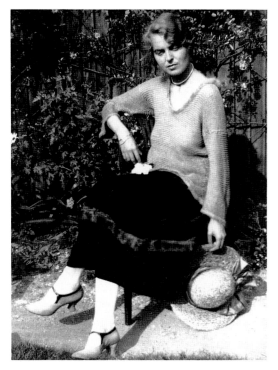

Patricia Preece, c. 1929. Estate of Dorothy Hepworth.

Fig. 20 *Combing Hair, Stanley and Patricia*, from Scrapbook Drawings, *c.* 1943–4. Stanley Spencer Gallery / Astor Collection.

Fig. 21 *Patricia Shopping*, from Scrapbook Drawings, *c.* 1943–4. Stanley Spencer Gallery / Astor Collection.

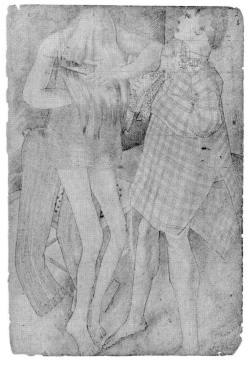

Stanley and Unity, *c.* 1934. Estate of Stanley Spencer.

Soon after the Spencers took up residence in Cookham, Stanley's old acquaintanceship with Patricia Preece, a glamorous though impecunious artist living in the village, burgeoned into a close friendship and then into an obsession, with Patricia's encouragement. As Hilda described the situation in a letter written in the bitter aftermath of divorce:

> I am now sure that Patricia had one thought only in her mind and that was to get the money and, finding Stanley a possible person, she set about to procure him, trying to keep the road clear to get rid of him when she wanted to . . . She vamped him to a degree unbelievable, except in cinemas. I often wondered how Stanley could stand up against it. If he went to her house, she always received him half or a quarter dressed, with perhaps a dressing gown on. She was always daring him to kiss her and, when he did not do so, said he was only a C3 man.[67]

Preece had lived in Cookham since 1927. Spencer had originally met her in a village teashop later called The Copper Kettle. Part of her attraction for him was her foreignness. She was *Vogue*ish in appearance, upper middle class in background: Spencer always had a predeliction for 'the nobs', and Preece's contemporary vampiness is captured in a sequence of drawings showing, for example, *Combing Hair, Stanley and Patricia* (fig. 20) and *Patricia Shopping* (fig. 21). She had an insatiable appetite for jewels, silk stockings, high-heeled shoes and the 'hundreds' of dresses that Spencer lavished on her, reckless of the effect upon his own precarious financial state.

But another element in Stanley's adoration of Patricia Preece was her long familiarity. He felt she was a part of the texture of the village, newly rediscovered, yet another joyful resurrection. In paintings of this period he juxtaposes Patricia

and the known, loved places of his childhood. An earlier drawing, study for the month of April: *Neighbours*, had depicted a Patricia-like blonde temptress encroaching upon the front garden of Fernlea (fig. 22). *Separating Fighting Swans* (cat. 17) now shows Preece on the Thames riverbank, perched beside an all-too-phallic bollard, while the angels in the corner give the union their blessing. Like some other religious artists of the mid-twentieth century, notably Eric Gill, Spencer struggles to align male sexuality with Godliness:

> Without belief, without utter faith & confidence, there is impotence. A man raises a womans dress with the same passionate admiration & love for the woman as the priest raises the host on the altar.[68]

Fig. 22 Study for the the month of April: 'Neighbours', for Chatto & Windus Almanack, 1926. Stanley Spencer Gallery/Barbara Karmel Bequest.

Hilda remained essential to Spencer, at the centre of his artistic vision, the imagined recipient of all his writings. He once told her she was the only person he could be himself with. The paradoxical integrity of their relationship can be glimpsed in the portrait *Hilda, Unity and Dolls* (cat. 35), painted at the height of their emotional disturbances. Spencer wanted Patricia but he needed to keep Hilda, proposing a permanent triangular relationship. His fascination with the notion of a pair of women can be traced as far back as the Slade. An early oil painting, *Two Girls and a Beehive*, a soulful double portrait of the Cookham butcher's daughters, Dorothy and Emily Wooster, was later described by Spencer as 'a fusion of my desires . . . the place, the girls and the religious atmosphere'.[69]

Spencer's yearning for two women, as it gathered in intensity, developed into a longing for more women, whole gatherings of women. In his painting *Promenade of Women* he sees each of them as his love letter to the other, with their qualities accentuated by comparison with the other females in the entourage. Encouraged by God, there is a general assenting: 'There is no one saying no in my pictures all are saying yes.'[70] The Cookham child's desperation for connections had been taken up and worked on by the adult artist, enlarged into a vision of a world in which all living creatures had to do with Stanley Spencer, even those as yet unknown. Spencer explained this in exhilaration in his essay in *Sermons by Artists* (1934):

> Every thing or person other than myself is a future potential part of myself, or a revealer of and an agent in revealing unknown parts of myself: unknown husbands, wives, lovers, worshippers, never before seen and only known by a persistent desire or passionate longing, supported by a kind of consciousness of their existence.[71]

Stanley painting, with Hilda and Shirin watching, early 1930s. Estate of Stanley Spencer.

The sense of divine toleration surges into Spencer's paintings of the mid-1930s. These are active, whirling paintings, often high-coloured panoramas of permissiveness. What Spencer was hoping for was to convey the impression of unlimited possibilities of passion and desire at the centre of God's creativity. In *Love Among the Nations* (cat. 24) the barriers of race recede in a bonanza of mixed-race lovemaking in which the child-figure of Spencer plays his own ecstatic if somewhat baffled part. The related picture, *The Turkish Window* (cat. 20), in which young men make love to veiled women behind bars, develops the 'love-without-

Fig. 23 *Sunflower and Dog Worship*, 1937. Private Collection.

boundaries' ideas espoused by Spencer in Macedonia. As the artist points out in his commentary, even the bars are sympathetic to the ideal rhythmic give and take of love. Stanley Spencer's pantheistic visions reached out to union with animals and plants. In *Sunflower and Dog Worship* (fig. 23) a Hilda-figure yields to the embrace of a large sunflower and Stanley licks tongues with a Dalmatian.

Spencer laid claim to a varied and imaginative repertoire of lovemaking as the way of holy revelation. In English art circles of the early twentieth-century such ideas had already been popularised by Ananda Coomaraswamy, a Hindu from Madras who eventually became curator of the Indian collection at the Boston Museum of Fine Arts. Coomaraswamy had a formidable influence on Gill and Jacob Epstein whose sculpture found direction from theories of the primitive sacredness of erotic art. Stanley Spencer's own interest in eastern religion was extended by his reading of Sir Edwin Arnold's *The Light of Asia* in the 1920s and by his friendship with the artist James Wood, an expert on Islam. Spencer fastened on Islamic authority in shifting boundaries between the sacred and profane, the beautiful and ugly, the forbidden and permitted. The Islamic and the Taoist attitudes to polygamy were especially endearing to Spencer at this time.

From the early 1930s, as Spencer was making his own bid for sexual freedom, the immense creative project known as 'the Church House' began to take shape in

Fig. 24 Sketch plan for Hilda Chapel at the Church House, 1948. Tate Gallery Archive.

his mind (fig. 24). This was to be his means of 'marrying' his old feelings of love for and dependence upon Cookham with his new feelings of heightened sexual awareness in the aftermath of meeting Patricia Preece. As at Burghclere the scheme was for a cycle of paintings within a special building. The idea had developed from his urge to continue the paintings in the Sandham Memorial Chapel out into the almshouses surrounding the Chapel itself. Spencer sketched out a number of plans for the Church House, some of which were based on the layout of Cookham Village, others of which came closer to the plan of an English parish church with a long nave, side aisles and subsidiary chapels. The Church House, which dominated Spencer's thinking from now onwards, was designed to be the setting for his large-scale celebratory cycles of sacred and erotic art.

Spencer planned three main sequences for the Church House: *The Pentecost* (which was never executed); *The Marriage at Cana* (cat. 58) in which he envisaged life as an eternal progressing through marriage, with final regeneration for the holy bride and groom; and *The Baptism of Christ* (cat. 55). These cycles were linked loosely under the descriptive title *The Last Day*, a final and triumphant expression of Spencer's essentially non-judgmental view of the Last Judgement, in which no one is discarded but – like the artefacts he rescued from the Cookham Village rubbish dumps – all are newly appreciated and redeemed. Cookham itself was envisaged as a Village in Heaven, in which the villagers, reborn as uninhibited and sexually desirable, would make love in the street.

Spencer never intended the Church House to be shocking. He was solemn in his admiration for such Indian sacred art as the temple carvings at Khajuraho, expressive of Krishna's love for the Gopis, in which the sexual act has a quality of nonchalance. But Spencer failed to find a patron for his building. Like Eric Gill and Jacob Epstein's schemes for an erotic Temple of the Sun, a new Stonehenge of enormous and phallic carved stone figures standing like gods and giants in the

Sussex landscape, Stanley Spencer's Church House was one of those potential twentieth-century masterpieces which, in the form he planned it, did not material-ise.

Spencer's passionate plea for integration not just with his fellow human beings but with the whole natural world of plants and animals and sun and moon has many echoes in the poetry and fiction of the period. There are obvious parallels with D. H. Lawrence, another product of the Nonconformist Biblical upbringing, with his vision of England transformed by love and truthfulness into a New Jerusalem and his struggles in finding a language to express the act of human con-gress that was central to this vision. *Lady Chatterley's Lover*, privately printed in Florence in 1928, was only finally published in its unexpurgated version thirty years later in Britain and the United States. In 1929 thirteen paintings by Lawrence were removed by the police from exhibition in a gallery in London and pronounced obscene. Six years later, two paintings submitted by Spencer, by then an Associate of the Royal Academy, for the Royal Academy Summer Exhibition at Burlington House were rejected by the Hanging Committee. The official letter of rejection used a standard formula that the Committee 'did not think these works of advantage' to Spencer's reputation or to 'the influence of the Academy'. The sub-text was that the Academy felt Spencer had become too idiosyncratic or too sexu-ally explicit for these works to be exhibited under its aegis. Spencer, mortified and furious, resigned.

One of the rejected paintings was *St Francis and the Birds* (fig. 25), a picture intended to hang in the nave of Spencer's projected Church House building. The adoring flock of English farmyard birds surrounds a figure of St Francis based upon the memory of Spencer's father in his dressing gown going to the larder in the narrow passage between Fernlea and the small adjoining house, 'The Nest', to find food for the hens and ducks. The figure of St Francis is so large and expansive because the message he bears is so wide-reaching: in his preaching to the birds Spencer has conceived that St Francis is expressing 'his union with nature and the romantic wilderness of it'.[72]

For Spencer it was a solemn painting of great meaning, and he defended it with vigour against those who denigrated it as caricature. It was sold the day after the Academy rejected it and presented to the enlightened academic, Dr Lynda Grier, Principal of the Oxford women's college, Lady Margaret Hall.

The second rejected picture, *The Dustman* or *The Lovers*, (cat. 19) was another Church House painting, which Spencer compared to 'watching & experiencing the inside of a sexual experience' in which all the participants 'are in a state of anticipation & gratitude to each other. They are each to the other & all to any one of them as peaceful as the privacy of a lavatory.' The painting is a local Cookham scene of resurrection with the reborn dustman and labourers being reunited with their wives, overflowing from the cramped, traditional English cottage garden. In this exultant picture the dustman is glorified and magnified: 'The joy of this bliss is spiritual & his union with his wife who carries him in her arms and experiences the

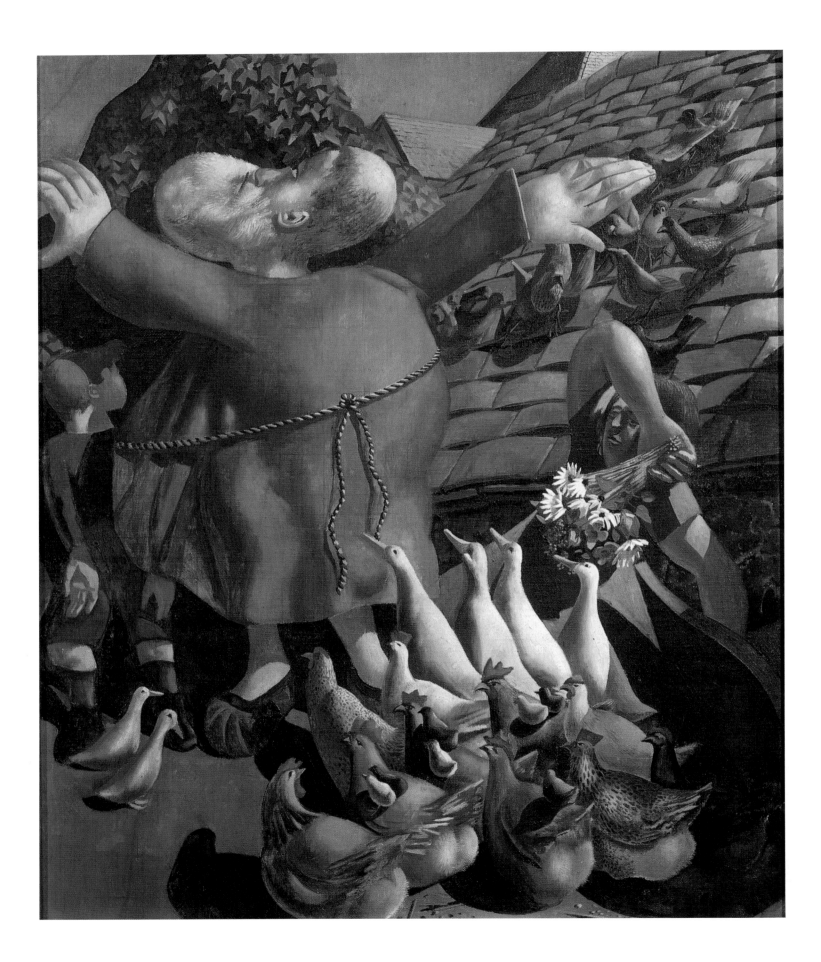

Fig. 25 *St Francis and the Birds*, 1935. Tate Gallery, London.

bliss of union with his corduroy trousers.' (Stanley had his own connections with that fabric since his brother Horace, a professional magician, was reputed to have been the first person in England to wear a pair of corduroys.) Spencer always found great satisfaction in looking at a reproduction of *The Dustman*, unable to understand why people found it problematic. 'It so says me', he wrote later, 'right on the target: the locked fingers under the braces.'[73] He noted that the old man in the top right hand corner – the Holy Ghost/Pa Spencer figure – was a necessary fixture in his life.

It is typical of Spencer that now, just at the period his own domestic life was in turmoil, his creative involvement in concepts of home intensified. Contemporary with *The Dustman*, with its teapot and its empty jam jar and its cabbage stalks, the gently reeking detritus of Cookham life, are two related paintings, *Workmen in the House* (cat. 22) and *The Builders* (cat. 21), both grudgingly accepted by the Academy in 1935. These go back to Spencer's sense of outside workmen, in his childhood, transforming the known physical parameters of childhood. In these paintings there is the excitement of incursion and commotion, of quiet domesticity under threat.

Between summers 1935 and 1936 Spencer was working on a series of nine paintings, the so-called *Domestic Scenes*, in which he revivifies his life with Hilda, running through the old, loved actions of the household – dusting shelves and turning out the chests of drawers – with what can be construed as a sense of mounting panic at the notion of their impending loss. His daughters Shirin and Unity make an appearance in these paintings. In *The Nursery* or *Christmas Stockings* (cat. 30) they are feeling their stockings to try to guess the contents, a memory entwined with Spencer's far-off Cookham childhood in which strange bumps in beds had a particular enchantment. He remembered the effect, beneath sheets, of the bodies of his parents with himself, the small boy, enclosed between the two white mounds.

It was a terrible period for Hilda. Her puzzlement and growing desperation emerge from her letters of the early 1930s. Extracts from these appeared in John Rothenstein's edition of *Stanley Spencer, The Man: Correspondence and Reminiscence*, published in 1979. They are almost unbearably poignant to read as Spencer's sexual fixation on Preece threatens Hilda's fragile mental balance. 'Physically and mentally I am going under', she wrote to him in 1935.[74] Her grief and her confusion had caused her to give up Christian Science.

The following year Hilda decided, after all, to institute proceedings for divorce and the decree absolute was issued in May 1937. In spite of the fact that Preece was lesbian and had been co-habiting with her partner, Dorothy Hepworth, for some years, she now agreed to marry Spencer. The wedding was held on 29 May 1937 in Maidenhead Register Office. A honeymoon was planned at the fishing village of St Ives in Cornwall. Preece and Hepworth, an enigmatic presence at the ceremony, set off to the rented cottage in advance. Hilda, having received a surprising invitation from Patricia to join Stanley at Lindworth after the wedding and then accompany

Richard Carline, Dorothy Hepworth, Patricia Preece (kneeling) and Mrs Carline (seated), early 1930s. Estate of Stanley Spencer.

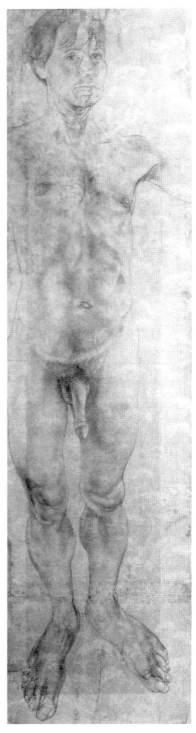

the party on the honeymoon, arrived in Cookham and spent the night with her newly remarried ex-husband. She did not go on to Cornwall with Spencer who, according to his own later account, attempted unsuccessfully to consummate his marriage to Patricia, storming out of the cottage to look for other lodgings when Patricia retreated to spend the rest of the night in Dorothy's room.[75] Had Preece engineered Hilda's visit to Lindworth, with its foreseeable consequences, to release herself from moral or legal obligation to enter into sexual relations with Spencer? It seems probable.

It is remarkable that through this troubled period of alternating personal tragedy and farce, Spencer's work was to flourish and develop. Spencer's creative urges seem to feed upon emotional and sexual agitation. In his plans for the Church House, his love building, he noted: 'Every desire giving me the one wish to paint.'[76] His landscape painting of the 1930s is astonishingly fecund. He goes back to his old territory in and around Cookham – *The May Tree* (cat. 16), *Cedar Tree, Cookham* (cat. 23), *Bellrope Meadow* (cat. 28), *Gardens in the Pound* (cat. 29), *Greenhouse and Gardens* (cat. 34) – and paints it with what seems like a new freshness, an almost agonised intensity, the heightened awareness one experiences in entering into a new relationship.

In a rare view of the English seaside, Spencer returns to *Southwold* (cat. 36), the small resort in Suffolk close to Wangford where he and Hilda were married. He went to Suffolk on his own, after the Patricia Preece débâcle, staying with his old seaside landlady. There is a powerful accumulation of emotion in his painting of the serried ranks of deck chairs, the windbreaks and the swimming suits, the trippers bravely picnicking along the pebbly shore. Though Spencer still had his

Figs 26 and 27 Self-portrait drawings, *c.* 1938. Private Collection, Switzerland.

Stanley Spencer and Patricia Preece marry at Maidenhead Registry Office on Saturday 29 May 1937. The witnesses were Dorothy Hepworth (left) and James ('Jas') Wood (right). Estate of Dorothy Hepworth.

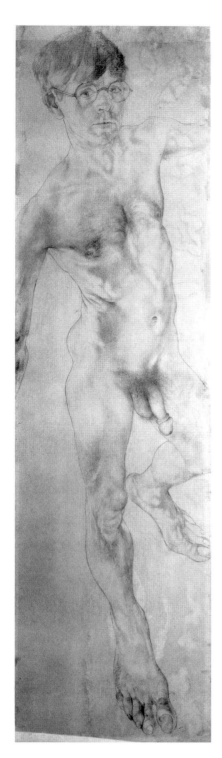

reservations about landscape it was necessary to him. More than his 'notion' pictures, landscape made him keep his bearings. He admitted 'It has been my contact with the world, my surroundings taken, my plumb line dropped.'[77]

In these same years of traumatic personal history Spencer embarked upon another kind of landscape. In his series of nude portraits of Patricia Preece, and of himself with Preece, Spencer investigates the landscape of the human body with an unflinching courage. He compared the effort of his observation of Preece to that of an ant crawling all over the contours of her body, scrutinizing every detail. A pair of nude self-portrait drawings, also dating from this period, shows a comparably candid observation at work (figs 26–7). The fact that the oils of Patricia Preece were painted directly from the model differentiates the 1930s nudes from the rest of Spencer's figurative work. They were rarely exhibited in Spencer's lifetime, partly because of their connection with his scandalous liaison with Preece but also because their fleshly candour appeared in the England of that period, when only implied eroticism was acceptable, shocking if not obscene. Spencer himself had a sense of their central importance in his *oeuvre* and the nude paintings were given special prominence in his plans for the Church House, hung together in a specially designed room 'to show the analogy between the church and the prescribed nature of worship, and human love'.[78]

Spencer never used professional models, 'not liking the idea'.[79] His portraits were always an intimate transaction, between artist and model. The 'double nude' portraits are dual transactions, in which the artist paints a self-portrait in conjunction with a portrait of the woman he loves. His portraits of Preece, painted between 1935 and their marriage two years later, confront the essential paradox of their relations: these nude paintings are about the blocking of desire. This is the woman in bed about whom Spencer once wrote 'As to giving herself to me, she removed all of herself up into her head which she buried in a pillow, and sub-let the rest of her shifting body...at high rental.'[80] The lack of reciprocation is made manifest in Spencer's portraits of Patricia staring blankly, dressed in black lace camiknickers; Patricia sprawled in bed, disdainful of an abject eager Stanley. We are aware of an acreage of distance between the naked couple in the painting that sums up twentieth-century non-communication, *The 'Leg of Mutton' Nude* (cat. 33). 'There is in it', as Spencer commented so bleakly, 'male, female and animal flesh.'[81] Perhaps he still hopes a little but not much.

'The nearer the bone the sweeter the meat.' This was a familiar saying of Spencer's Cookham Sundays, as his father carved the joint. The paintings of Preece, and the later nude of Hilda, which Spencer had intended as the first of a whole series, are as near to the bone as Stanley Spencer ever got. Where so much of his painting gravitated towards ecstasy, transforming the hideous experience into joyfulness, these portraits are quite different, sober and relentless. Spencer has faced the facts. Their cold frontality has no counterpart in Britain before the portraits Lucian Freud was painting from the 1950s on.

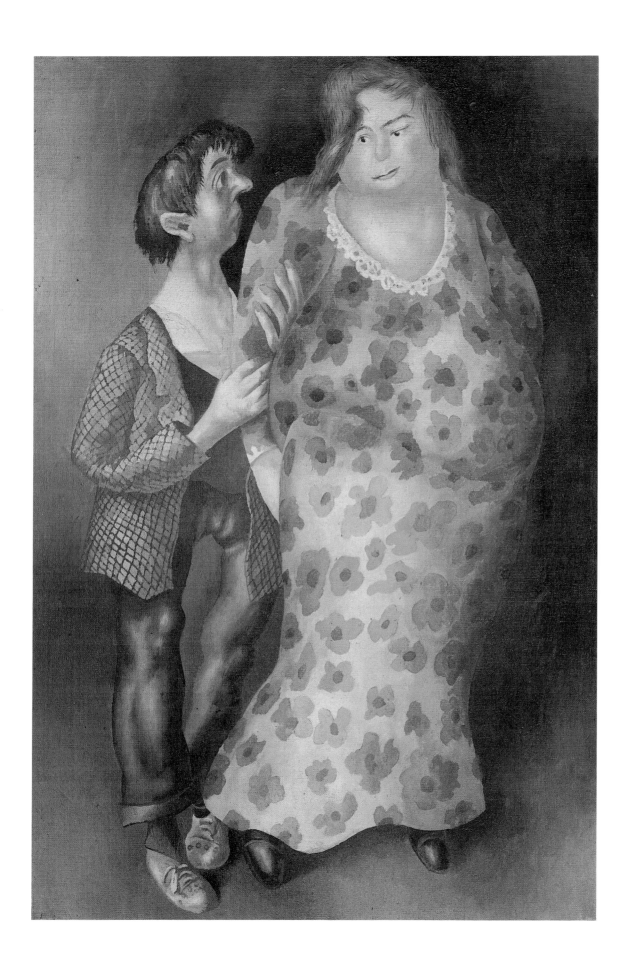

Fig. 28 *Beatitude 4: Passion or Desire*, 1933. Lefevre Gallery, London.

VIII

Now Spencer was out in the wilderness, removed from any realistic hope of permanent reconciliation with Hilda, estranged from Patricia to whom he had made over the deeds of Lindworth, his Cookham home. He was financially encumbered, and under constant pressure from Dudley Tooth, his agent since 1932, to concentrate on his highly saleable landscapes, for which there was always a waiting list, instead of the 'me' paintings to which he was emotionally committed. When Patricia decided to rent out Lindworth in 1938 he was effectively evicted, left with only the garden studio to work in. Later in that year he moved to Hampstead, renting a room in a tall, gaunt London brick building at 188 Adelaide Road, near Swiss Cottage Station and not far away from Hilda. He visited her often, repeatedly proposing remarriage.

Separated from cosy routines that he depended on, Spencer concentrated his creative energies on two substantial cycles, *The Beatitudes of Love* (cats 38–9) and *Christ in the Wilderness* (cats 42–3). These are sombre variations on love, desire and anguish, containing some of his most radical sexual imagery. The *Beatitudes* series, referred to by Spencer as his 'couple' paintings, was started in Cookham and completed in North London. Once again, these works were intended for Spencer's never-to-be-realised Church House project. He planned to hang them in small cubicles off the side aisles of the building, private spaces where 'the visitor could go and meditate on the sanctity and beauty of sex'.[82]

It was as obvious to Spencer as it was to the often outraged viewers of these paintings that his amorous couples are, by conventional standards, very ugly. Spencer described how the sight of *Beatitude 4: Passion or Desire* (fig. 28) 'fogged' the monocle of his early patron Sir Edward Marsh. 'Terrible, terrible, Stanley!' he exploded.[83] In these paintings the couples' relationship is that of the small-child-man beseeching sexual favours from a dominating woman, a giantess or harridan. Related drawings show Stanley marched along the street by a relentless Hilda (fig. 29). It is a painstaking and in some ways a prophetic exploration of the notion of woman on top, into which Spencer divests his own experience of marriage and also, perhaps, his memories of Sister Hunter, the bullying Scottish nurse in charge of the young recruit at Beaufort Hospital. He recounted her threats in a letter to his sister: 'By Jove Boy I'll put you through it the first day I set you under me. Lo behold the next day I was "under" her.'[84] In the *Beatitudes* one glimpses Sister Hunter standing over him lecturing him on scrubbing; while he scrubbed.

Spencer's clear-eyed view of human failings and disparities has led to some obvious comparisons with German Neue Sachlichkeit painters of the interwar period. But this is to ignore the trait of charity in Spencer whose paintings rarely show the cruel-satiric edge of a George Grosz or Otto Dix. They are not political in such an overt sense. In the *Beatitudes* Spencer has returned to his belief that the ugly is redeemable. His distortion of technique was instrumental to this process. In an essay in *Sermons by Artists*, he analysed the painter's creative generosity of vision, 'Distortion arrives from the effort to see something in a way that will enable

Fig. 29 *Me and Hilda, Downshire Hill* from Scrapbook Drawings, *c.* 1943–4. Stanley Spencer Gallery/Astor Collection.

him to love it.'[5] In Spencer's *Beatitudes* the flabby and ungainly and visibly ageing human couples, ecstatic in their mutual sexual awareness, are redeemed and rendered beautiful.

Spencer attached written narratives to each of his *Beatitude* paintings, short stories of the triumph of love over the unlikely. *Beatitude 4: Passion or Desire*, identified by Spencer as 'The Office Boy and his Wife', describes the mutual delight of the couple for whom sex has become a sublime habit: 'She has been felt and fingered by him for fifty years. He has emptied himself into her about eighteen thousand times.' Spencer lingers over the scene of their undressing:

> Each new fold in her skin appearing as her age increased was a new joy to him … her old joints ached for the affection of his gnarled hands. She remained standing like a cow in the stall being milked as he smoothed out the creases between her knees and joints. The curve of each cheek of her white buttocks hung and sagged like a wallet. She stood and he surveyed her as he does in the picture only now he does so from every angle … Some hours later when they were going to bed she said to him you know I feel wonderful with your stuff inside me. I think the idea of taking the sacrament must have come from this really. I can feel the virtue of you in me.'[86]

It is a reflection on the lasting sexual bond Spencer had expected between Hilda and himself.

Spencer painted four of his total of nine canvases in the *Christ in the Wilderness* series in 1939, in the solitude of his room in Adelaide Road. It was inevitable for him to relate his isolated struggles with those of Christ in his exile in wild places. 'The great adventure that Christ had all by himself with leaves, trees, mud and rabbits' was closely paralleled by the austerities of Hampstead pre-war bed-sitterland 'among two chairs, a bed, a fireplace and a table … I was as it were in a wilderness'.[87] He was at the time enduring what he called a 'mental struggle' to regain the early clarity of vision he had known when he painted *Zacharias and Elizabeth* (cat. 1) and other paintings of his youth. He was conscious of his painting of the 1930s having suffered from a 'split in his feeling', which had drawn him 'too much one way', towards sexual subject matter. In his *Wilderness* series Spencer intended to return to the pure and Biblical.

This was another grand design never completely realised. Spencer had planned forty panels, one for each of Christ's forty days of torment, and had indeed completed a layout of forty preliminary drawings each ¾ in. square. The paintings were designed to be mounted around the chancel roof of the Church House, looking, as Spencer put it, like the scales of a great mackerel. One feels more than ever tantalised that the House was never built. The paintings he completed have a strength and a simplicity, a sophisticated yet almost primitive directness, one does not often find in Spencer's later work.

In this series he returns to contemplation of religious themes of God the creator and Christ the interceder between man and nature. The hens and chickens, foxes,

horribly predatory eagles, share in the banishment of Christ. 'Although there are none about I feel this is Christ giving the once-over to the fleas and bugs and lice department' as Spencer comments spryly.[88] In the recesses of his memory was his own furtive exercise in communing with nature:

> When I was young, the W. C. at Fernlea was a latrine in the garden. Sometimes I would pick up a worm or a frog and lay it on my skin as I sat on the seat. This gave me a sense of intimacy with them.[89]

In his painting *Christ in the Wilderness: the Scorpion* (cat. 42) Spencer's benign Christ figure, cradling the ferocious small creature, shows a similarly anxious curiosity.

In the *Wilderness* sequence Spencer burrowed into his spiritual past, finding there the stimulus for new direction in his painting. He wrote lyrically about the loneliness of self-discovery in Adelaide Road: 'I felt there was something wonderful in the life I was living my way into, penetrating into the unknown me . . . I loved it all because it was God and me all the time.'[90] The figurative distortions of the paintings are part of this whole revelatory experience. The queer misshapen figures of Christ *in extremis* in the wilderness link Spencer's painting backwards to the visionary oddnesses of Fuseli and Blake as well as – even more obviously – forwards to the anguished, figurative art of Francis Bacon. They give Spencer an important involvement in the history of twentieth-century confrontation with self.

IX

In September 1939 Britain declared war on Germany. Spencer spent the next six years, from May 1940 to March 1946, working on another epic series of war paintings, *Shipbuilding on the Clyde* (cat. 44–5). He is one of only very few official British war artists, his Slade contemporary Paul Nash being another, whose works span two world wars.

The impact of the Second World War on British life was very different from that of the Great War of 1914–18. The country was now faced with what seemed the real threat of German invasion; British cities underwent sometimes devastating bomb attacks; the Second World War effort impinged directly on many more civilian people's lives. In this sense the Second World War was a domestic war and Spencer, based at Lithgow's shipyard at Port Glasgow in Scotland, painting merchant ships under construction, was recording activities essential to national survival. To maintain supplies of food and raw materials in Britain enough new ships had to be constructed to replace merchant ships sunk by German submarines.

The upsurge of activity in wartime was the saving of an important Glasgow industry hit hard by the depression of the 1930s. For Spencer too the commission in the shipyards came as a kind of salvation at a time of intense personal disorienta-

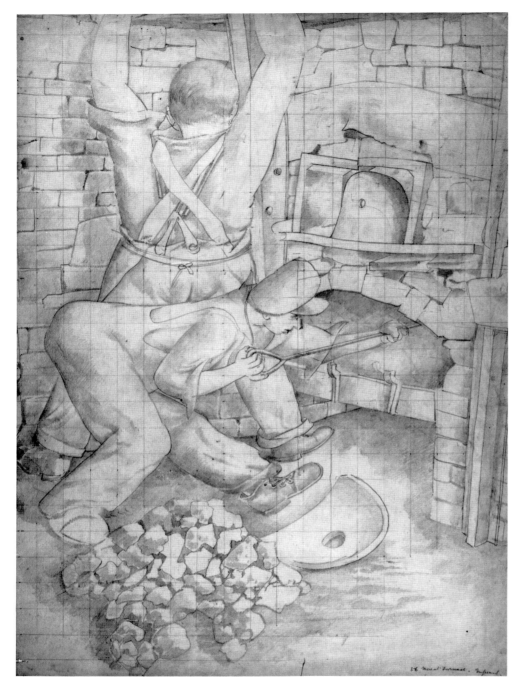

Fig. 31 Self-portrait for *Welders*, Clyde Shipbuilding series, 1940. Imperial War Museum, London.

Fig. 30 Clyde Shipbuilding *Furnaces* composition, 1940. Imperial War Museum, London.

tion. The lives of ordinary working people interested him immensely. When he travelled (though Spencer was never a great traveller) the scenes that moved him most were those of everyday urban poverty. After a visit to Leeds in the 1920s he had reported 'I was in the worst slums most of the time. The smells were vile but it was very sad & wonderful. I am particularly keen on the washing day in the slum.'[91] He recognised it as a good subject for a painting.

In Glasgow he made the same imaginative leap into the lives of the workers in the shipyards, respecting their skills and their traditions of workmanship and

finding a connection between the nesting instincts of the villagers in Cookham and the humanizing tendencies of men in Lithgow's yard:

> People generally try to make a kind of "home" for themselves wherever they are or whatever their work, which enables the important human elements to reach into and pervade, in the form of mysterious atmospheres of a personal kind, the most ordinary procedures of work or place. Many of the places and corners of Lithgow's factory moved me in much the same way as I was by the rooms of my childhood.[92]

Lithgow's shipyard also came to seem a Heaven, of a sort.

In his paintings of the First World War for Sandham Memorial Chapel Spencer had glorified the menial: the sacred unobtrusiveness of water bottle filling, locker washing, laundering, kit inspecting, map reading. He now focused his attention on the grave and exacting technicalities of ship building: plumbing, riveting and rigging; furnace building (fig. 30); welding, burning; constructing the template; bending the keel plate. Spencer saw the work as worship. He observed: 'Everything I see is manifestly religious and sexual . . . it is not that coils of rope suggest haloes it is just that all these men, hawsers, strings, as in all forms have a hallowing effect of their own . . . it is part of their nature.'[93]

The Clyde Shipbuilding project was once again conceived on a monumental scale. Spencer's proposal was for a frieze seventy feet long, composed of three tiers of elongated panels, each illustrating one of the major occupations of the shipyard. Each composition was built up from many hundreds of quick life drawings, executed in the shipyard, often on a convenient long roll of toilet paper. A *Daily Telegraph* reporter described how he produced a roll of pencilled sketches from his coat pocket, unrolling the thirty-five feet drawing down the length of the table in his Port Glasgow lodging house. Spencer referred to these as 'scrappy notes but they are more useful to me than elaborate finished drawings'. At the next stage he produced more carefully composed and finished drawings which he then squared off. The drawings were transferred at full size to the canvas. As at Burghclere the huge murals are composed of a multitude of independent groupings, which gives them the miraculous sense of simultaneous events so familiar from paintings by Bellini or Carpaccio. It could be said that in Spencer's *Shipbuilding* canvases, Old Masters and Socialist realists meet. Spencer's self-identification with the workers manifests itself in the multiple self-portraits he included in the series (fig. 31), emphasising his vision of the artist not as the detached observer but creatively involved in the war effort itself.

Only eight of the projected thirteen canvases were finished by 1946 when the War Artists Advisory Committee was disbanded after the Allied victory. There are signs in this cycle that Spencer himself was running out of energy. The *Clyde Shipbuilding* series lacks the central visual focus that the transcendental *Resurrection of the Soldiers* gives to the murals at Burghclere. More essentially, without its own purpose-designed building, this sequence cannot rise to the sense

Stanley Spencer in the shipyard making studies on toilet roll. Getty Images.

Stanley Spencer in the shipyard, photograph by McCoombe for *Picture Post*, 2 October 1943. Getty Images.

of containment within the war experience that the murals at Sandham Memorial Chapel so compellingly and movingly achieve. All the same, taken together, Spencer's work at Port Glasgow and at Burghclere is a uniquely powerful interpretation of twentieth-century Britain at war.

Working at the shipyards Spencer was aware of artefacts as well as people. His drawings record tools, materials, machinery, what to him was a new landscape of

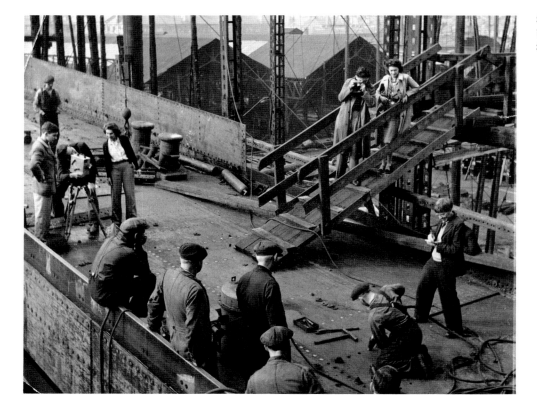

Stanley Spencer in Port Glasgow shipyard being filmed by Jill Craigie for 'Out of Chaos', 1944. Estate of Stanley Spencer.

industrial productivity. Some of these drawings were the basis for paintings independent of the War Artists' commission. In the *Scrap Heap* (cat. 46) Spencer's sublime instinct for the reclamation of rubbish can be seen at work again. In a transformation scene that reminds one of the talents of his conjuror brother Harold, Stanley Spencer turns the mound of rusting iron into another burning bush.

In Port Glasgow, with his avid curiosity, he explored the city hinterland way beyond the shipyards. He felt an almost mystic sense of possibility: 'there is an undefined not-yet-come-to-earth-Port-Glasgow-epitomising something which I hope to find and arrive at'.[94] Graveyards still had a strong emotional pull on him. One evening in his lodgings Spencer was interrupted from his writing by the insistent playing of a jazz band in the room below and decided to walk up past the gas works towards the cemetery on the hill outside the town. He registered it as 'an oval saucer-upside-down-shaped hill hedged in by high red brick tenements looking down it; a sort of green mound in a nest of red with here and there the Clyde and distant hills showing between gaps in the blocks of tenements'. It reminded him, once again, of Donne and in particular the passage comparing the resurrection of the dead to a king ascending the hill of Sion.

As he approached the cemetery Spencer felt acutely conscious of the other non-industrial everyday Port Glasgow: rows of men and women scurrying along the streets; men lounging against high sunlit factory walls; children lying face down like miniature pavement artists, using coloured chalk to make drawings on the road. Such scenes struck him as being 'full of some inward surging meaning, a kind of joy, that I longed to get closer to and understand and to in some way fulfil'. He felt, as he walked on, that 'all this life and meaning was somehow grouped round and in some way led up to the cemetery on the hill outside the town'. Spencer writes of the experience in language of an almost apocalyptic splendour, describing Port Glasgow cemetery with the visionary rapture of a William Blake or a John Clare:

> I seemed then to see that it rose in the midst of a great plain and that all in the plain were resurrecting and moving towards it . . . I knew then that the resurrection would be directed from this hill.

Spencer used the oval-saucer-shaped hill as the subject of his landscape, *Port Glasgow Cemetery* (cat. 51). It was also the stimulus for his last ambitious cycle on the themes of resurrection, the *Port Glasgow Resurrection* series which occupied him from 1945 to 1950. Here Spencer treats another episode of cataclysmic international history in terms of the impact of war upon the rhythms of normal domesticity.

His concept had originally been for one vast canvas, fifty feet across, showing Christ on the Hill of Zion, seated in judgment, with the resurrected rising from graves grouped around him in a fan shape. This form of composition had already been in evidence in Spencer's First World War painting of the Travoys. As it

developed, the scheme was much amended, broken down into a series of smaller paintings, most of them triptychs as in *Resurrection: Reunion* (cat. 47). A connection with Italian and Flemish church art is obviously made, but Spencer hoped to render his sequences of mystical events 'as real as going shopping' through his fond accumulation of contemporary detail.[95] People rise from graves resembling prim divided-off front gardens. Women wear the frumpy garments dear to Britain in the 1940s: criss-cross pattern skirts and jumpers; brightly coloured floral frocks.

These paintings are permeated by the images of waking up, shaking oneself and getting going. In the three-part *Resurrection with Raising of Jairus's Daughter* (cat. 50) there is a strong sense of the upheaval in the neighbourhood, including even the dislodgment of the paving stones, caused by resurrecting soldiers returning from the war. The sequence recaptures with extraordinary vividness the mixed feelings of rejoicing and foreboding experienced in Britain in the years between D-Day and the Festival of Britain in 1951. And not only in Britain. As shown in correspondence with his brother Gilbert, Stanley was confronting problems of readjustment experienced by any war-torn nation resuming ordinary social interchange after the end of hostilities.[96] The crucial personal question is the anxiously cosy 'Where ever have you been all this while?'

Stanley Spencer painting *Christ Preaching at Cookham Regatta*, c.1959. © Peter Spencer Coppock.

Fig. 32–33 *Christ Preaching at Cookham Regatta* (unfinished 1959). Stanley Spencer Gallery.

X

Before the First World War the great event of Cookham summer was Regatta Day, planned for in eager anticipation in the village. A crowd of outside visitors converged upon the river, promenading down the banks in fashionable clothes. With its programme of watersports, the band in scarlet uniforms, illuminations, fireworks and a fairground in the evening, it was a quintessentially Edwardian occasion. The river itself contained a floating mass of people joined together in groups, though segregated by the strict rules of class distinction.

Stanley Spencer painting *Christ Preaching at Cookham Regatta*, 1959. Getty Images.

According to Gilbert Spencer they resembled 'rather gay little floating islands', holding onto one another's boats and punts.[97] The atmosphere of Venice-on-the-Thames was heightened with the appearance of an ebony gondola, concealing behind its closed curtains the aged local dignitary Lady Radnor, with a professional Italian boatman at the prow.

This annual transformation of Cookham made a lasting impact upon Spencer. He returned in his late work to the scenes that had so transfixed the children, gazing out of open windows as if from little boxes in a theatre in the cool summer evenings. Even the Chinese lanterns, which in pre-First World War Cookham would be strung across the punt poles or pushed out of village windows on the end of bamboo rods, reappear in *Christ Preaching at Cookham Regatta: Conversation between Punts* (cat. 60). Stanley Spencer painted this in 1955.

During the war years, while Spencer was in Glasgow, he had travelled back intermittently to Cookham, lodging with his cousin Bernard Smithers. He returned there permanently in September 1945, taking over Cliveden View, a

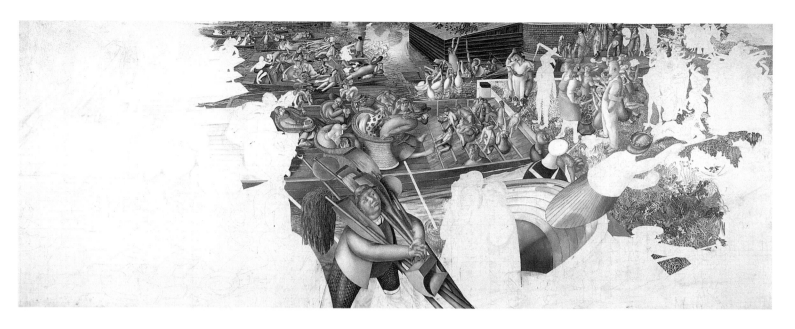

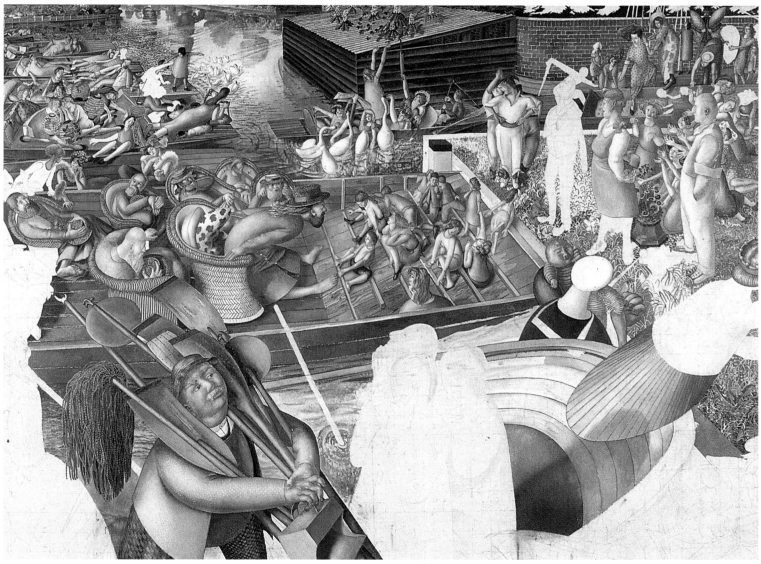

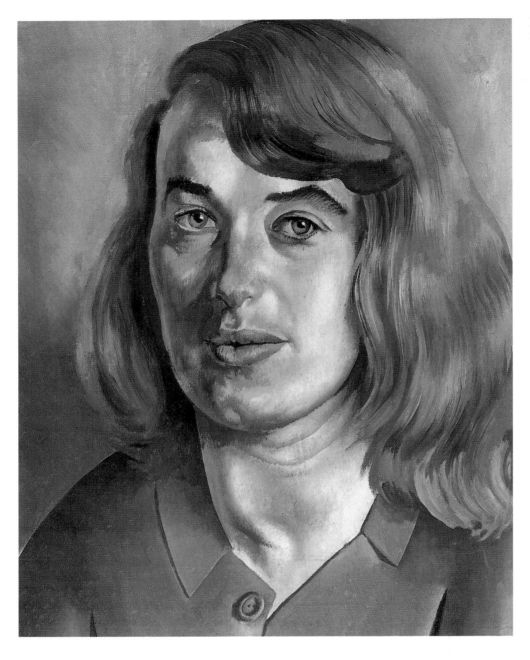

Fig. 34 *Daphne*, 1940–9. Abbot Hall Art Gallery, Kendal.

Stanley Spencer opening an exhibition at High Wycombe, 1950s. Estate of Stanley Spencer.

small house in Cookham Rise, a mile or so outside the village, from his now ailing sister Annie. The house belonged to his brother Percy Spencer. Stanley Spencer's paintings over the next decade reflect the relief of this return to his roots. There are in all seven paintings in the series of *Christ Preaching at Cookham Regatta*, including one unfinished at Stanley Spencer's death (figs 32–3). The painting shows Christ sitting in the centre of the festive summer crowds, in the old horse ferry barge on the Thames near Cookham Bridge. The landlord of the Ferry Hotel, a well-known landmark on the waterfront, regards the preaching Jesus wih suspicion from his lawn. This enormous squared-up canvas (81½ × 211 in.) has for years hung as the centrepiece of the Stanley Spencer Gallery in Cookham. Spencer's vision of Christ anglicised has exerted a peculiar grip on popular imagination. The

Charlotte Murray with her husband Graham, *c.* 1944.
Courtesy Beatrice Murray.

painting is referred to by Derek Walcott, the Nobel prize-winning poet, born in St Lucia, in his poem, 'Midsummer England':

> Great summer takes its ease,
> ankling the shallows, cloudy dresses bloat
> and cling clearly round the women's knees
> as Christ harangues the indifferent from his boat
> by Cookham's river.[98]

Another reminiscent painting completed by Spencer at this period was *Christ in Cookham* (cat. 56). Christ and his disciples sit ranged in the back garden of Quinneys, Bernard Smithers' Cookham house, with a background of an orchard and the village school. The disciples, Spencer commented, 'look rather like a football team being photographed'.[99] There is a hint of Léger in its brawny concentration and roundnesses of form.

After his devastating second marriage Spencer had several lovers. The first of these was Daphne Charlton (fig. 34), a handsome effusive woman who, like almost everyone in Spencer's female entourage, had trained as a painter at the Slade. Their affair was at its height in 1940 and Spencer captures its flamboyance in a double portrait, *On the Tiger Rug* (fig. 35), a scene of anthropomorphic sexual ecstasy. The drawing still exists but the painting is now lost. Spencer's next important liaison of the war years was with the woman referred to as 'Madame X' in early biographies of Spencer. She was Charlotte Murray, a musician he met in Glasgow who later became a psychiatrist in London. Murray is the subject of one of Spencer's most magnificent portraits, *The Psychiatrist* (cat. 49).

Spencer's plans for the Church House, his temple of eroticism, were still burgeoning. There would now be a Daphne Chapel and a Charlotte Chapel in addition to his Patricia Chapel. He also envisaged an Elsie Chapel, celebrating his attraction, though never apparently his sexual union, to Elsie Munday, the maid at Burghclere who moved with the family to Cookham. His childhood fascination with servants, and particularly maids in uniform, reached its apotheosis in life with his own servant, and Stanley Spencer's household sketches of Elsie chopping wood, Elsie breaking fire-wood, Elsie gathering in stockings from a clothes line are among the most intensely erotic of his drawings (fig. 36). Elsie's sister Phyllis was another of his idols and, in another exquisite drawing, he pictures himself doing obeisance to her right foot (fig. 37).

But Hilda was always at the centre of his scheming. In his imagination Spencer never really left her. He went on visiting and writing to her almost daily through her nervous breakdowns of the 1940s. For part of this period Hilda was confined at Banstead Mental Hospital in Epsom. Stanley's long, rambling, sensual and sometimes incoherent letters continued even after her death from cancer of the breast in 1950. Stanley had been present when she died.

Over the next decade his great preoccupation was the Hilda Chapel, otherwise known as the 'you-me' room for Church House.[100] Some of the erotic Hilda

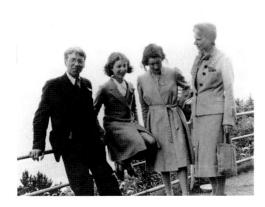
Stanley and Hilda on a visit to Shirin and Unity at Badminton School, 1943. Courtesy Jean Storry.

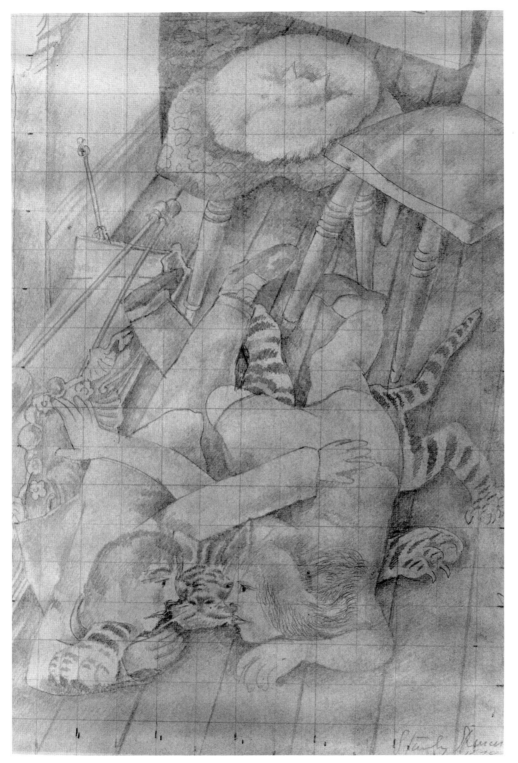

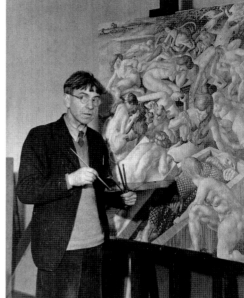

Stanley Spencer at work on *The Temptation of St Anthony*, c. 1945. © Peter Spencer Coppock.

Fig. 35 Study for *On the Tiger Rug*, 1934. Ashmolean Museum, Oxford.

Stanley with Unity, 1958. John Neal Photography, Maidenhead.

drawings are incorporated into Spencer's painting, *The Temptation of St Anthony* (cat. 48), in which the saint is confronted by a writhing sea of Hildas. The cushiony and cosy *Love Letters* (cat. 53) was envisaged as the Hilda Chapel altar piece. Like comfortable children they tease each other, Hilda posting an envelope into

Fig. 36 *Taking in Washing, Elsie*, from Scrapbook Drawings, *c.* 1943–4. Stanley Spencer Gallery/ Astor Collection.

Fig. 37 *Phyllis, Elsie's Sister, Lindworth, Cookham*, from Scrapbook Drawings, *c.* 1943–4. Stanley Spencer Gallery/ Astor Collection.

Stanley's jacket pocket while Stanley kisses a love letter. A remembered sexual ritual of their early days was reading their love letters out loud.

For many paintings of this period Spencer was reconstituting earlier drawings made in Hilda's lifetime. In *Hilda and I at Pond Street* (cat. 61) Spencer travels back to a visit made to the then convalescing Hilda in the Carlines' house in Hampstead: 'In the drawing Hilda flops in her own chair (with) plenty of cushions pushed into the bottom of her back. Ungainly in her passionate determination to be comfortable. Adorable to me of course.'[101] *Hilda Welcomed* (cat. 57) was painted in 1953 for what was by now designated the Hilda Memorial Chapel and shows Hilda being welcomed at Fernlea by the rather unlikely reception committee of Spencer, their daughters Shirin and Unity, Stanley's sister Patricia and Charlotte Murray, the psychiatrist. His artistic adulation of his dead wife was obsessive. Perhaps it was the only means that Spencer had of recognising their tragic incompatability and his own considerable cruelty to Hilda, recycling her so wonderfully in his mind.

The power went out of some of Spencer's painting in the 1950s. His thin flat quality of paint sometimes had a certain deadness, the more noticeable in a period at which American artists were preoccupied with painting expressively upon the canvas surface. Spencer's visionary intelligence was no longer totally consistent, occasionally seeming to parody itself. But the flashes of brilliance still appear in such sudden extraordinary details as the white, tiered wedding cake in *The Marriage at Cana: Bride and Bridegroom* (cat. 58). The appalling, gleeful violence of *The Crucifixion* (cat. 62) shows Spencer still painting with a ferocious power.

The Crucifixion is the only painting in which Spencer confronts violence with the disconcerting candour he arrives at in his portraits. This is a picture in which real pain is made manifest while the moon-faced Cookham villagers look on. It was commissioned for Aldenham School, a boys' school connected with the Brewers' Company, and Spencer later startled the assembled boys and masters by telling them:

I have given the men who are nailing Christ on the Cross – (and making sure they make a good job of it) – Brewers caps, because it is your Governors, and you, who are still nailing Christ to the Cross.[102]

Early in 1959, after an operation for the cancer that was soon to kill him, Spencer moved back into his old home, Fernlea (now renamed Fernley). Lord Astor, his Cliveden neighbour, had arranged it. His life had come full circle. The *Self-Portrait* (cat. 64) painted by Spencer at the age of almost seventy has the same quality of fearlessness as the portrait of 1914. In July 1959 Queen Elizabeth II knighted Stanley Spencer, an honour which transformed Patricia Preece into Lady Spencer. On December 14 1959 he died at the Canadian War Memorial Hospital at Cliveden. He was finally reclaimed by the British art establishment. At his memorial service in St James's, Piccadilly, the address was given by Sir Charles Wheeler, the President of the Royal Academy which had rejected Stanley Spencer in 1935.

For years afterwards his reputation remained equivocal, with much of the erotic work remaining unseen or misunderstood. But it became clear gradually that Stanley Spencer was an incomparably committed, original and inspirational painter. This was, after all, the artist who had cried out on his Macedonian sick-bed 'I long for Glory, the Fra Angelico "Gloria", I long to *be*, to *live*.'[103]

A perceptive *Times* critic wrote in 1935 that the public would be wise to study Stanley Spencer carefully 'because it is reasonably certain that in fifty years time he will be recognised as one of the very few contemporary painters who have really counted in the history of English art'.[104] It is only now, in the context of the late twentieth-century revival of the figurative, that we are able to see Spencer as the crucially significant artist he is.

Stanley and Gilbert in the garden at Fernlea (by then renamed 'Fernley') 1958–9. Estate of Stanley Spencer.

Stanley Spencer leaving Mrs. Mackay's shop in Cookham High Street. Getty Images.

NOTES

1 John Rothenstein, *Summer's Lease, Autobiography 1901–1938*, Hamish Hamilton, London, 1965, p. 234

2 Quoted Kenneth Pople, *Stanley Spencer*, Collins, London, 1991, p. xiii

3 Stanley Spencer, 'Autograph Essay on Love and Painting', *c.* 1927–33, Tate Gallery Archive (TGA) 8022.55, p. 27

4 Gilbert Spencer, *Stanley Spencer by his Brother*, Victor Gollancz, London, 1961, p. 89

5 ibid., p. 37

6 Quoted Maurice Collis, *Stanley Spencer*, Harvill Press, London, 1962, p. 18

7 Gilbert Spencer, *Stanley Spencer*, p. 99

8 ibid., p. 176

9 Quoted Maurice Collis, *Stanley Spencer*, p. 28

10 Stanley Spencer, 'Numbered Writings', TGA 733.2.35

11 Quoted Richard Carline, catalogue of exhibition, *Stanley Spencer RA*, Royal Academy, London, 1980, p. 15

12 Gilbert Spencer, *Stanley Spencer*, p. 113

13 Quoted Keith Bell, *Stanley Spencer, A Complete Catalogue*, Phaidon, London, 1992, p. 15

14 Quoted Jane Allison, *Stanley Spencer, The Apotheosis of Love*, Barbican Art Gallery, London, 1991, p. 46

15 Stanley Spencer to his sister, Florence Image, 12 October 1918, TGA 756.45

16 Quoted Christopher Neve, *Unquiet Landscape*, Faber and Faber, London, 1990, p. 37

17 Quoted Richard Carline, catalogue of exhibition, *Stanley Spencer RA*, p. 12

18 Quoted John Rothenstein, *Time's Thievish Progress, Autobiography III*, Cassell, London, 1970, p. 51. 'Ta' is a period diminutive for 'Thanks'

19 Quoted Maurice Collis, *Stanley Spencer*, p. 29

20 Gilbert Spencer, *Stanley Spencer*, p. 74

21 Stanley Spencer to Florence Image, 1917, TGA 756.25

22 Gilbert Spencer, *Stanley Spencer*, p. 48

23 ibid., p. 49

24 Colin Hayes, *Scrapbook Drawings of Stanley Spencer*, Lion and Unicorn Press, London, 1964, pl. 1

25 Gilbert Spencer, *Stanley Spencer*, p. 101

26 John Rothenstein, *Time's Thievish Progress*, p. 71

27 Gilbert Spencer, *Stanley Spencer*, p. 104

28 David Sylvester, catalogue of exhibition, *Drawings by Stanley Spencer*, Arts Council, London, 1954, p. 2

29 Gilbert Spencer, *Stanley Spencer*, p. 103

30 Stanley Spencer, 'Numbered Writings', TGA 733.2.4

31 Quoted John Rothenstein, *Summer's Lease*, p. 133

32 Stanley Spencer, account written in Canadian War Memorial Hospital, Cliveden, 7 December 1959. Acknowledgments to James Demetrion for bringing this passage to my attention.

33 Colin Hayes, *Scrapbook Drawings*, pl. 14

34 Anthony Gormley, catalogue of exhibition, *Stanley Spencer*, Arts Council, London, 1976, p. 23

35 Gilbert Spencer, *Stanley Spencer*, p. 133

36 Quoted Judith Nesbitt, catalogue of exhibition, *Stanley Spencer, A Sort of Heaven*, Tate Gallery, Liverpool, 1992, p. 54

37 Stanley Spencer to Florence Image, 1915, TGA 756.1

38 Quoted Richard Carline, *Stanley Spencer at War*, p. 58

39 Quoted Kenneth Pople, introduction to Spencer-Chute correspondence, Stanley Spencer Gallery, Cookham

40 Stanley Spencer to Florence Image, 1915, TGA 756.1

41 Stanley Spencer to Will Spencer, 12 February 1918, TGA 756.31

42 Stanley Spencer to Florence Image, 24 February 1918, TGA 756.34

43 ibid., undated 1918, TGA 756.41

44 ibid., 10 June 1917, TGA 756.21

45 ibid., undated 1917, TGA 756.17

46 ibid., undated 1916, TGA 756.9

47 ibid., 17 July 1917, TGA 756.22

48 ibid., undated 1916, TGA 756.9

49 Stanley Spencer to William and Annie Spencer, 23 October 1918, TGA 756.47

50 Quoted Keith Bell, *Stanley Spencer*, p. 421

51 Stanley Spencer to Florence Image, 24 February 1918, TGA 756.34

52 Quoted in catalogue entry for *Swan Upping*, (Cat. 6)

53 Max Beckmann to Minna Beckmann, 18 April 1915, Quoted in catalogue of exhibition, *Otto Dix 1891–1969*, Tate Gallery, London, 1992

54 John Rothenstein, *Time's Thievish Progress*, p. 56. 'Got the wind up' is period slang for 'scared'

55 George Behrend, *Stanley Spencer at Burghclere*, Macdonald, London, 1965, p. 6

56 Quoted *Stanley Spencer at Burghclere*, National Trust Guide, London, 1991, p. 15

57 Quoted Keith Bell, *Stanley Spencer*, p. 114

58 Quoted Richard Carline, catalogue of exhibition, *Stanley and Hilda Spencer*, Anthony d'Offay Gallery, London, 1978, No. 5

59 Quoted Anthony Gormley, catalogue of exhibition, *Stanley Spencer*, p. 21

60 Quoted Maurice Collis, *Stanley Spencer*, p. 83

61 Quoted Keith Bell, *Stanley Spencer*, p. 371

62 Stanley Spencer, Scrapbook Drawings, pl. 22

63 Quoted Richard Carline, *Stanley Spencer at War*, p. 172

64 Quoted Maurice Collis, *Stanley Spencer*, p. 88

65 *The Times*, London, 28 February 1927

66 Eric Gill, article for *Order*, quoted Robert Speaight, *The Life of Eric Gill*, Shenval Press, London, 1966, p. 202

67 Quoted John Rothenstein, *Stanley Spencer, The Man: Correspondence and Reminiscences*, Paul Elek, London, 1979, p. 48

68 Quoted Jane Allison, *Stanley Spencer, The Apotheosis of Love*, p. 72

69 Quoted Keith Bell, catalogue of exhibition, *Stanley Spencer RA*, p. 39

70 Quoted Jane Allison, *Stanley Spencer, The Apotheosis of Love*, p. 46

71 Stanley Spencer, *Sermons by Artists*, Golden Cockerel Press, 1934

72 Quoted Keith Bell, catalogue of exhibition, *Stanley Spencer RA*, p. 132

73 See catalogue, cat. 19

74 Quoted John Rothenstein, *Stanley Spencer*, p. 56

75 See full account in Kenneth Pople, *Stanley Spencer*, pp. 364–5

76 Stanley Spencer, 'Numbered Writings' catalogue, TGA 733.2

77 Quoted Andrew Causey, catalogue of exhibition, *Stanley Spencer RA*, p. 32

78 Quoted Keith Bell, catalogue of exhibition, *Stanley Spencer RA*, p. 152

79 Quoted Keith Bell, *Stanley Spencer*, p. 332

80 Quoted Kenneth Pople, *Stanley Spencer*, p. 332

81 Quoted Keith Bell, catalogue of exhibition, *Stanley Spencer RA*, p. 152

82 ibid., p. 166

83 Quoted Maurice Collis, *Stanley Spencer*, p. 144

84 Stanley Spencer to Florence Image, 1916, TGA 756.3

85 Stanley Spencer, *Sermons by Artists*

86 Quoted Jane Allison, *Stanley Spencer, The Apotheosis of Love*, p. 56

87 Quoted catalogue of exhibition, *Stanley Spencer RA*, p. 170

88 ibid., p. 171

89 Quoted Maurice Collis, *Stanley Spencer*, p. 140

90 Quoted Keith Bell, catalogue of exhibition, *Stanley Spencer RA*, p. 170

91 Stanley Spencer to Florence Image, 25 June 1920, TGA 756.50

92 Quoted catalogue of exhibition, *Shipbuilding on the Clyde*, Imperial War Museum, London 1997, p. 3

93 ibid., p. 4

94 Stanley Spencer, *Stanley Spencer: Resurrection Pictures*, Faber and Faber, London, 1951

95 Quoted Keith Bell, *Stanley Spencer*, p. 427

96 Stanley Spencer to Gilbert Spencer, 21 November 1949, TGA 70.21/7

97 Gilbert Spencer, *Stanley Spencer*, p. 84

98 Derek Walcott, 'Midsummer England' from *Sea Grapes* collection, 1976. Included in *Poems 1965–80*, Jonathan Cape, London, 1992. I am grateful to Andrew Dempsey for pointing out these lines.

99 Quoted Kenneth Pople, *Stanley Spencer*, p. 473

100 Quoted Jane Allison, Stanley Spencer, *The Apotheosis of Love*, p. 22

101 Quoted Keith Bell, *Stanley Spencer*, p. 502

102 Quoted John Rothenstein, *Stanley Spencer*, p. 131

103 Stanley Spencer to Florence Image, 3 October 1918, TGA 756.43

104 *The Times*, London, 27 April 1935

CATALOGUE NOTE

The Tate Gallery Archive acquired Stanley Spencer's papers from his family in 1973. They consist of a bewildering array of 88 notebooks, 2415 letters, 431 numbered pieces of writing, 13 diaries, 29 miscellaneous files, 523 unnumbered pieces of writing, numerous lists of works, 84 sketches and drawings; and total about three million words. It is clear that Spencer intended to put his papers in order for an autobiography, but this was never achieved. Most of the material is undated but a good deal of it appears to have been written in the late 1930s and the 1950s. Spencer wrote notes about the content and meaning of some of his paintings, and it is from these that the material in this catalogue is largely drawn. The Tate Gallery Archive number is given in brackets after the text. Since Spencer's writings form a sort of stream of consciousness, punctuation was of no interest to him. Spelling and punctuation have been amended to make these texts more readable.

Other quotations have been taken from published sources, notably from letters quoted in *Stanley Spencer: The Man: Correspondence and Reminiscences*, edited by John Rothenstein, Paul Elek, London, 1979, referred to here as Rothenstein; *Stanley Spencer: A Biography* by Kenneth Pople, Collins, London, 1991, referred to here as Pople; and *Stanley Spencer: A Biography* by Maurice Collis, Harvill Press, London, 1962, referred to here as Collis.

All works are oil on canvas unless otherwise stated. Height precedes width. References given in the form 'Bell' plus '000' are to Keith Bell, *Stanley Spencer: A Complete Catalogue of the Paintings*, Phaidon Press Ltd, London 1992.

ZACHARIAS AND ELIZABETH

1913–14
140 x 140 cm
The Executors of Mary Adshead's Estate
Bell 16

The biblical text that inspired this
painting comes from St Luke 1, 6, which
describes the priest Zacharias and his wife
Elizabeth: 'And they were both righteous
before God, walking in all the
commandments and ordinances of the
Lord blameless.'

'Zacharias appears in the foreground at an
altar. Sweeping down towards him is an
imagined angel. Further back among the
grass and just by an old yew hedge Zacharias
appears again with Elizabeth. Elizabeth has
her arm crooked, and rests it on a tray-like
frond of the yew. Her hand disappears into
the tree. Behind the wall to the left is a
kneeling figure and above the wall in the top
centre of the picture, just by the sky, is
another head and shoulders of a figure. She
is Elizabeth again, on her own, just as
Zacharias is alone (with the angel), as he is
making his sacrifice. I just wanted someone
in that juncture of the wall and the
greenhouse. I was a young twenty-two when
I painted it. It was painted in our Fernlea
dining room and Pa was giving piano lessons
on my right. The dining room table was
tipped up to form an easel and other
children were lined up along the dark paper
patterned wall, mostly from the back lane
school, waiting their turn after twelve in the
morning. And my memory is also filled with
Pa practising his Beethoven.' [Note written 7
December 1959; 733.1.1]

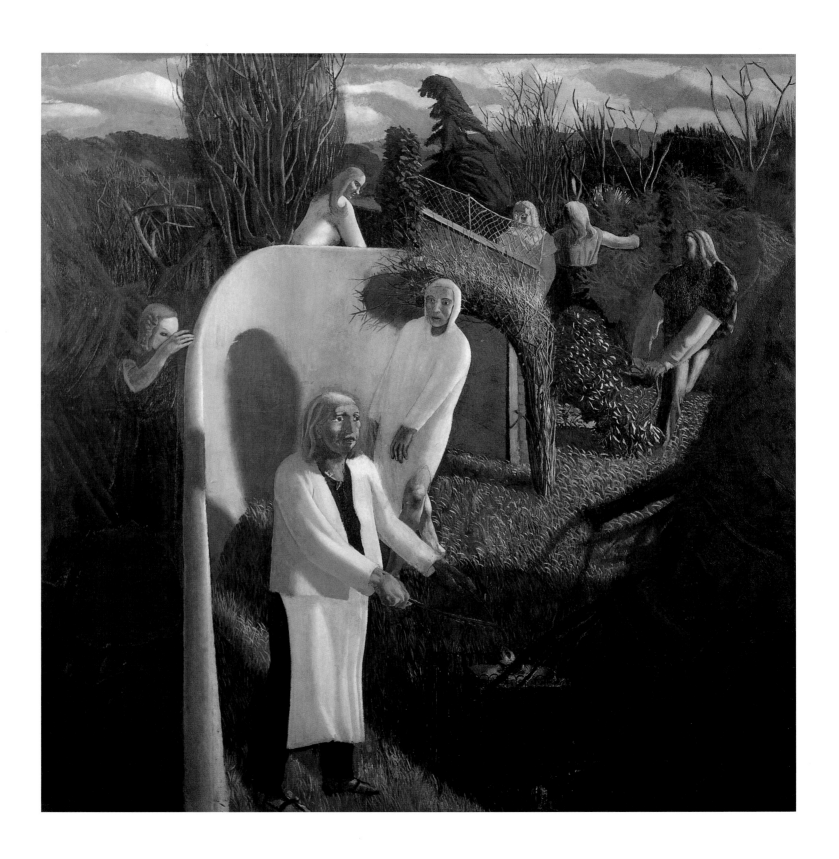

SELF-PORTRAIT

1914
63 x 51 cm
Tate Gallery, London; bequeathed by Sir
Edward Marsh through the Contemporary
Art Society, 1953
Bell 17

> Spencer's first self-portrait in oils; he was
> at work on the painting when war was
> declared on 4 August 1914.

'I am doing a portrait of myself . . . I fight
against it but I cannot avoid it.' [Letter to
Edward Marsh 1913 from C. Hassall, *Patron
of the Arts: A Biography of Edward Marsh*
Longmans, London 1959]

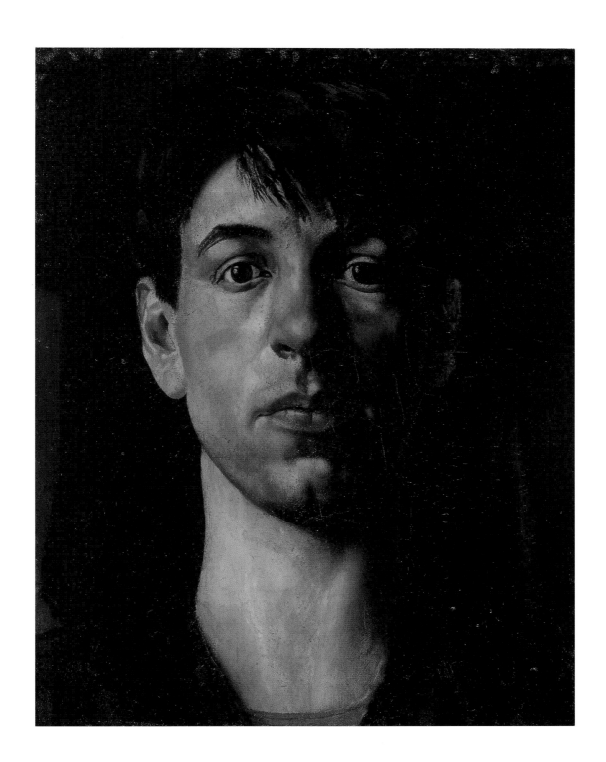

COOKHAM

1914
45 x 54.9 cm
Tullie House, City Museum & Art Gallery,
Carlisle
Bell 19

Spencer's first pure landscape in oils. The
scene has been identified as near Terry's
Lane, Cookham, leading up to Winter
Hill, a little beyond Rowborough House.
(Alec Gardner-Medwin, Pople, p.68)

'I think the pure landscape you have of mine
has a feeling leading to something I want in
it. I know I was reading *English Ballads* at
the time and feeling a new and personal
value of the Englishness of England.'
[Comment to Edward Marsh who bought the
painting in 1914, Pople p.70]

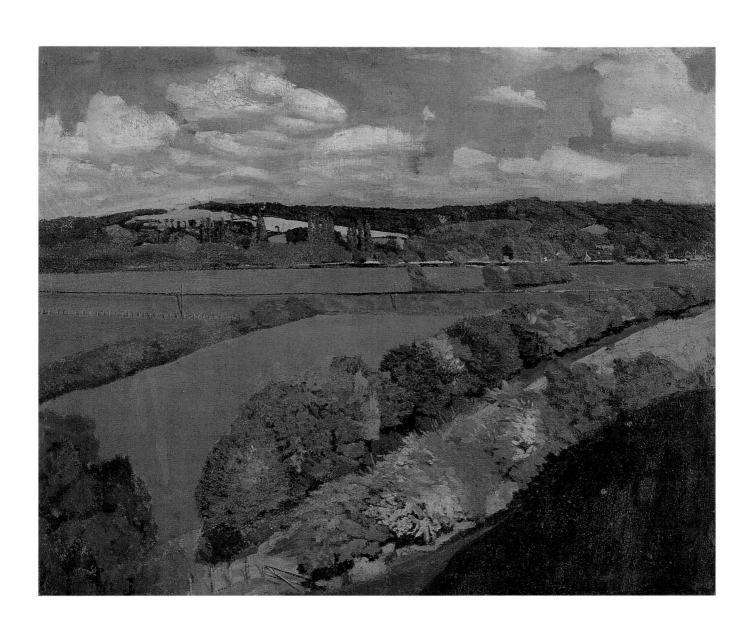

4

THE CENTURION'S SERVANT

1914
114.5 x 114.5 cm
Tate Gallery, London; presented by the
Trustees of the Chantrey Bequest,1960
Bell 21

> Based on the biblical story of Christ
> healing a centurion's servant from a
> distance, Luke 7, 1–10.

'In *The Centurion's Servant* I was wanting to
do a painting of the meeting between Christ
and the centurion to begin with. This
seemed beyond me; but I began to find my
mind in very outdoor places in trying to
imagine what this scene would be like. I
vaguely remember willows and sunlight in
certain parts of Cookham. In that baffled
state my mind wandered off to some shade,
and in doing so I wondered what the scene
would be actually at the house where the
servant was, seven miles away. Here I
seemed to find better foothold. I don't think
it struck me then, as it does now, that the
room I selected as being the bedroom in
which this servant was to suddenly revive
was our own servant's bedroom: I mean that
they were both servants, and both in
bedrooms. Perhaps the centurion's servant
being a male made a difference. But I was
impressed by the thought that here in our
own home, where all was so familiar, was
something almost unknown, a treasure
island, a secret place. I almost expected our
own servant's face to shine as Moses did
when he came down from the mountain,
when she came down in an afternoon frock
from this room. When I passed the door I
was impressed also to hear her talking to
some invisible person, a sort of angel, which
was the servant next door. She was talking
through the wall, as our attic and the one
next door had only a wall between them –
this I did not know until later. This attic had
a dark recess, in which was the big bed and
the china knobs could be seen now and then
when the door was open. But there was never
apparently any ban on our going into the
attic, and I remember up until shortly after I
began to go to the Slade, I used usually to sit
by the gable window, and talk to the servant
while she was dressing . . . at this time I liked
to gaze round the church while praying, and
feel the atmosphere I was praying in. In the
picture I have remembered my own praying
positions in the people praying round the
bed . . . because I knew the state of mind I
wanted . . . was to be peaceful as mine was in
church, even though the miracle had
occurred. The position of the figure on the
bed was arrived at through a consideration
that did not materialize. I had originally
thought of the meeting of Christ and the
centurion; then when I was feeling there was
too much an out-of-doors element in the
idea, I considered also including the scene in
the servant's bedroom showing his
miraculous recovery. I thought then that I
would like to have two pictures in one frame,
with a frame division between them. Both
pictures were to show their connection with
each other by some sort of echo . . . and that
this might be done in the design. In the
meeting picture the centurion was to repeat
something of the position of the servant
lying on the bed, which can, I think, be seen
to be similar in position to a person walking,
only it is lying down. I tried this many times
but it did not come as I wanted it, and finally
I painted the bedroom idea alone.' [733.3.21]

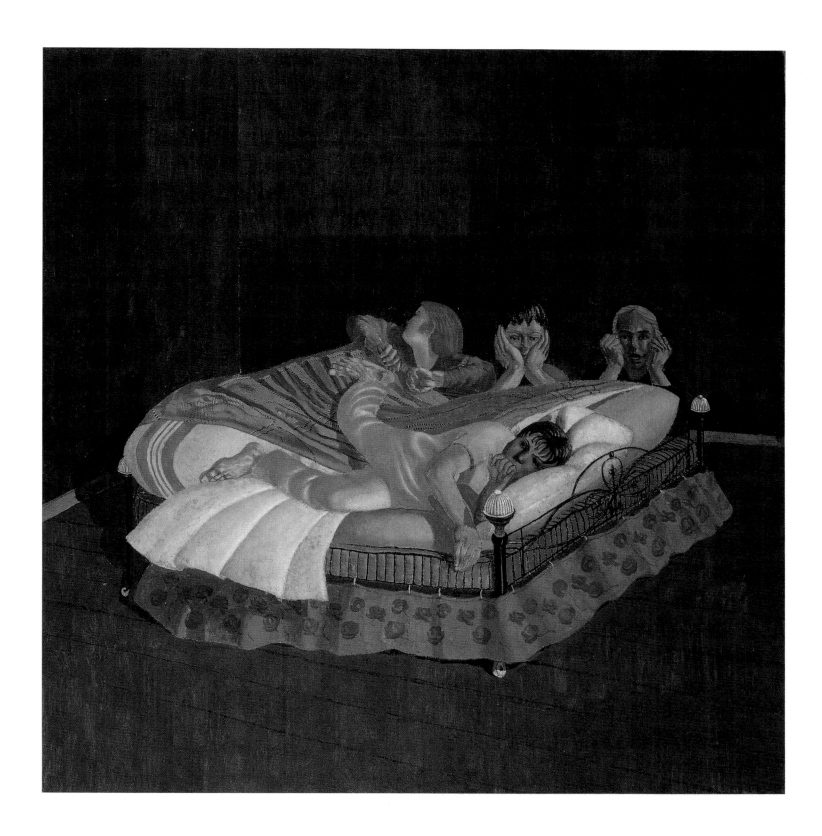

5

MENDING COWLS, COOKHAM

1915
109 x 109 cm
Tate Gallery, London; presented by the
Trustees of the Chantrey Bequest, 1962
Bell 26

> A view of oasthouses (buildings
> containing a kiln for roasting hops or
> malt) from the nursery window of
> Fernlea.

'Saw cowls as satisfying things, like a child
seeing a stone Buddha.' [733.2.321]

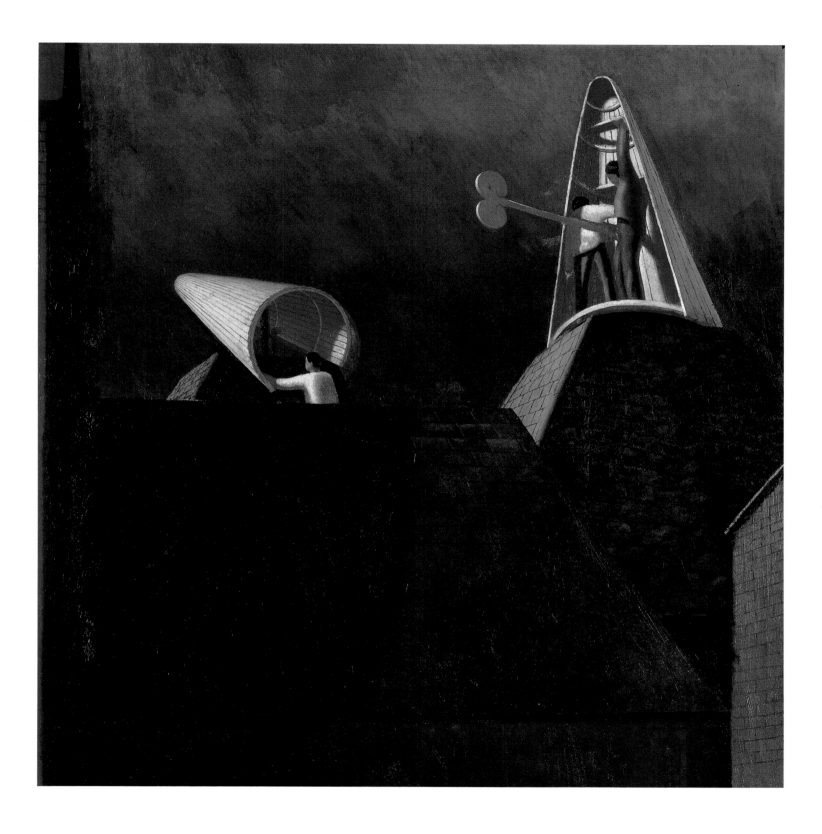

SWAN UPPING AT COOKHAM

1915–19
148 x 116.2 cm
Tate Gallery, London; presented by the
Friends of the Tate Gallery, 1962
Bell 27

The painting was begun in 1915 when approximately the top two-thirds were done; the remainder was finished in 1919 after demobilisation. Swan Upping is a traditional annual ceremony, held at the end of July, on the River Thames between London and Henley. It is undertaken by the Royal Swanherd and the Swan Wardens of the Dyers' and Vintners' Companies of the City of London, which have their origins in the mediaeval trade guilds, set up to protect and promote the interests of their members. Young swans on the river are caught and marked to determine ownership. The cygnets of each family are marked in the same way as the adult birds, one nick in the beak for the Dyers' birds and two for the Vintners'. The Queen's swans are not marked since all unmarked swans on the Thames are hers by Royal prerogative.

'The whole of my experience in the nearly four years of my being in the '14–18 war comes between the painting of the upper and lower half of this picture. As the war drew to an end, it became agonizing to me wondering if I should be snatched away. Apart from greed for life, I felt I had got a lot up my sleeve that I wanted to produce before I died, and every day I was being detailed off for worse and worse dangers. As an infantry man, what would have been the use of this insignificant fragment of gunfodder that I was, if I had said to the sergeants, "I have a picture at home and I just want to finish it before going into this attack." In any case, I was in the Vardar valley preparing for a big offensive, while my picture, as I hoped, was where I left it at home in Cookham. It was just the fact that there was a remote possibility that I might still be living in a time of peace and no war, and painting this picture up in my bedroom at home that was so agonizing . . . It can be imagined what I felt when I did at last, in fact, walk into my bedroom at home, and see this picture leaning with its face to the wall on the far side of the big bed. I walked round the bed to it, and laid my hands on it once more. Well, there we were looking at each other; it seemed unbelievable but it was a fact.' [733.2.44]

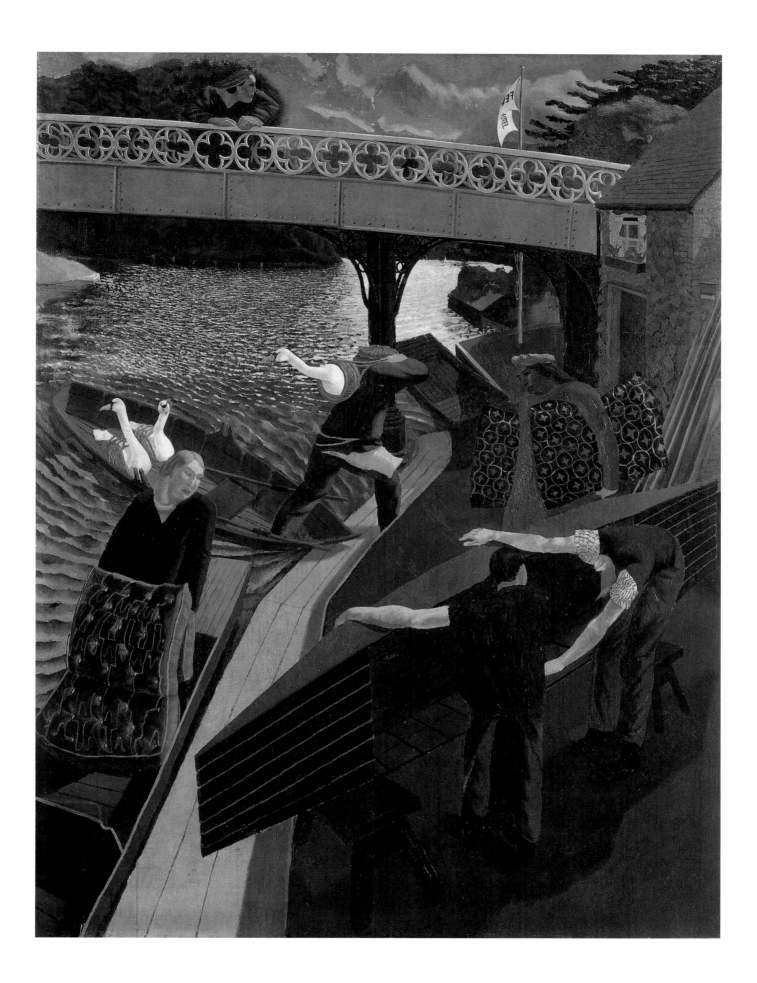

7

TRAVOYS WITH WOUNDED
SOLDIERS ARRIVING AT A
DRESSING STATION AT SMOL,
MACEDONIA

1919
183 x 219 cm
Imperial War Museum, London
Bell 30

Spencer began this after demobilisation,
and painted it for the Ministry of
Information. The incident depicted is the
following: about the middle of September
1916, the 22nd Division made an attack
on Machine Gun Hill in the
Doiran–Vardar Sector and held it for a
few nights. During this period the
wounded passed through the dressing
station in a constant stream by means of
the mountain ambulance transport shown
in the painting.

'When I did Travoys . . . I still determined
that a painting that I did was to be a refuge
to me, and I found that through having that
purpose in view not only did it not separate
me from making a true war picture but
brought me nearer the truth . . . It was
possible even in a war to establish to a
greater or lesser degree a peaceful
atmosphere, and of hope, and some sort of
constructive life was sustained in this way. I
was impressed with the calm way the
wounded men spoke to each other . . . about
some cabbages they had been trying to grow
for instance. As far as was possible a homely
atmosphere was being preserved in spite of
what was happening. After the war, when I
tried to remember the compositional
drawing I had made at the time but which
was lost when my kit was stored for the final
move into Bulgaria, it seemed a kind of
lesser crucifixion; I mean, not a scene of
horror but a scene of redemption from it,

and I was as right in making it a happy
picture as the early painters were right in
making the crucifixion a happy painting as
they often did.' [733.3.21]

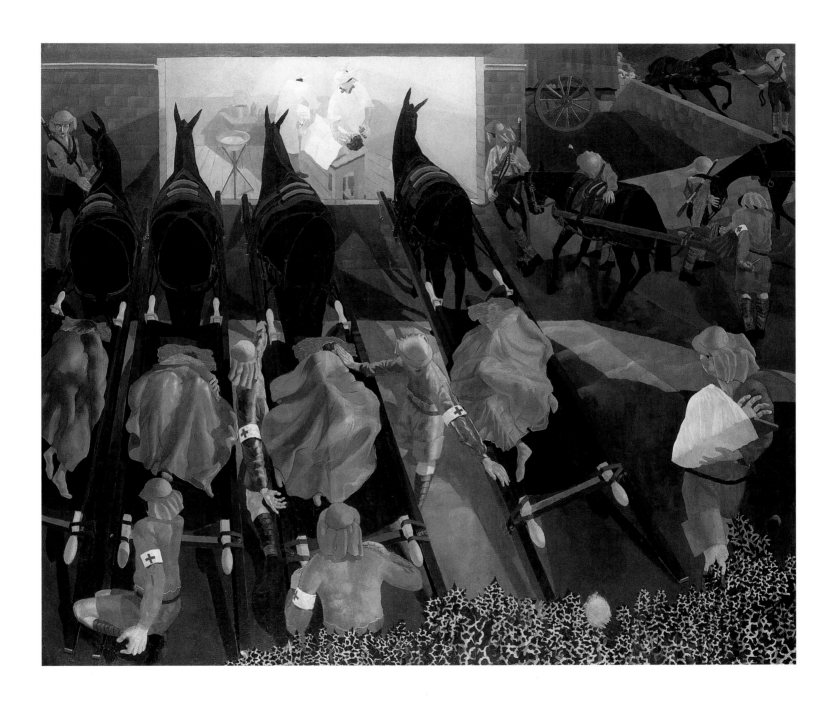

THE LAST SUPPER

1920
91 x 122 cm
Stanley Spencer Gallery, Cookham-on-
Thames
Bell 34

> The composition is based on an idea
> drawn before the artist joined the army in
> 1915.

'Find old study of Last Supper done before
war, and try to continue developing it. Am
pleased with addition of the legs under the
table. The place is the inside of the old Malt
houses. I liked the red wall among the sandy
coloured walls. Could not get the feeling of
the place which at the beginning was
indivisible from a concept I had of Christ. It
is still there in my mind. But it never came
into the picture.' [733.3.1]

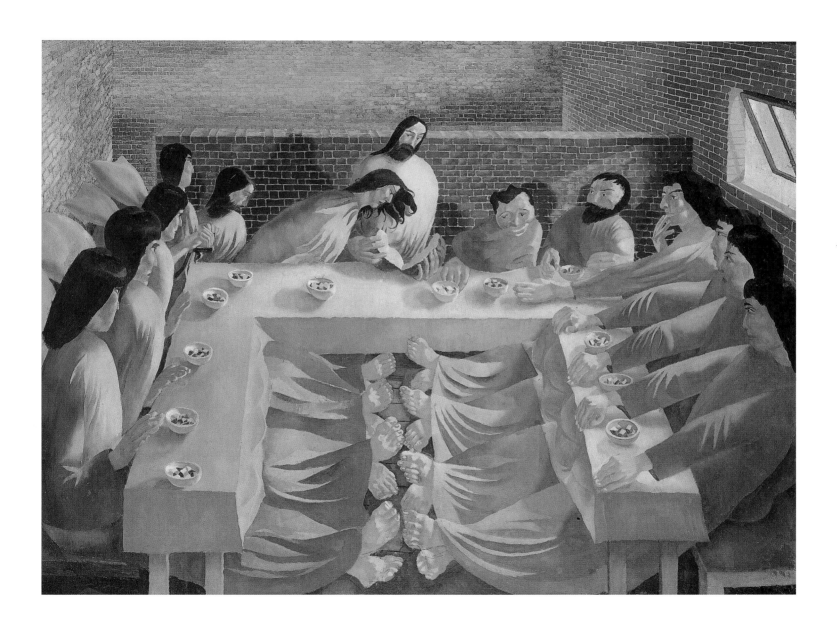

CHRIST CARRYING THE CROSS

1920
153 x 143 cm
Tate Gallery, London; presented by the
Contemporary Art Society, 1925
Bell 38

The house is the artist's in Cookham built
by his grandfather.

'When I was thinking of the picture and
wishing for it to come into the light of day . . .
I saw Fairchild's builder men go past the
'Nest' carrying ladders, and there was one . . .
[like] . . . Christ carrying the Cross. Also my
feeling . . . was one of joy. It was joy and all
the common everyday occurrences in the
village were reassuring, comforting
occurrences of that joy . . . The men carried
the ladders and Christ carried the Cross. It
may have been, in fact . . . that the Cross was
extremely heavy and a great burden and
causing much suffering in having to be
carried, but the aspect of the story was in . . .
my wishing for this Calvary scene in this
picture . . . was of the same reassuring order
. . . as I feel in times of happiness in seeing
ordinary domestic circumstances . . . The
movement of the way to Calvary passes from
the right to the left; rather the movement of
a breaker approaching a shore. As youths we
stood with other village youths in a gate
opposite our house, and watched the people
go by on Sundays and in the evening. The
three men in the central part of the bottom
of the picture form this onlooker-part of the
scene. To the left of these is a wide street
coming towards the spectator, through the
iron palings at the side of which other men
peer down at the . . . stooping figure of the
Virgin. Other onlookers in the left bottom
corner shade their eyes, and one is clearing
his eyes.' [733.10.58]

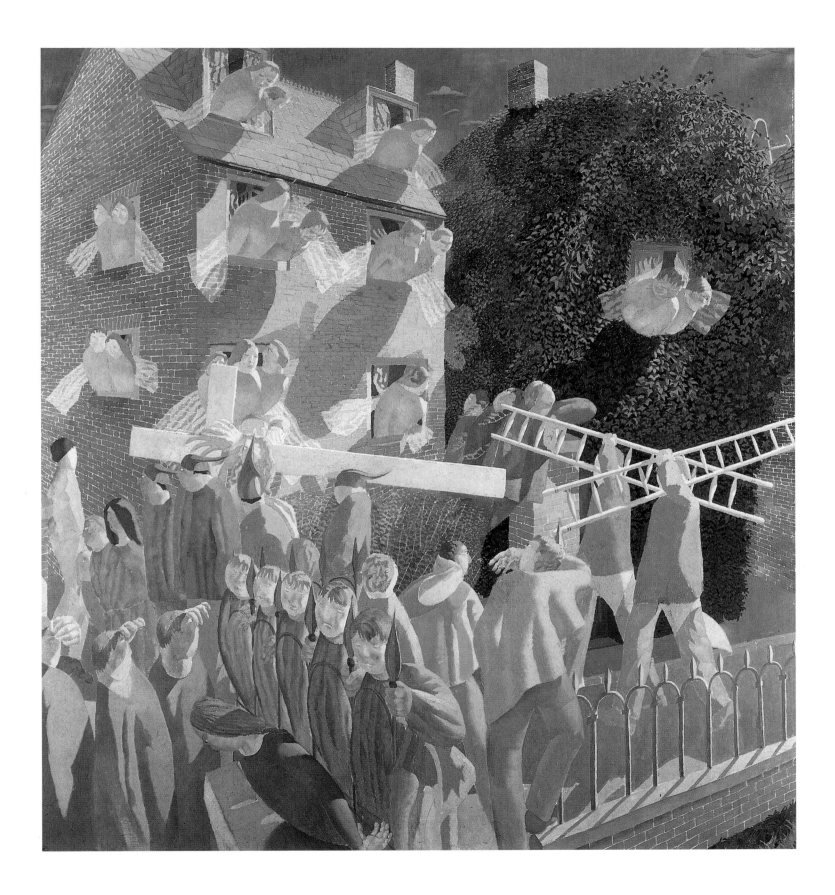

THE CRUCIFIXION

1921
Oil on paper mounted on canvas
71.4 x 111.7 cm
City of Aberdeen Art Gallery & Museums
Collections
Bell 77

'This I did at Petersfield and it was the first stage of what was to be a big effort, and I think an interesting one. The three ravines slicing into the hillside were to be below the walls of Jerusalem, and acting in concert with the transverse arms of the crosses was to be a sort of railing on the side of the road, over which people looked. Behind and above that was to be, on the right, the . . . part of the temple showing the veil being rent, and to the left were the streets showing the people wondering at the dead who walk in shrouds. Then I began to feel that the street scenes would be so small . . . and some vague and dim notion that the veil was not to the right. I am now fairly sure that the veil continues on upwards from about three-quarters of the way up the cross, but how it could be managed I don't know. I am sure if I was commissioned I could carry out a great altarpiece of the Crucifixion . . . The idea of being in ravines saves the men having to use ladders.' [733.3.1]

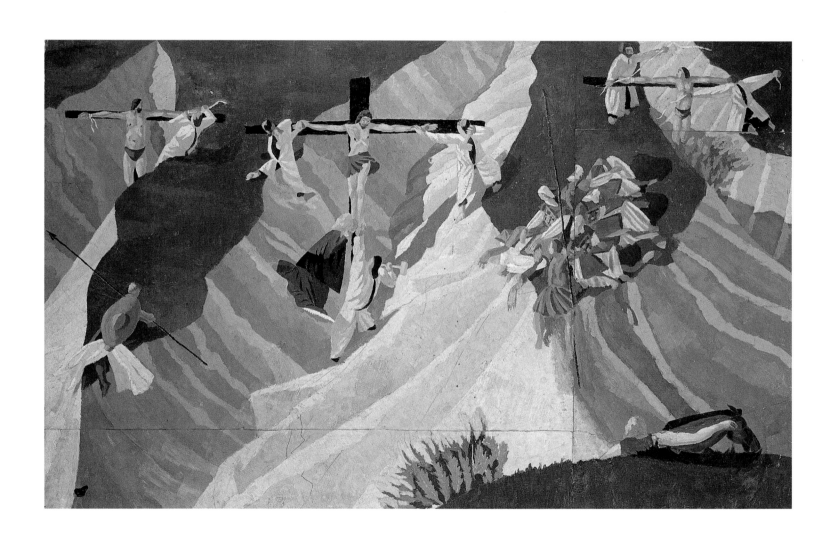

CHRIST'S ENTRY INTO
JERUSALEM

1921
114.5 x 144.5 cm
Leeds Museums and Galleries, City Art
Gallery
Bell 70

'Occupants of houses coming down garden
paths, between cabbages etc. Others at the
fence & sitting on the fence (from a scene I
saw at a place in Durweston). Others coming
through garden gates into street. Could get
no clear idea of Christ on donkey but have
had clearer ideas since, and must one day do
it again.' [733.3.1]

THE BETRAYAL

1922–23
123 x 137 cm
Ulster Museum, Belfast
Bell 91

'The scene takes place behind the school
room in Cookham. There is a space behind
the corrugated sides of the school and the
wall in which . . . much rubbish is thrown.
This was a great hunting ground for me, and
a good place for getting out of the way. For
some time I had the motif in my mind of
the disciples walking away. I was interested
in the rhythm of the movement of the
disciples produced by their disturbed
thoughts at what was taking place. In Peter,
whose cloak is raised by the movement of his
arm to strike off the ear of the High Priest's
servant, I imagined he was irritated at the
success of the High Priest's venture, and the
glib way he was marching off with Christ
. . .' [733.3.1]

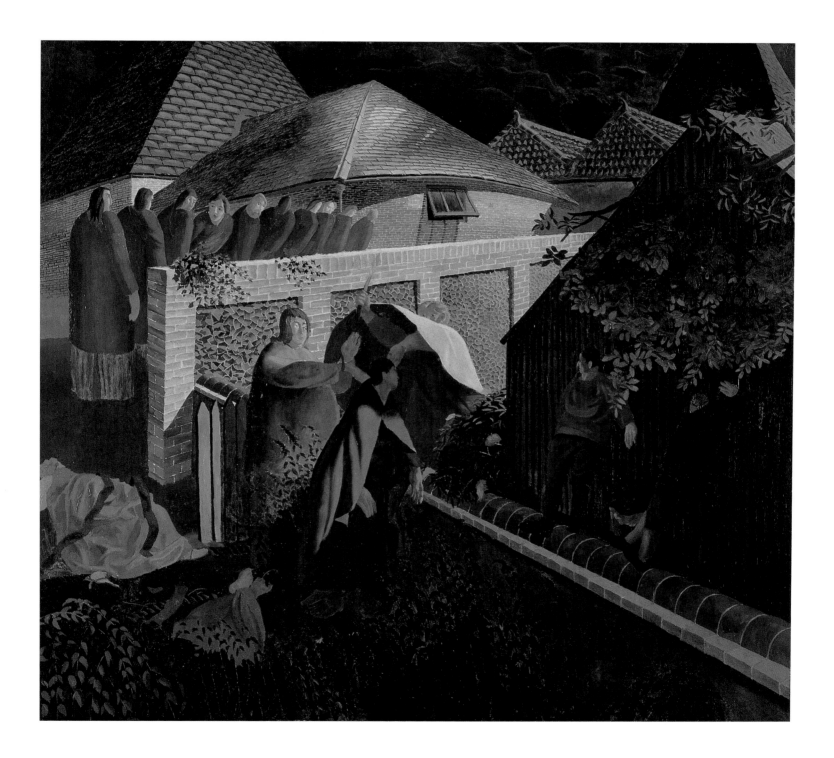

THE RESURRECTION, COOKHAM

1924–27
274.3 x 548.6 cm
Tate Gallery, London; presented by Lord
Duveen, 1927
Bell 116

'I was on bedrock in this picture. I knew it was impossible for me to go wrong . . . It may be of interest to give a description literally of what the people in this picture are doing. Reading from left to right: People tracing their own names out on the stones, and above wandering off towards the river. There is a white hedge of May and some Cow Parsley. As it is Heaven there is no hurrying to be off, and I have expressed their being content to remain where they are by the reclining man on the tombs, bottom left. A girl smells a flower to see if it still has the same scent. I remember at home my mother used always to give my father's coat a "brush down" before he left to go teaching. So by the tower the wives brush the earth off their husbands' coats, adjust their collars and button their coats etc. The long row of saints or holy men, ranged in sort of stone seats, like small buttresses projecting all along the side of the church, are meant to express different levels or states of spiritual thinking, such as contemplation, consideration, pondering, understanding, adhering, believing and so on. They are doing the chief jobs of thinking. They represent the resurrection of thought and reason etc. The other resurrecting ones are doing the simpler jobs of enjoying the peace. They have resurrected from a state of rest into a new state of rest, the lively and productive state of peace. And so they are, as it were, at home before they have got right out of their graves. Some have got right out and are showing the perfection of doing nothing. The blacks are respectively enjoying: 1. feeling a round stone; 2. feeling

an arm; 3. resting an arm on a soft spongey object; 4. resting the hand on a many-faceted piece of rock; 5. feeling the surface of the ground; 6. playing with sand; 7. putting a hand in a hole; 8. touching the hem of Christ's robe. The reclining stone figure seems also to share the joy of the resurrection, although he remains the stone he is. The relationship of the relative shapes of the porch, and the ivy covered tomb in the foreground, the tall dark fir to the right of this tomb, and the grave with the wreaths constitutes the main structure in which the picture rests . . . I liked the fact that as I placed the grand wreaths on the grave just mentioned, I noticed that the grave was covered with ordinary meadow growth – clover, plantains, etc, so that the flowers would mix. It was like an act of worship to a patch of meadow, and the clover rising among the wreath of garden flowers was like souls arriving in heaven. I also liked the bas relief of the sort of Lord Mayor man, on the stone above him, almost repeating his movement. And the girl's dress patterned with flowers similar to those on her grave. The girl resurrecting by the wall covered with virginia creeper is showing the other girl a wreath that she put on the other's grave, and the affectionate message she wrote on it . . . In the bottom right-hand corner is another "me" . . . The collapsing tombs interlock like the pages of a book. I love the pages of a book, an open book, and so I am where I love to be.' [733.3.1]

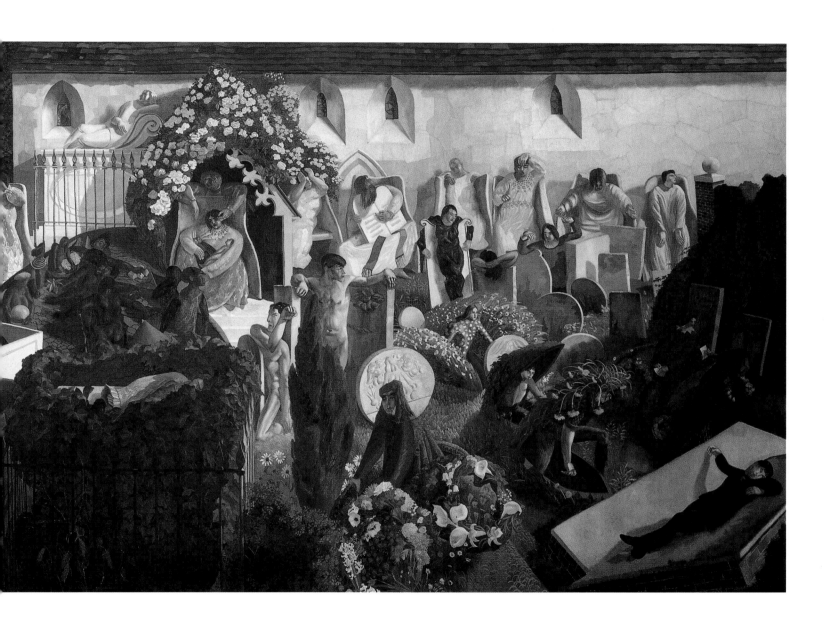

14

COTTAGES AT BURGHCLERE

1930
62.2 x 160 cm
Syndics of the Fitzwilliam Museum,
Cambridge
Bell 132

One of a few landscapes Spencer painted
in the vicinity of Burghclere where he
moved with his family in May 1927 to
work on the Sandham Memorial Chapel.

GYPSOPHILA

1933
70 x 86.4 cm
Private Collection
Bell 149

Painted in the garden of the vicarage
adjoining Cookham Church.

THE MAY TREE

1933
86.4 x 137.2 cm
Private Collection
Bell 142

'I am tucked away in a deserted corner of a
Cookham meadow where there is much May
tree and stinging nettle and wild flowers.
One of the May trees was dying off when I
got to it so of course it is that colour in the
painting.' [Letter to Dudley Tooth giving an
account of the problems in painting a similar
May scene, Bell 142]

SEPARATING FIGHTING SWANS

1933
91.4 x 72.4 cm
Leeds Museums and Galleries, City Art
Gallery
Bell 152

'This is an effort to combine an incident in
my life with a person in my life, and a place
in Cookham, and a religious atmosphere . . .
In it the associations are my separating two
fighting swans in a park in Poole, Dorset; my
feeling about Patricia [Preece, Spencer's
second wife]; my feelings of the sloping
beach of My Lady Ferry; and a drawing of
angels I had done when in Durweston.'
[733.3.1]

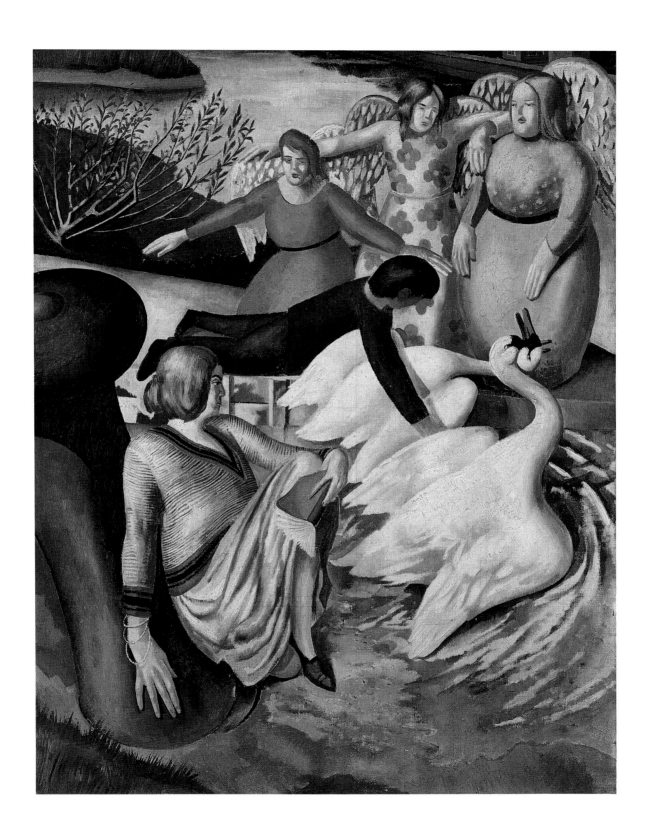

PORTRAIT OF PATRICIA PREECE

1933
83.9 x 73.6 cm
Southampton City Art Gallery
Bell 154

'I gave myself completely to the peculiar excruciating exquisiteness I found in her, and I wish you could have seen how lovely she looked, arranged in the hundreds of dresses I got her. There was a sort of passionate intensity and meaning in her loveliness, and perfect shape and appearance. She achieved something in and through that fine and exquisite lady appearance . . . her high heels and straight walk used to give me a sexual itch, and yet it was never any good, except at first.' [733.2.111, note from Stanley Spencer to Hilda]

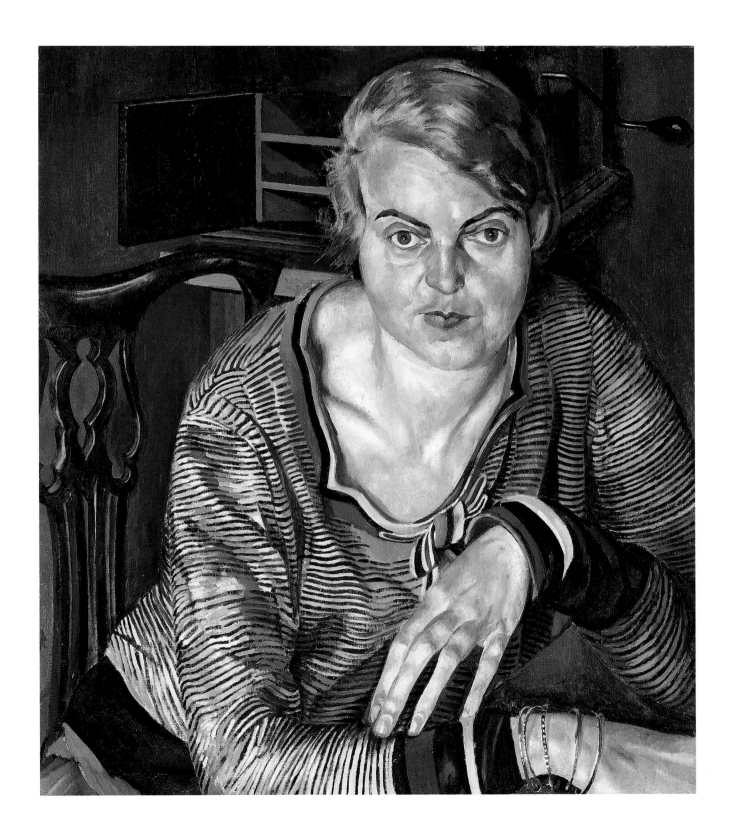

19

THE DUSTMAN or THE LOVERS

1934
114.9 x 122.5 cm
Tyne and Wear Museums, Laing Art Gallery,
Newcastle upon Tyne
Bell 163

'I feel, in this Dustman picture, that it is like
watching and experiencing the inside of a
sexual experience. They are all in a state of
anticipation and gratitude to each other.
They are each to the other, and all to any one
of them, as peaceful as the privacy of a
lavatory. I cannot feel anything is Heaven
where there is any forced exclusion of any
sexual desire . . . The picture is to express a
joy of life through intimacy. All the signs
and tokens of home life, such as the cabbage
leaves and teapot, which I have so much
loved that I have had them resurrected from
the dustbin because they are reminders of
homelife and peace, and are worthy of being
adored as the dustman is. I only like to paint
what makes me feel happy. As a child I was
always looking on rubbish heaps and in
dustbins with a feeling of wonder. I like to
feel that, while in life things like pots and
brushes and clothes etc. may cease to be
used, they will in some way be reinstated,
and in this Dustman picture I try to express
something of this wish and need I feel for
things to be restored. That is the feeling that
makes the children take out the broken tea
pot and empty jam tin.' [733.3.74]

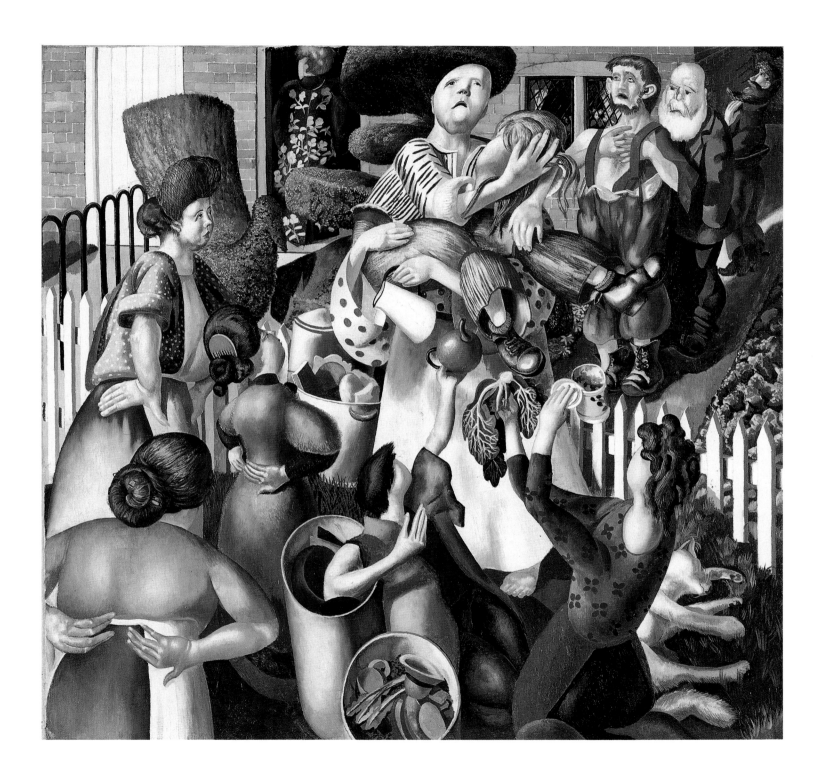

THE TURKISH WINDOW

1934
61 x 86 cm
Cdr L.M.M. Saunders Watson, Rockingham
Castle
Bell 162

'This picture forms a part really of *Love Among the Nations* [cat. 24], and it should be considered as attached to the left hand end of it. In the centre of this picture there is a glassless window, a wide open arch, and bulging forward [a] wrought iron trellis grill through which can be seen veiled women in black veils and white shroud-like clothes. I am getting all I can out of it through the emissaries I have sent, each expressing all that is me and handing it in to the women through the bars . . . The floor, so to speak, of the bulging window overhangs the ground, and in between the ground and this floor of bars, a youth gazes up at the face of a woman who lays on the floor of the cage and gazes down at him. They could remain doing just that for ever. There are several young men making love through the bars, and the bars seem to understand the matter that is taking place. While they keep the two parties from each other, [they] admit as much lovemaking as is required for the moment. A negro also joins in on the right, and on the left are two Turkish women veiled in black flower-designed veils. (These veils I saw completely obscure the face.) And one of them is being kissed through the veil, so that the youth kisses a flower and some portion of a leaf. The little pots on the right are what they make coffee in or tip it out of into the little cups. I am very keen on the group and this window.' [733.3.2, no. 101]

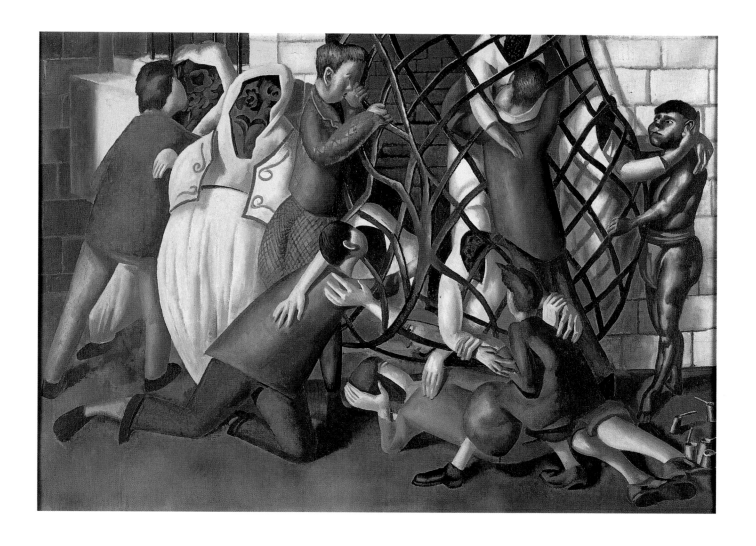

THE BUILDERS

1935
111.8 x 91.8 cm
Yale University Art Gallery, New Haven
Bell 169

'When I was living at Burghclere, I wrote to
Hilda and described the Night Jars [a
nightjar is an uncommon woodland bird] in
the evening down the Ox drove in the oak
trees . . . It was difficult to see them in the
trees, but I thought they conveyed to me the
same degree of initiation into the inner
mysteries of other natures than human ones
. . . I felt that they had their life and their
own local feeling, and the branches of trees
and leaves would have the same signification
as furniture in a room would have for us.
These were their homes and establishments,
and for one Night Jar to see his wife in some
particular relationship to some oak leaf; its
head in relation to the scollops of a leaf
would be the same as seeing one's own wife
on a sofa with her head in relation to its
crowned back . . . Immediately below them
are some men removing a template, having
just finished an arch of bricks . . . This idea
was suggested to me by seeing a template
being used in Hampstead one day . . . and in
seeing and helping Mr Head, the builder at
Burghclere, fitting into the arched recesses
the stretcher frames for my canvases. I did a
study of the men measuring the wooden
frame work . . . Personally I think they are
horrible mechanical devices, and are
responsible for arches now being so
symmetrical, when the old builders used to
use their eye. But I dare say I am ignorant on
this matter. They may always have used
them; I know not. Then there are the men
easing the hods of bricks on to their
shoulders, which I saw in Fairchild's yard
one day.' [733.3.1, no 96]

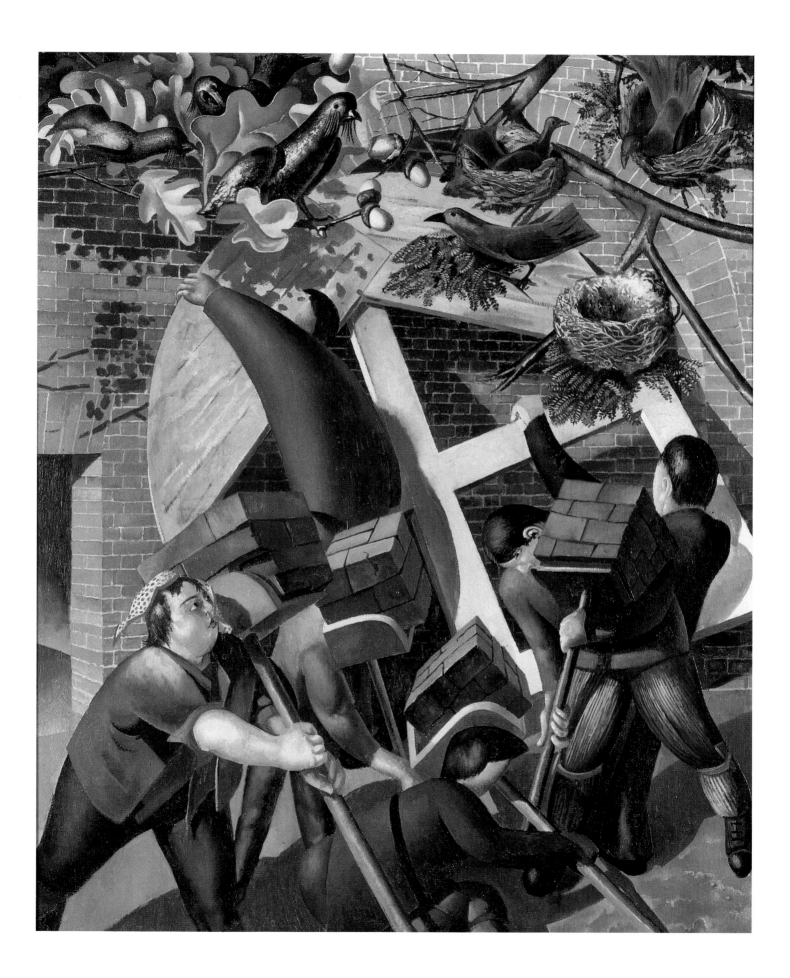

WORKMEN IN THE HOUSE

1935
113 x 92.7 cm
Collection of the late W.A. Evill
Bell 168

'When [I was] a child, one of the greatest
incidents in life was the changing of
wallpaper in a room, and seeing what the
room looked like with the bed in another
corner and noting how it seemed to become
somewhere else. Sometimes the 'other places'
that these rooms became seemed to further
emphasize the feeling I always had for that
room, so that the returning of every thing to
exactly where it was before was not always a
comfort to me, but mostly it was. In this
picture I have felt that the sense of it being a
home has been switched and added to by the
presence of the workmen, and to see some
out of doors element in the most indoor
place was like a new thought or idea coming
into one's mind, or absorbing something out
of the world into one's own nature and
being. Quite different from the effect of
visitors because these men are part of the
structure of the house. This man is to do
with the doors and door hinges, and that
man is wallpaper etc. This picture shows, on
the left, a carpenter looking along the edge
of his saw examining the teeth. The scene of
the picture is more or less the kitchen of my
cottage at Burghclere. The kitchen grate is
being mended, and a workman is grouting
out the cement . . . with an iron wedge. He
was asked by the servant (bottom right) if he
would like her to shift the clothes line, but
he told her it was not in his way. And so one
sees it lying across his back and the stockings
on it. He has pulled out the fender so as to
get at what he is doing. Below him is the
servant buttoning on a gaiter, preparatory to
going out, and the young child who is about
two years old is doing what they often do.

This little girl was always fond of playing
with clothes pegs, which she was able to get
at with great ease, because they were in a
clothes basket under the kitchen table . . .
being wedge- shaped she felt they fitted on
to something.' [733.3.2]

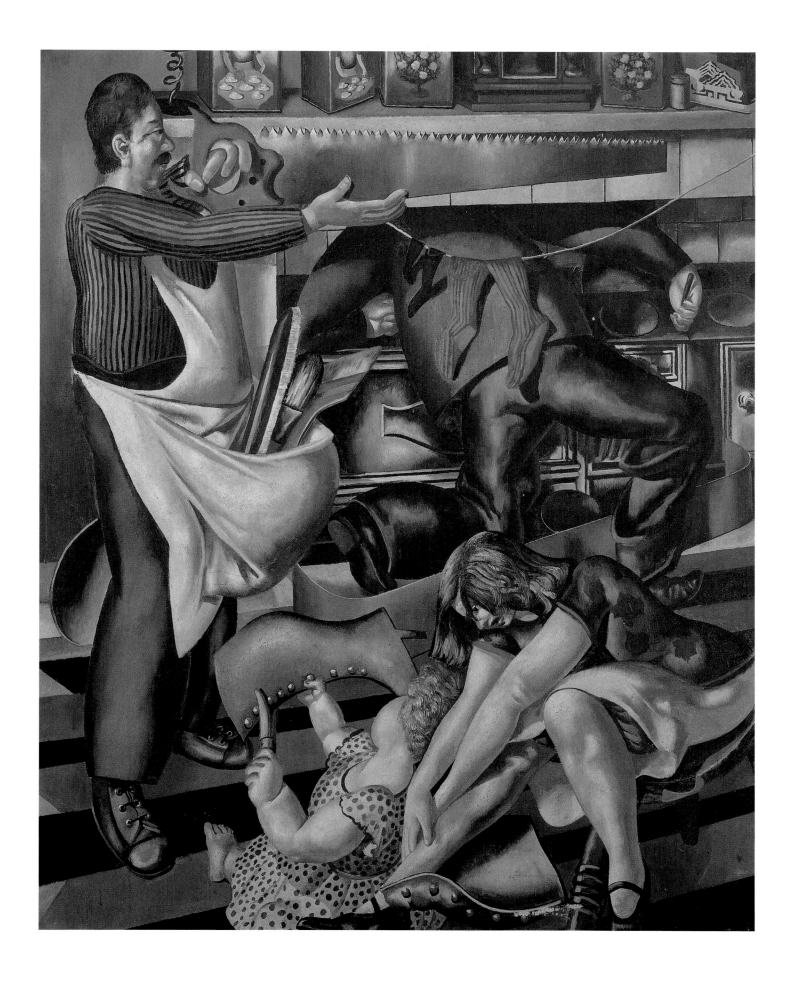

23

THE CEDAR TREE, COOKHAM

1935
75 x 70 cm
Private Collection
Bell 174

LOVE AMONG THE NATIONS

1935
95.5 x 280 cm
Syndics of the Fitzwilliam Museum,
Cambridge
Bell 172

'. . . a memento of my visits to Mostar and
Sarajevo (in 1922), and my feelings for the
east generally . . . I have longed as usual to
establish my union with those aspects of life
which I feel are definitely to do with me and
not cut off by nationality; love breaks down
barriers. Overcoming of obstacles is the food
of love, and a barrier or resistance is only an
incentive in my case. It rides over
everything.' [733.3.1]

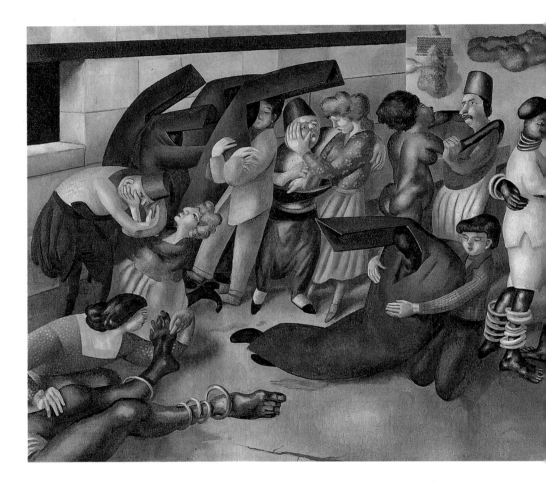

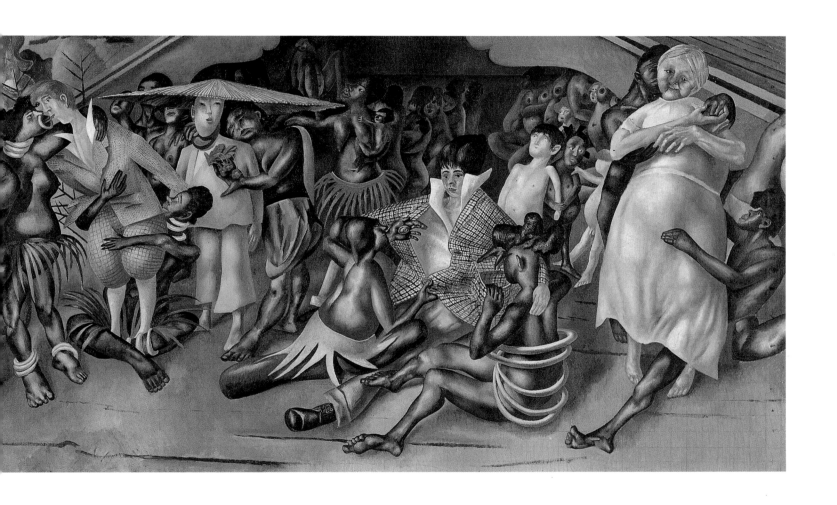

NUDE, PORTRAIT OF PATRICIA PREECE

c. 1935
76.2 x 50.8 cm
Ferens Art Gallery, Kingston upon Hull City
Museums & Art Galleries
Bell 165

> The first of a series of nudes of Patricia
> Preece painted between 1935 and
> Spencer's marriage to her in 1937.

'It is damnable that the only great things of life are put into a blasphemous category . . . I *hate* the *mistress* atmosphere. I would like about half a dozen homes in which I was 'father' in each one. If I had the money I am sure I could live in absolute happiness with *each* wife if I had a dozen and I often think the irritableness that men so often experience in themselves in their homes is because they are wanting a change of wife . . . it isn't just a change it is the fact that a new experience helps one to come to a greater understanding and realisation of the old experience . . . Whatever one does is always represented in some disgusting way . . . when we used to meet I was afraid of the business of leaving Hilda as I had not then found anyone sufficiently strong to make me able to break away. Patricia made it possible because I felt a sort of religious fervour towards her . . . She approves absolutely in my having as many women as I want. She is not herself like that and has not such inclination, but sees no reason why I should not gratify any such feeling . . . I think the whole of my life especially the art manifestations of it has been a slow realisation of the mystery of sex . . . What you once said that you felt you had some personal experience with a person when you had drawn them, don't you think that experience was a wonderful *sexual* experience?' [Letter to Peggy Andrews 1936–37, Rothenstein p.58]

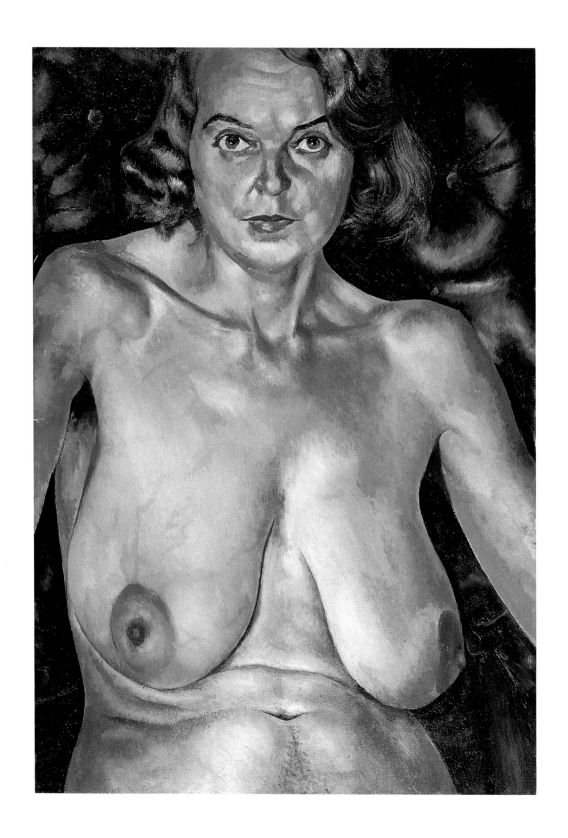

NUDE (PATRICIA PREECE)

1935
51 x 76 cm
Ivor Braka Ltd, London
Bell 166

The second nude portrait of Patricia
Preece painted by Spencer in 1935.

'There is nothing the least particle "wrong"
in wishing to have a union with several
people one knows. To me human
relationships which *perforce* exclude any sex
feelings are like expurgated books. You are
trying to do something which demands every
ounce of your being with only one part of it,
like trying to write without using your
hands, or always standing on one leg . . . It is
like the way people will have my pictures "as
long as there are no figures in it".' [Letter to
Peggy Andrews 1937, Rothenstein, p.60]

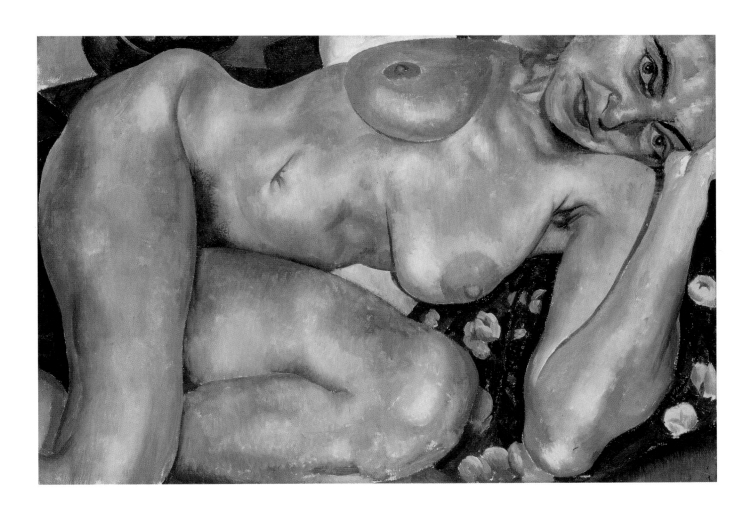

NUDE (PORTRAIT OF PATRICIA PREECE) or GIRL RESTING

1936
61 x 91.5 cm
Private Collection; courtesy of Ivor Braka
Ltd, London
Bell 222

> Spencer estimated that he spent over
> £2000 on jewellery and clothing for
> Patricia in the two years prior to his
> marriage to her.

'In spite of my excitement at Hilda's
inelegance, I have a passion for feminine
daintiness and elegance, and in one way, if I
can as it were get there, it fits more with my
sexual needs than with the more usual kind
of attraction.' [Pople p.304]

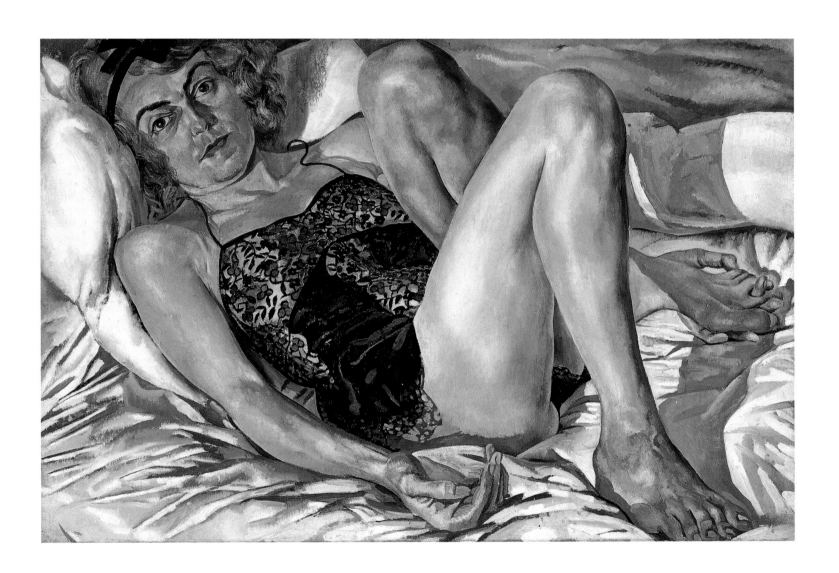

BELLROPE MEADOW

1936
91.5 x 129.5 cm
Rochdale Art Gallery
Bell 207

The tower of Cookham Church is on the
left and a house known as Cookham End
(since demolished) on the right.

'When I lived in Cookham I was disturbed
by a feeling of everything being
meaningless. But quite suddenly I became
aware that everything was full of special
meaning and this made everything holy. The
instinct of Moses to take his shoes off when
he saw the burning bush was similar to my
feelings. I saw many burning bushes in
Cookham. I observed this sacred quality in
most unexpected quarters.' [*Sermons by
Artists*, Golden Cockerel Press, 1934]

GARDENS IN THE POUND,
COOKHAM

1936
91.5 x 76.2 cm
Leeds Museums and Galleries, City Art
Gallery
Bell 208

THE NURSERY

1936
76.5 x 91.8 cm
The Museum of Modern Art, New York; gift
of the Contemporary Art Society, London,
1940
Bell 197

'This is an attempt to express the atmosphere
I felt in the nursery as a child . . . In this
picture, you see along the upper part the
children at the bottom end of their beds on
the winter morning when still dark, feeling
their stockings which, as is often the custom
where a lot of presents are given, their
mother's old stockings. The hair of the
children is in curlers, such as I used to have,
which consisted of strips of some sort of rag.
The filled socks is another of those examples
of anticipated pleasure that I enjoy painting,
such as the anticipated pleasure of what was
going to be on the next page of a wallpaper
book, or the anticipating of the getting into
bed of the wife . . . Stretching across the
floor is a procession of paper nuns which my
eldest brother showed me how to make, and
this became a favourite occupation
afterwards. I liked the fact that they made
different characters, and one never knew
until they were bent over to make the shape
of the hood what they were going to be like.
I liked the feeling of length it gave to the
line of people, being a bit odd in my size and
shape. I liked a long string of horse
chestnuts.' [733.3.2, no. 113]

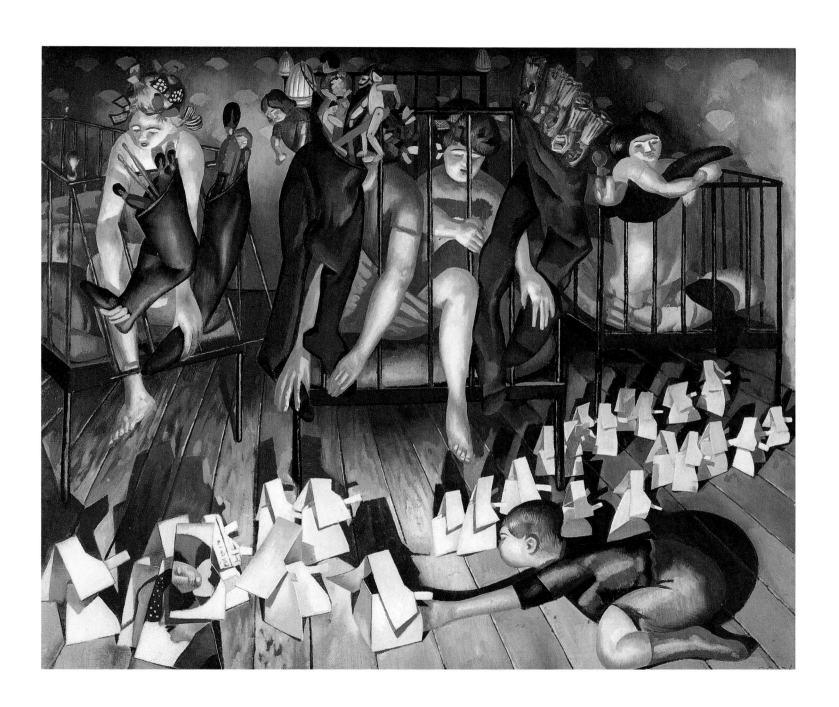

SEATED NUDE

1936
76.2 x 50.8 cm
Private Collection
Bell 307

The only nude painting of Hilda,
Spencer's first wife. The painting was
largely done in 1936, the year in which
Hilda divorced Spencer (a decree nisi was
obtained November 1936; made absolute
25 May 1937. Spencer married Patricia
Preece 29 May 1937). A drawing of 1931,
Hilda with Beads, formed the basis of this
painting.

'About six months ago I did an oil painting
of you from that nude to the waist drawing I
did of you at Burghclere. Even that is
extraordinary next to the ones of Patricia. I
think that even now while we are in the
midst of this legal fight that in our real
selves we continue to be utterly at one,
rejoicing in our oneness.' [733.3.31]

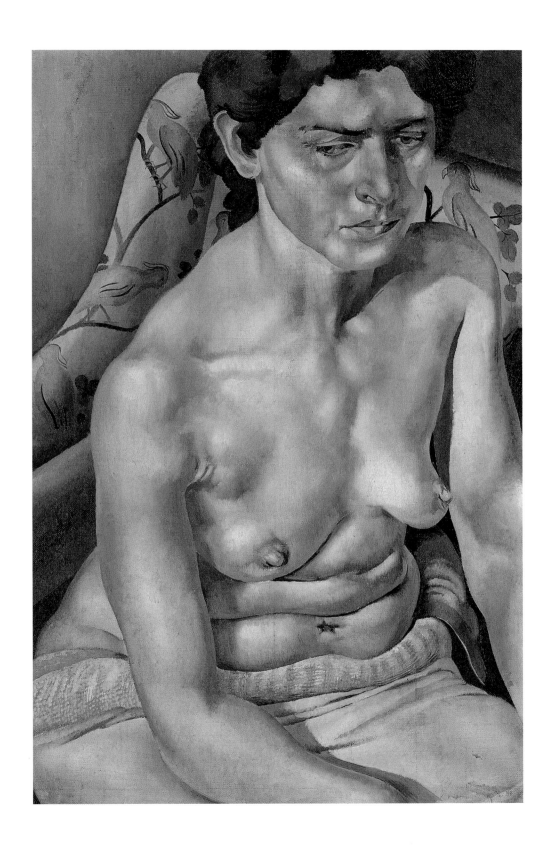

SELF-PORTRAIT WITH PATRICIA PREECE

1936
61 x 91.5 cm
Syndics of the Fitzwilliam Museum,
Cambridge
Bell 223

> The first of two double nude portraits, in
> which Spencer painted himself with
> Patricia Preece.

'I wish my shows could include the nudes
that I have done. I think that to have them
interspersed in a show would convey the
range of my work. They are quite different. I
wish there were more of them, but I have
never had professional models, not liking the
idea . . . They have such an effect on the
other works.' [733.8.22]

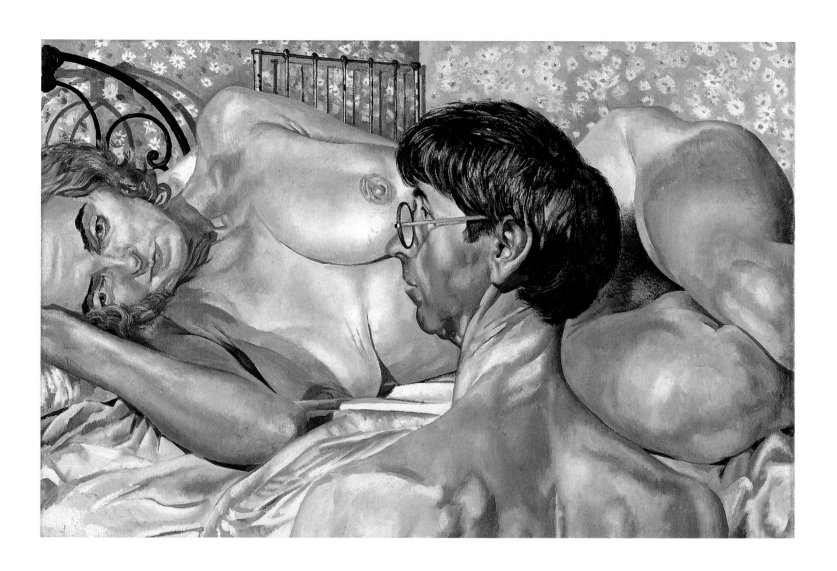

DOUBLE NUDE PORTRAIT: THE
ARTIST AND HIS SECOND WIFE

1937
91.5 x 93.5 cm
Tate Gallery, London; purchased 1974
Bell 225

'I also began . . . a painting in the evening
from life of a double nude. A man sits and
contemplates the woman. He is squatting
and fills the space between the woman's
arms resting above her head and her raised
knees . . . Both figures are life-size. The
uncooked supper is in the foreground and on
the right is a Valor oil stove lit. [733.2.34]
I have now brought back home the big
double nude. When I put it alongside any of
my other work it shows how needed it is to
give my work the variety that is so
refreshing. This big double nude is rather a
remarkable thing. There is in it male, female
and animal flesh. The remarkable thing is
that to me it is absorbing and restful to look
at. There is none of my usual imagination in
this thing: it is direct from nature and my
imagination never works faced with objects
or landscape. But there is something
satisfying in looking at it. It was done with
zest and any direct painting capacity I had.
Sept. 1955.' [733.8.2]

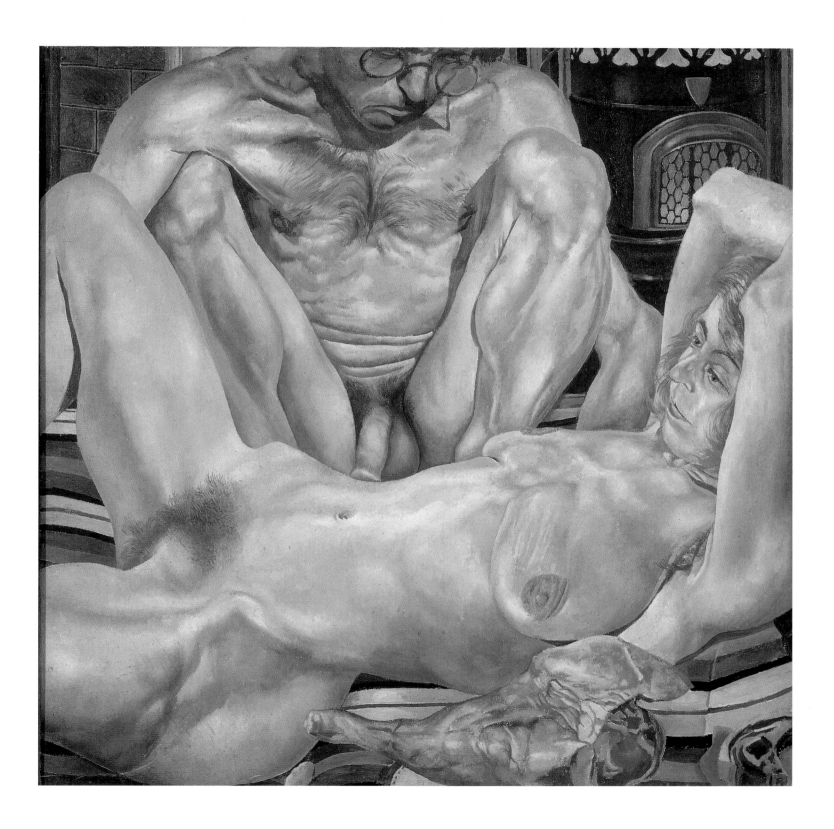

GREENHOUSE AND GARDEN

1937
76.2 x 50.8 cm
Ferens Art Gallery, Kingston upon Hull, City
Museums & Art Galleries
Bell 243

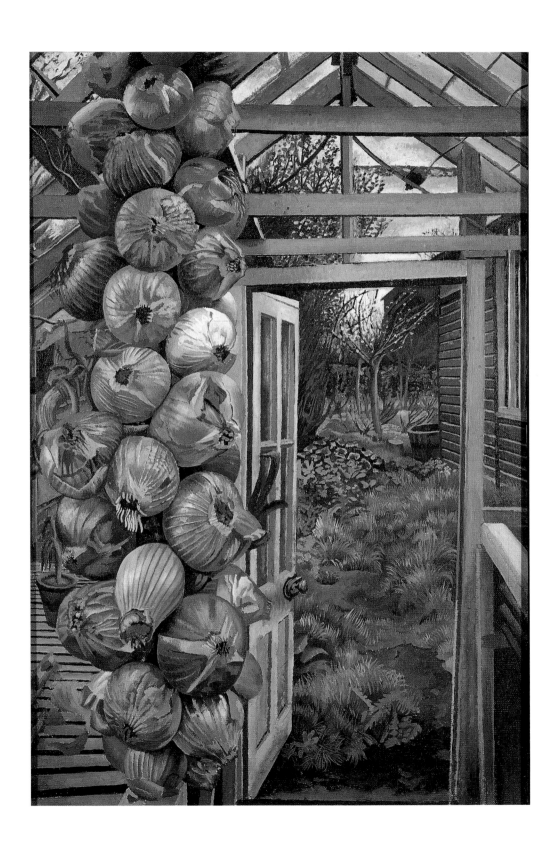

HILDA, UNITY AND DOLLS

1937
76.2 x 50.8 cm
Leeds Museums and Galleries, City Art
Gallery
Bell 229

Painted shortly after Spencer's divorce
from Hilda, with their second daughter,
Unity, then aged seven. Spencer was
staying in Hampstead, in Hilda's family
house, in the hope of luring Hilda back to
live with him in Cookham.

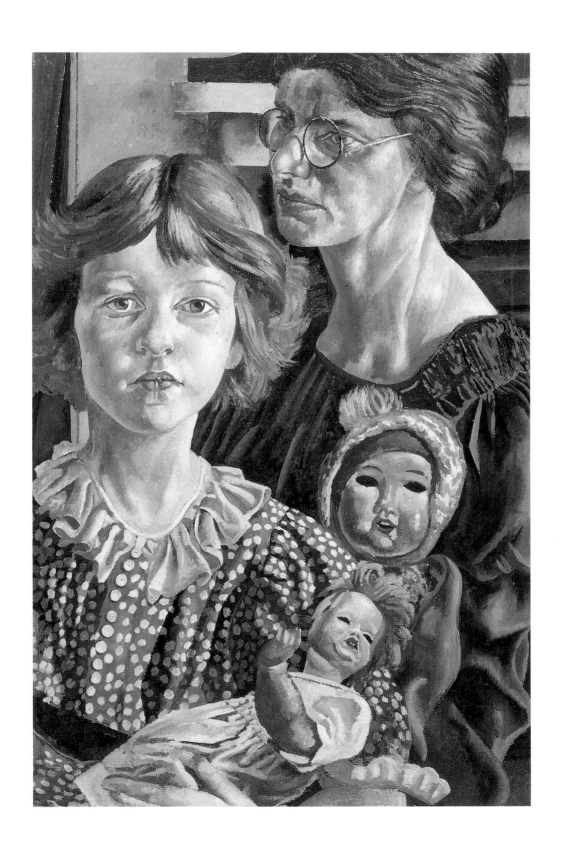

SOUTHWOLD

1937
67.5 x 97.9 cm
City of Aberdeen Art Gallery & Museums
Collections
Bell 235

Spencer visited Southwold on the Suffolk coast several times in 1924 while staying with his brother Gilbert and Hilda Carline in nearby Wangford. He and Hilda visited Southwold again the following year when they returned to Wangford to be married. This view of the beach was painted after the failure of his second marriage to Patricia Preece, when Spencer had unsuccessfully tried to persuade Hilda to return to Wangford on a second honeymoon.

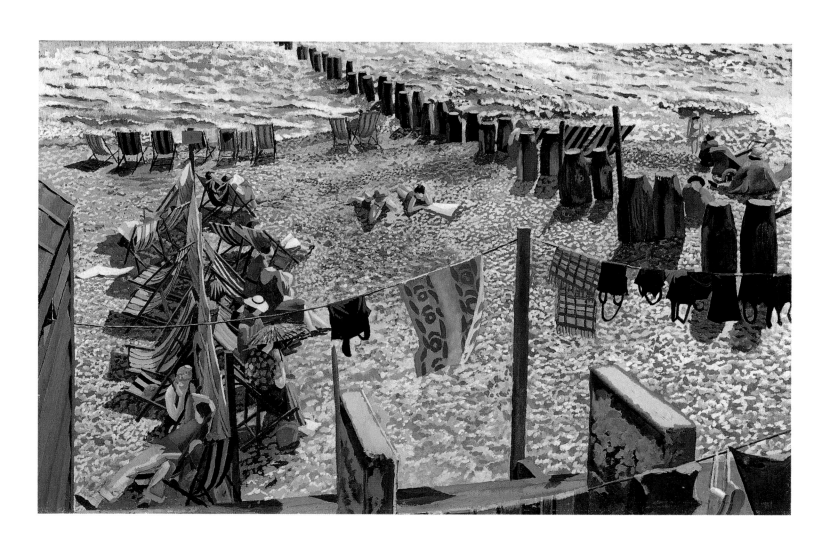

LOVE ON THE MOOR

1937–55
79.1 x 311.9 cm
Syndics of the Fitzwilliam Museum,
Cambridge
Bell 415

A celebration of Hilda who appears in the
form of a statue of the goddess of love
with a sizeable supporting cast of
villagers, including Spencer himself who
can be seen twice; as a boy behind the
makeshift goal, and as an adult embracing
Hilda's legs in the statue. The painting
was begun in 1937 and then set aside,
presumably because of the controversial
nature of the subject. It was taken up
again in 1949 but not finally completed
until 1955.

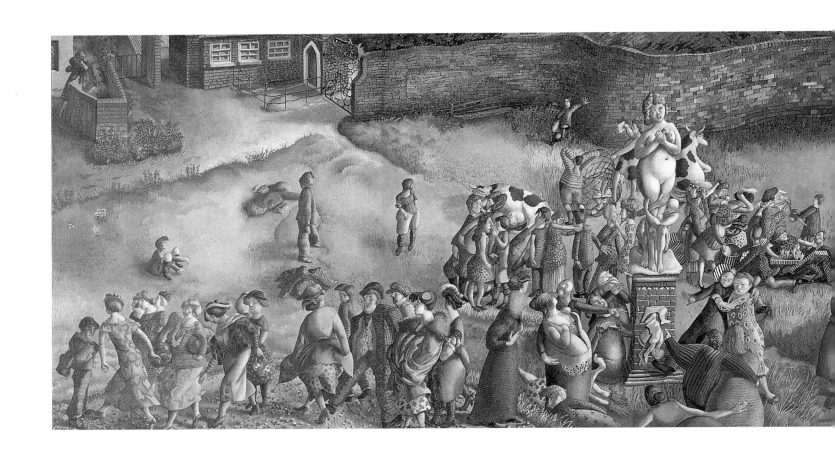

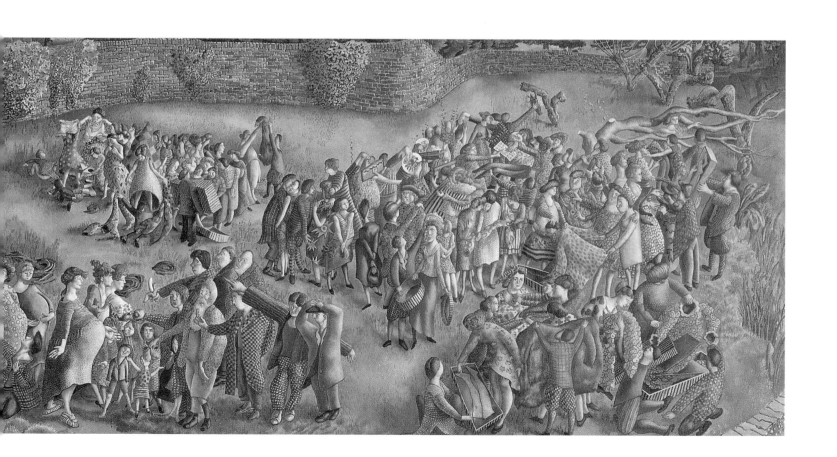

BEATITUDE: CONSCIOUSNESS

1937
76.2 x 50.8 cm
Private Collection
Bell 274f

> The 'Beatitudes of Love' form a series of
> ten paintings intended to hang in cubicles
> off the aisles of The Church House, where
> they could be viewed in private.

'Each of the pictures shows the twinned and
unified souls of two persons. The
composition turns the two into one person
and becomes a single organism . . . I can do
without all my pictures except these. They
are more genuine than any religious
painting I have ever done . . . I have never
seen any paintings that more truly reveal the
individual . . . I saw – and this interested me
most – that the religious quality I had been
looking for and had never found in my work
hitherto, now in my sex pictures showed
itself for the first time . . .' [Collis, pp. 141,
142]

'Without any particular reason for it, they
are suddenly aware of each other, and
whereas in ordinary associations there are
preliminary signs etc., in this case it is just
what there is not, a something that stands in
the way of intimacies etc is found not to be
present. And the couple start licking each
other's tongues when a moment before they
could never have believed it possible. But it
means and expresses something, and they do
it with great fervour . . . Everything has a
number of jobs to do in a picture, and often a
distortion occurs when something happens to
have so much to express . . . you must
remember that if I am drawing an arm in a
picture I am performing some part of a
drama, and my mind is on what the play is
about, and what the point of the whole play
is . . . I call it Consciousness because it is like

waking up and realising all one has been
missing while asleep, and making up for lost
time . . . They are both aware that they both
want to do the same thing. They don't say
what they want to do to each other, and they
know what they are. He knows that she is a
dress maker, and she knows that he is a
grocer's assistant. They know that they are
both strong, and that they are going to exert
their physical strength on each other. She
has never thought about her boring healthy
body. A solid woman who has done work, and
scrubbed floors, and who has always had a
happy temperament, and has never thought
much above being a help to everybody . . .
and now suddenly with all her sense and wits
about her, she finds herself doing this, not
helplessly, but with meaning and intention
and purpose. She feels "this is the first time
I've ever talked sense". He is telling her with
his tongue all the things she has never
thought of before . . . He had walked past
her place and seen her scrubbing her
doorstep or talking to a woman neighbour,
and longed for her. They were still unknown
but they were joined by their faces. She has
never met this situation before, and not
having any clear idea except that she thinks
it is good . . . he is thinking of her legs. Later
on they wrestle in the bedroom, and male
and female strength is felt.' [733.3.3]

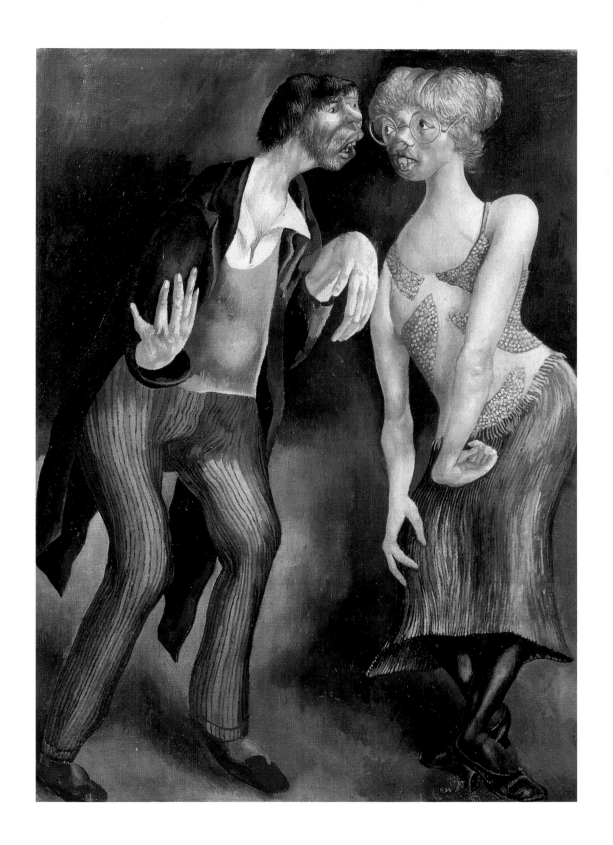

BEATITUDE: CONTEMPLATION

1938
91 x 61 cm
Stanley Spencer Gallery, Cookham-on-
Thames
Bell 274e

The figure in the foreground appears to
represent the artist. A similar figure
appears in another of the Beatitude series,
Desire, where the diminutive male looks
longingly at the huge female figure. In
Contemplation three sets of couples are
seen gazing into each other's eyes.

'A husband and wife and others . . . are
engaged in contemplation of each other, as if
expressed by their rapt gaze, as though they
would never stop looking . . .' [Collis p.141]

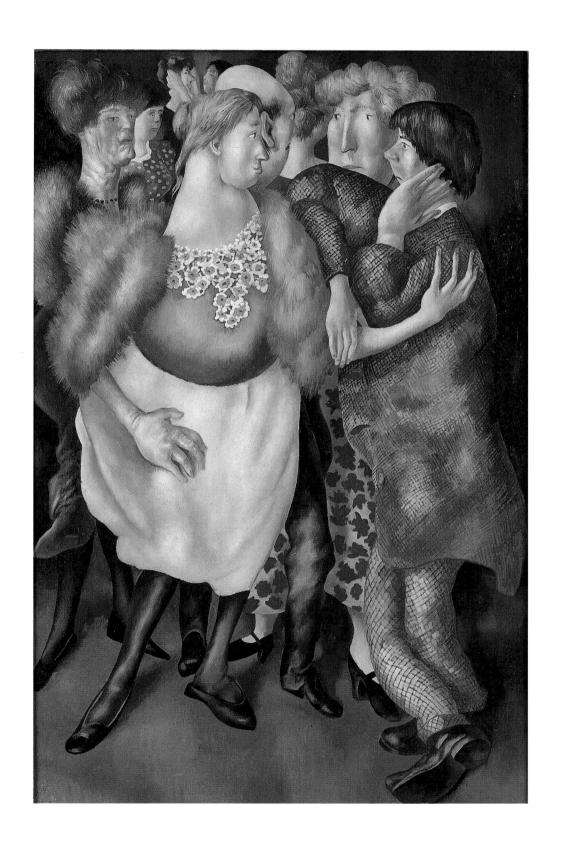

COOKHAM, FLOWERS IN A WINDOW

1938
50.8 x 76.2 cm
The Carrick Hill Trust, South Australia
Bell 266

A view from Lindworth, the substantial Victorian villa in the middle of Cookham occupied by Spencer from 1932 to 1938. He had bought the house with the proceeds of the sale of *The Resurrection, Cookham* (Cat. 13), but made the house over to Patricia as early as 1935, two years before their marriage. The view is from the bedroom window, showing the large garden shed used as Spencer's painting studio. The house still stands, but the shed has been demolished.

THE VALE OF HEALTH,
HAMPSTEAD

1939
61 x 81.3 cm
Glasgow Museums: Art Gallery and
Museum, Kelvingrove
Bell 284

Spencer left Cookham in 1938, after
Patricia turned him out of Lindworth. He
stayed at various houses in Hampstead,
north London: first with the Rothensteins
(John Rothenstein had recently become
Director of the Tate Gallery); then with
Malcolm MacDonald (son of Ramsay
MacDonald, Labour Prime Minister in
1924 and from 1929–31) and finally in
rented rooms in Adelaide Road, close to
Hilda and the Carline family.

CHRIST IN THE WILDERNESS: THE SCORPION

1939
56 x 56 cm
Art Gallery of Western Australia
Bell 283c

'In doing these paintings of *Christ in the Wilderness* it was my wish that they should have been seen separately: one for, and on, each day of Lent. I thought that if a little shrine or frame could have been made, so that each of these same sized canvasses could be placed in it and removed from it each day, that like a calendar, the changing every day of these paintings of Christ's 40 days and 40 nights fast would help a person during Lent. In these works I have regarded Christ's dwelling in the Wilderness as a prelude forming part of the Ministry (or as an introduction of considerable duration). Except for the last days when he was tempted, I don't know of any statements which refer directly to his life during this period except the reference to his fasting. But there is evidence of an appreciation of nature and nature's ways in all his sayings . . . That being so, I have tried to visualize the being he is, and the life he lived from day to day using the sayings etc as a clue and guide . . . In the life of Henry David Thoreau [1817–62], as told in his "Walden" . . . it is possible to feel the possible passionate life one might have, and live in a wilderness alone. I read this years ago . . . and it gave me an insight in to the relationship of mankind or the integrity of mankind with nature.' [733.2.60]

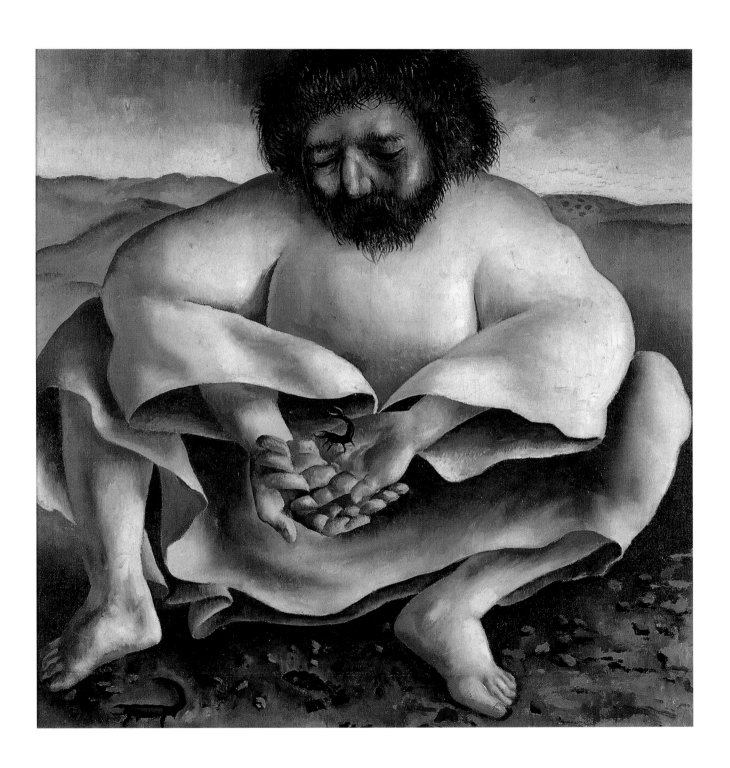

43

CHRIST IN THE WILDERNESS:
RISING FROM SLEEP IN THE
MORNING

1940
56 x 56 cm
Art Gallery of Western Australia
Bell 283e

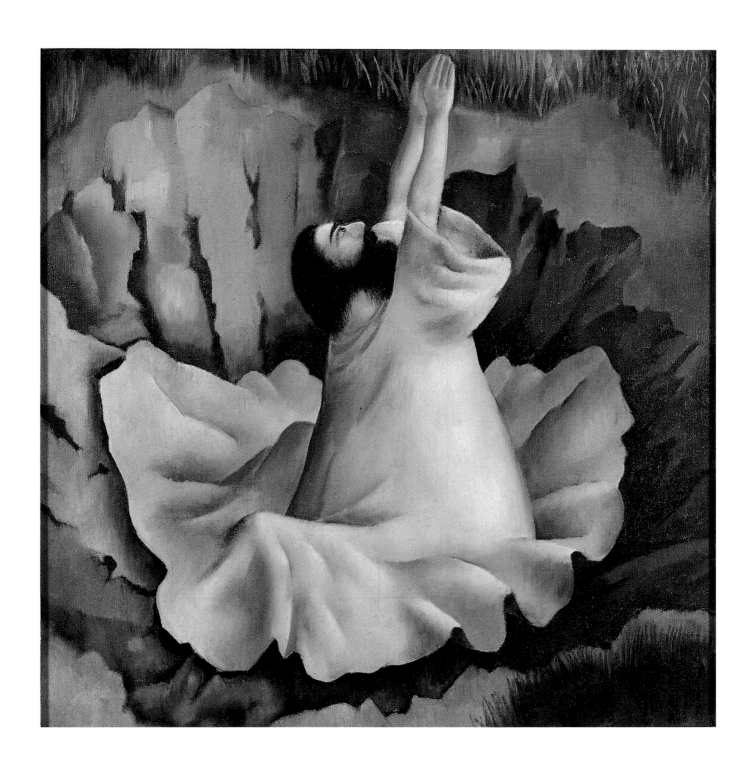

SHIPBUILDING ON THE CLYDE: BURNERS

1940
Triptych (left to right): 50.8 x 203.2 cm;
106.7 x 153.4 cm; 50.8 x 203.2 cm
Imperial War Museum, London
Bell 328b

> The War Artists Advisory Committee, chaired by Kenneth Clark, commissioned Spencer to paint a series of shipyard paintings in March 1940. Following a visit to Port Glasgow on the Firth of Clyde, 15 miles west of Glasgow itself, Spencer conceived a plan for a series of paintings of which eight large canvases were completed.

'In my work I am exposed far more to the weather than a great many people whether soldiers or sailors or any of the civil defence services. I have to rough it, I can tell you. I have three miles to walk daily in the rain. I don't go by bus because they are all packed and one can stand in the rain for as long as the walk can take. Not *one* of my five visits to Scotland have I known what it was like to walk in boots that did *not* let the water in . . . Also for some of the views I have drawn I have had to, and still have to, stand where the tide comes in and I have found myself standing in water once or twice . . . I don't wish to be an official war artist but I must have that much at least of official war artist comforts . . . it was only through the great kindness of the Scotch people at Port Glasgow that I had a comfortable time . . . I am on the same basis as a private soldier as far as supplies are concerned.' [Letter from Spencer to Dudley Tooth, 1944. Rothenstein, p.91.]

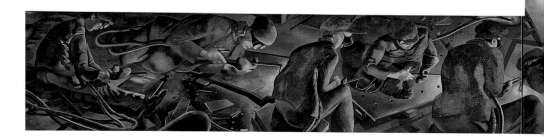

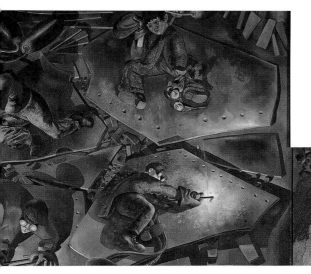
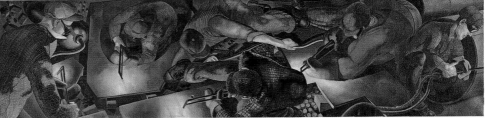

45

SHIPBUILDING ON THE CLYDE:
BENDING THE KEEL PLATE

1943
76 x 575 cm
Imperial War Museum, London
Bell 328f

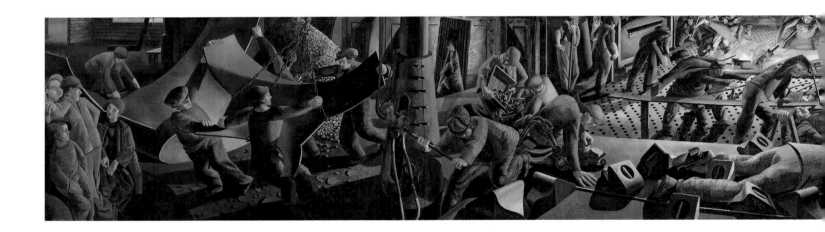

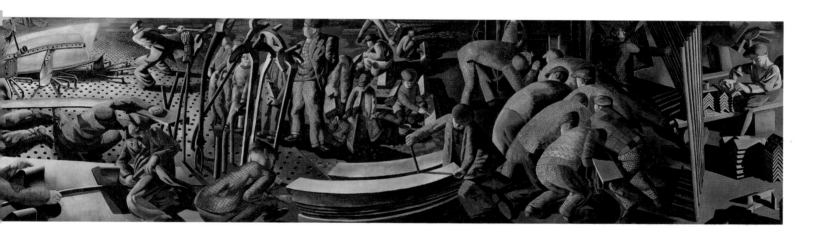

THE SCRAP HEAP

1944
50.7 x 76.1 cm
Art Gallery of New South Wales
Bell 317

Almost certainly a view of rusting steel
plates in Port Glasgow, painted at the time
of the War Artists Advisory Committee
commission (1940–46), though not part of
it.

THE RESURRECTION: REUNION

1945
Triptych: left and centre panels: 75.5 x 50.8
cm; right panel: 76 x 50.2 cm
City of Aberdeen Art Gallery & Museums
Collections
Bell 358d

'One evening in Port Glasgow, when unable
to write due to a jazz band playing in the
drawing-room just below me, I walked up
along the road past the gas works to where I
saw a cemetery on a gently rising slope . . . I
seemed then to see that it rose in the midst
of a great plain, and that all in the plain
were resurrecting and moving towards it . . .
I knew then that the Resurrection would be
directed from this hill . . . In *Reunion* I have
tried to suggest the circumstances of the
Resurrection through a harmony between
the quick and the dead, between the visitors
to a cemetery and the dead now rising from
it. These visitors are in the central panel, and
the resurrected are in the panels right and
left . . . Here I had the feeling that each
grave forms part of a person's home just as
their front gardens do, so that a row of
graves and a row of cottage gardens have
much the same meaning for me. Also
although the people are adult or any age, I
think of them in cribs or prams or mangers.
"Grown ups in prams" would express what I
was after . . .' [Collis p.194]

THE TEMPTATION OF ST ANTHONY

1945
121.9 x 91.4 cm
Private Collection
Bell 329

Painted for a competition run by an
American film company, Loew-Lewin
Inc., for their motion picture production of
Maupassant's *Bel Ami*, in which the
winning painting was to appear. Other
entrants included Leonora Carrington,
Ivan Albright, Salvador Dali, Paul
Delvaux, Dorothea Tanning, Abraham
Rattner and Max Ernst, and the works
were to be judged by Alfred H. Barr Jr.,
Marcel Duchamp and Sidney Janis. [Bell,
cat. 329]

Max Ernst was declared the winner
receiving an award of $2500 and Spencer
was given a consolation fee of $500.

St Anthony lies in a half open
sarcophagus surrounded by naked women,
among whom Hilda Carline appears in
red underwear, looking down at the saint.

'This story is the naming of creation, its
animals etc., by Adam . . . This ordering and
dispensing of things, so fitting and so
amiable is what moves St Anthony and gives
him a feeling of a need for completeness by
mergence in such harmony . . . It is not a
turning away from what he sees, but a
waiting for a time when he finds his own
spiritual niche in the harmony.' [Bell, cat.
329]

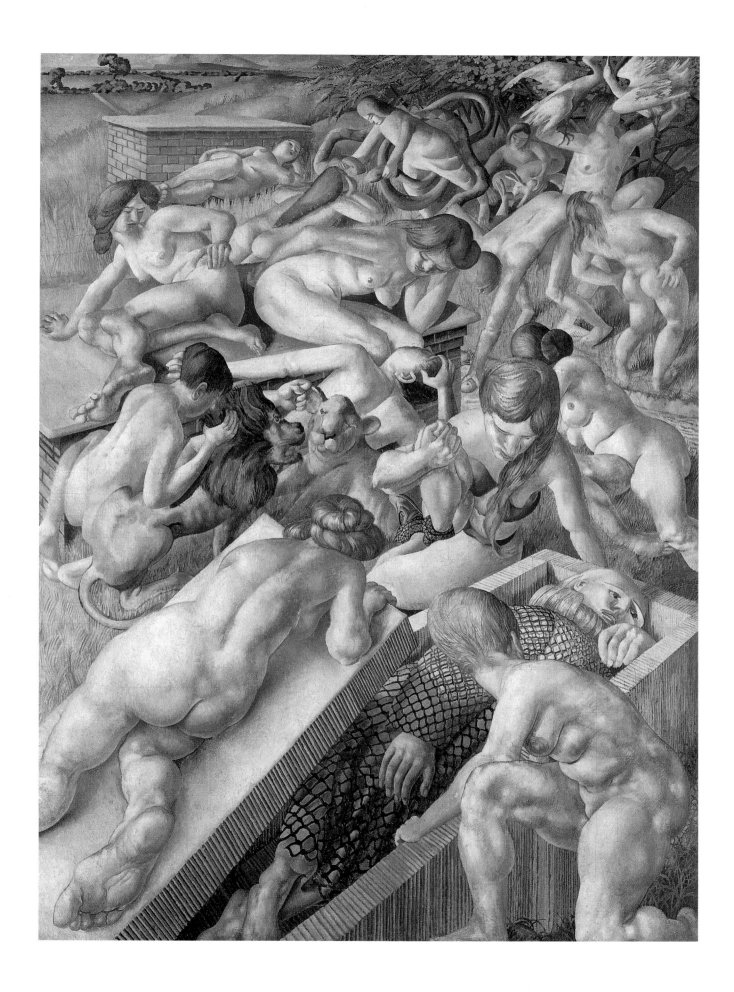

THE PSYCHIATRIST

1945
74.9 x 49.5 cm
Birmingham Museums and Art Gallery
Bell 327

A portrait of Charlotte Murray, whom
Spencer met in the winter of 1943–44
while working on his shipyard paintings
in Port Glasgow. Charlotte was born in
Germany and studied psychiatry under
Jung. An émigré, she had married
Graham Murray, the art master at Port
Glasgow High School, to whom Spencer
was introduced when looking for models.

'I still hope for this life to be a continual
parcel-opening experience, a permanent
birthday, no ups and downs, but love on love.'
[letter from Spencer to Charlotte Murray,
1945, Pople, p.438]

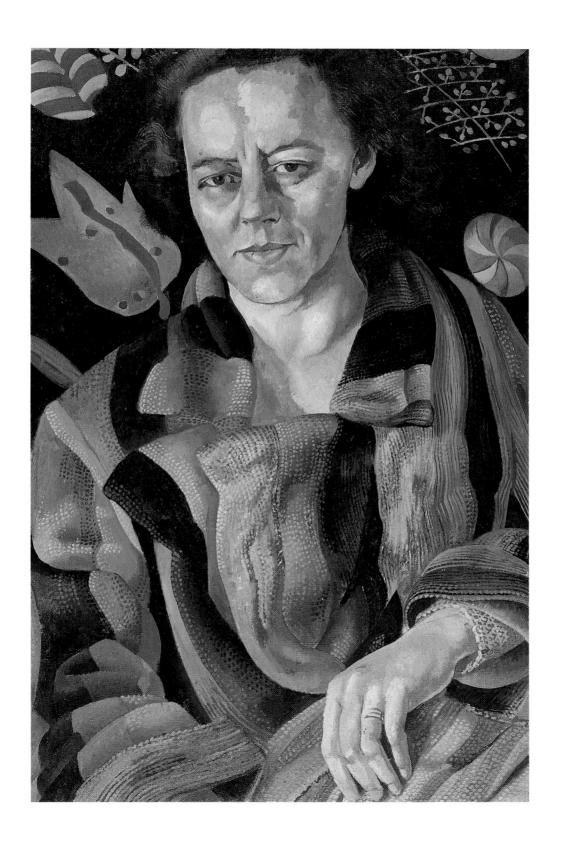

THE RESURRECTION WITH THE
RAISING OF JAIRUS'S DAUGHTER

1947
Triptych: centre panel 76.8 x 87.4 cm;
side panels 76.8 x 50.8 cm
Southampton City Art Gallery
Bell 358g

PORT GLASGOW CEMETERY

1947
50 x 76 cm
British Council Collection
Bell 338

'I felt that all this life and meaning somehow
grouped round and in some way led up to the
cemetery on the hill outside the town, an
oval saucer-upside-down-shaped hill of
green mound in a nest of red . . . And I
began to see the Port Glasgow resurrection
that I have drawn and painted in the last five
years. As it has worked out this hillside
cemetery has become The Hill of Sion.'
[733.8.61]

GOOSE RUN, COOKHAM RISE

1949
76.2 x 50.8 cm
Private Collection; courtesy Massimo
Martino SA, Mendrisio,
Switzerland
Bell 344

LOVE LETTERS

1950
86.5 x 117 cm
Thyssen-Bornemisza Collection, Castagnola-
Lugano
Bell 359

> Hilda died in 1950, the year of this
> painting showing Hilda and Stanley
> communicating through letters. They
> conducted a voluminous correspondence
> from the late 1920s onwards, never
> posting the letters but reading them aloud
> to one another. The correspondence
> continued after their divorce in 1937, and
> Spencer continued to write hundred-page
> letters to Hilda even after her death.

> 'I thought about a week ago . . . that I would
> love to stick all mine and your letters . . .
> neatly all over the asbestos walls of the
> studio . . . what a marvellous feeling of
> communion of all our thoughts. We would
> be writing letters for the screen and making
> wallpaper.' [Letter from Spencer to Hilda, 7
> July, 1930, Rothenstein, p.41]

PORTRAIT OF DAPHNE SPENCER

1951
92.5 x 61.5 cm
Ulster Museum, Belfast
Bell 370

One of four portraits of the sitter, painted
on Spencer's visits to Merville Garden
Village, Northern Ireland. Daphne was
the daughter of Spencer's brother, Harold,
and was nineteen when this was painted.

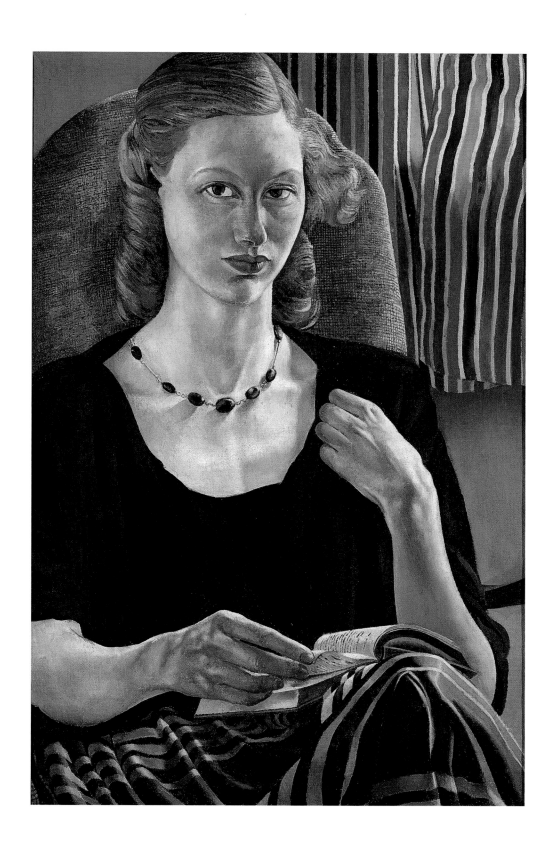

THE BAPTISM

1952
76.2 x 127 cm
Private Collection
Bell 380

The setting is the bathing pool on the
Thames at the Odney Club, Cookham,
where Spencer swam as a young man.
Intended as the central altarpiece in the
Baptism of Christ series, to hang in The
Church House, and linking in with the
Marriage at Cana series, the painting is
based on a drawing made in 1945–6.

CHRIST IN COOKHAM

1952
127 x 205.7 cm
Art Gallery of New South Wales. Watson
Bequest Fund 1952
Bell 378

Christ sits in an armchair, surrounded by
disciples on the left and worshippers on
the right. The painting was intended as
part of a series of works celebrating the
everyday lives of the people of Cookham,
their daily activities transmuted into
scenes of religious significance.

'The events must seem as real as going
shopping . . . I am always wanting to
establish a union between myself and what
is divine and holy.' [733.3.1.88]

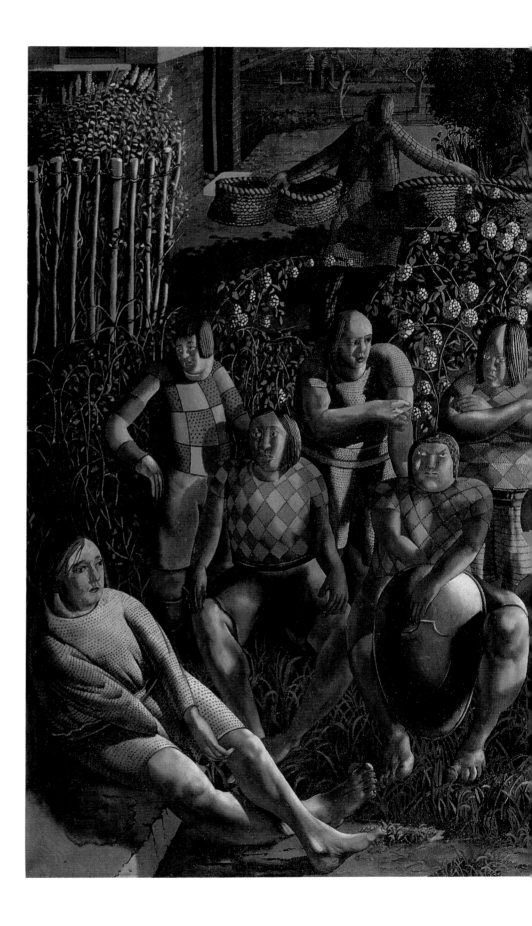

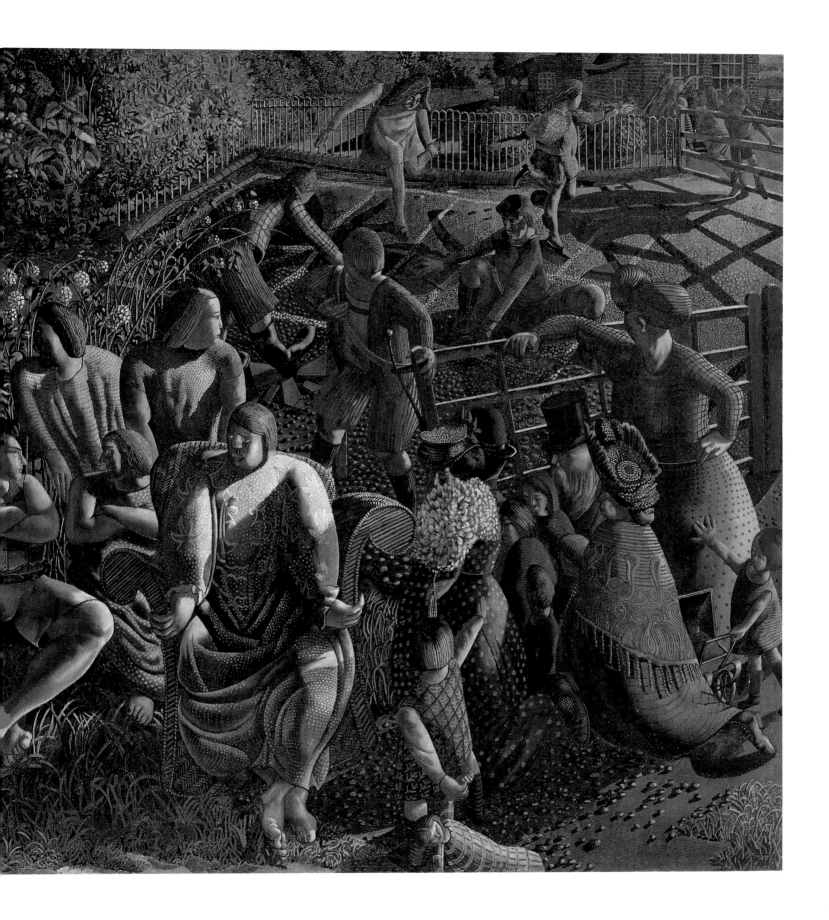

HILDA WELCOMED

1953
140 x 95 cm
Art Gallery of South Australia, Adelaide.
Morgan Thomas Bequest Fund 1956
Bell 384

The scene takes place on The Last Day,
and the newly resurrected Hilda, who had
died in 1950, has returned home to be
welcomed by Stanley and their two
daughters, Shirin and Unity. The painting
was intended for the Hilda Memorial
Chapel in the Church House, a celebration
of his spiritual union with his first wife,
which he maintained through numerous
letters written to her after her death.

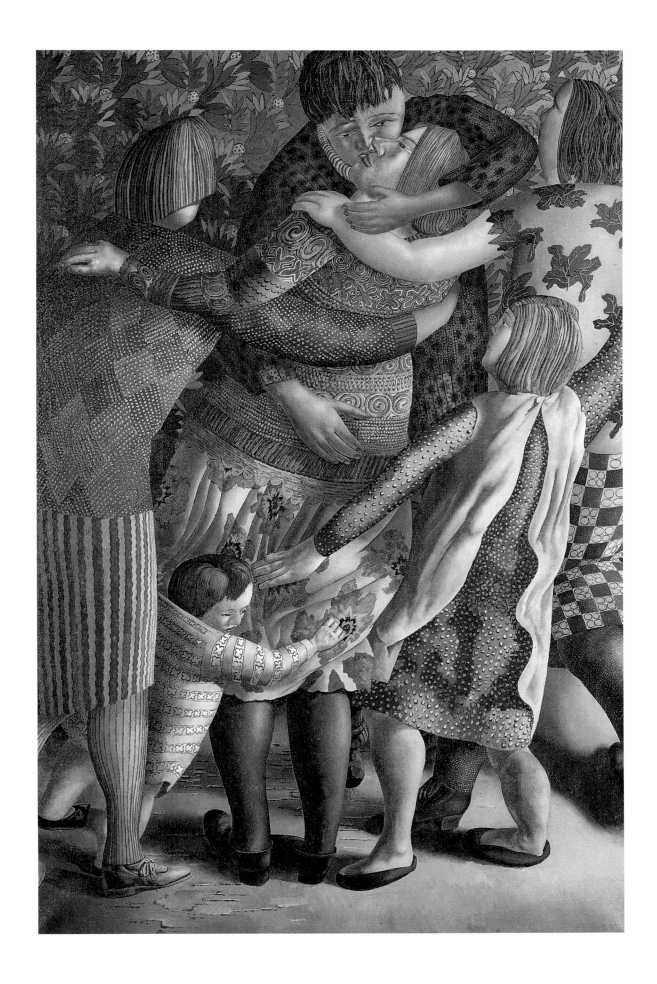

THE MARRIAGE AT CANA: BRIDE
AND BRIDEGROOM

1953
66 x 51 cm
Glynn Vivian Art Gallery, City and County
of Swansea
Bell 385

'In working out a scheme celebrating the
marriage at Cana, it is reasonable that I
should have thought of the various
circumstances surrounding, and directly
bearing, on this great event. How often I was
filled with wonder as a child, when in the
kitchen I would hear the babble of a party
going on in the dining-room, and look up
expectantly at the servant when she returned
from taking something into the dining room
in the hope of hearing what was happening.'
[733.10.8]

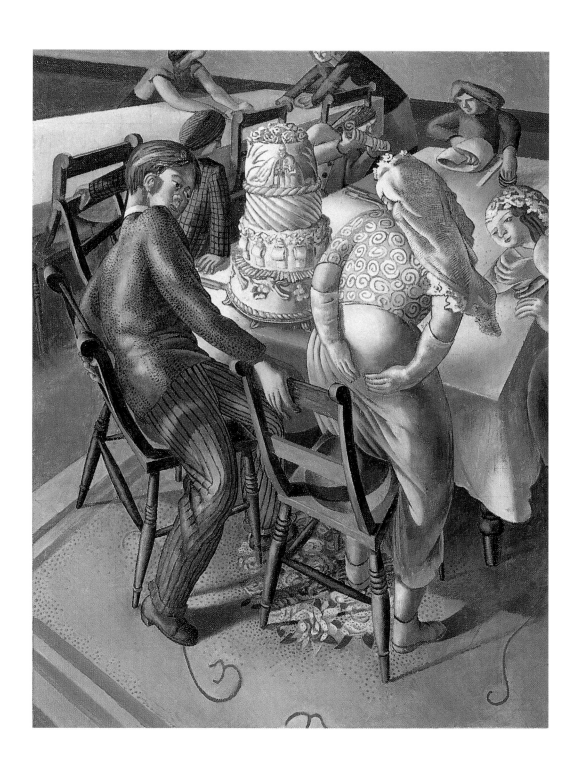

CHRIST PREACHING AT
COOKHAM REGATTA: GIRLS
LISTENING

1953
137 x 152
Private Collection
Bell 386

'The Regatta Series seems now to be a
chapel, in which there would be three main
pictures, each of the same part of the
incident, namely Christ preaching from a
boat; and the rest in paintings of various
sizes . . . The central notion is Christ
preaching. In the sideways barge could be
disciples listening . . . there seem now to be
two Christs . . . one where he is preaching to
the Ferry Lawn (the Berks side of the river),
and one where he is preaching to the people
coming from Cookham Lock (the Bucks
side).' [733.10.96]
'I must get Mr Tuck [the boat house owner]
to stand as I saw him down at the boat house
one day. As is characteristic, at the end of the
day, all the oars are taken from the river craft
and locked up in the boat house. Mr Tuck
was standing in a punt and leaning on a
great armful of oars, which he was wedging
against the step on the landing stage, and
chatting to someone on the bank. It was a
pause and so a position of rest was found.
The other drawing is a sort of echo of this
shape. It occurs in the listening crowd in the
boats and punts. It is the man who pulls two
punts together by standing with one leg in
each, and the punt pole anchored between
them. The crowd is all around him and
above, and here moving swiftly along
through the crest of the crowd an eights boat
is seen. This makes the same curious shape
of tripod and telescope as Christ and the
disciples and the boatmen.' [733.10.95]

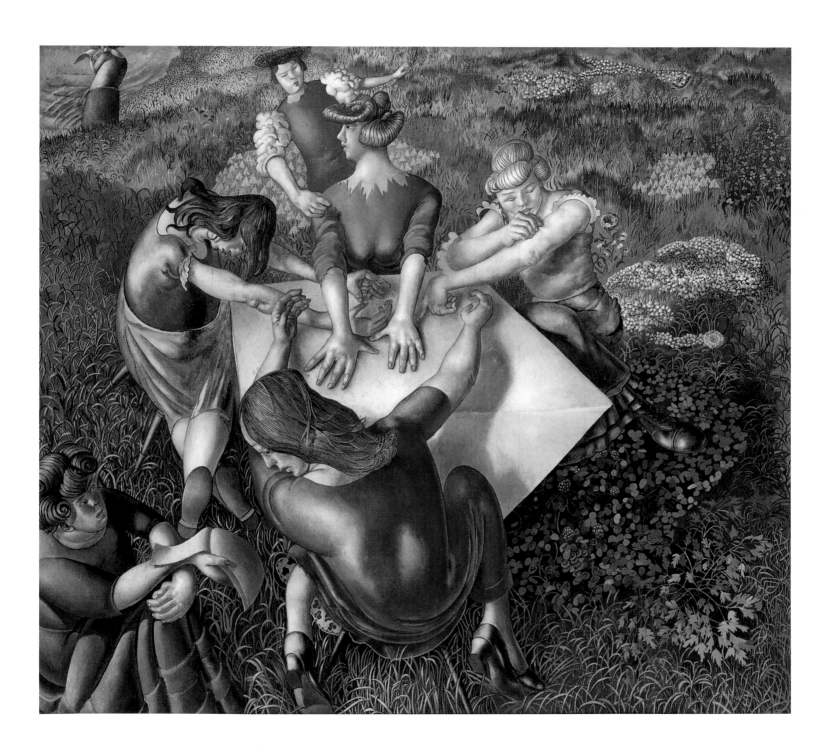

CHRIST PREACHING AT
COOKHAM REGATTA:
CONVERSATION BETWEEN
PUNTS

1955
106.7 x 91.5 cm
Private Collection
Bell 413

'At the present time I am enjoying my
cogitations and drawing resulting therefrom
. . . Christ preaching as he did from a boat in
a lake . . . has somehow become linked up
with Cookham Regatta: still a thing of the
early nineteen hundreds. I have done heaps
of large red chalk drawings all about this
one notion.

In the olden days, and in the evening just
after sunset, the river craft boats, punts and
canoes, etc. drifted downstream from the
race-course reach, under Cookham Bridge . . .
In this open space of the river, the punts etc.
used to hang about round the old horse ferry,
which was moored alongside the "Ferry"
hotel lawn. From this wide shallow horse
ferry used to be given "Grand Evening
Concerts". Colonel Ricardo had famous
people from London and my elder brothers
played Handel, & everybody in the boats &
on the land listened. It isn't such a far cry
between people listening to Handel and
people listening to Christ preaching.' [Letter
from Spencer to Edward Beddington-
Behrens, 27 March 1952]

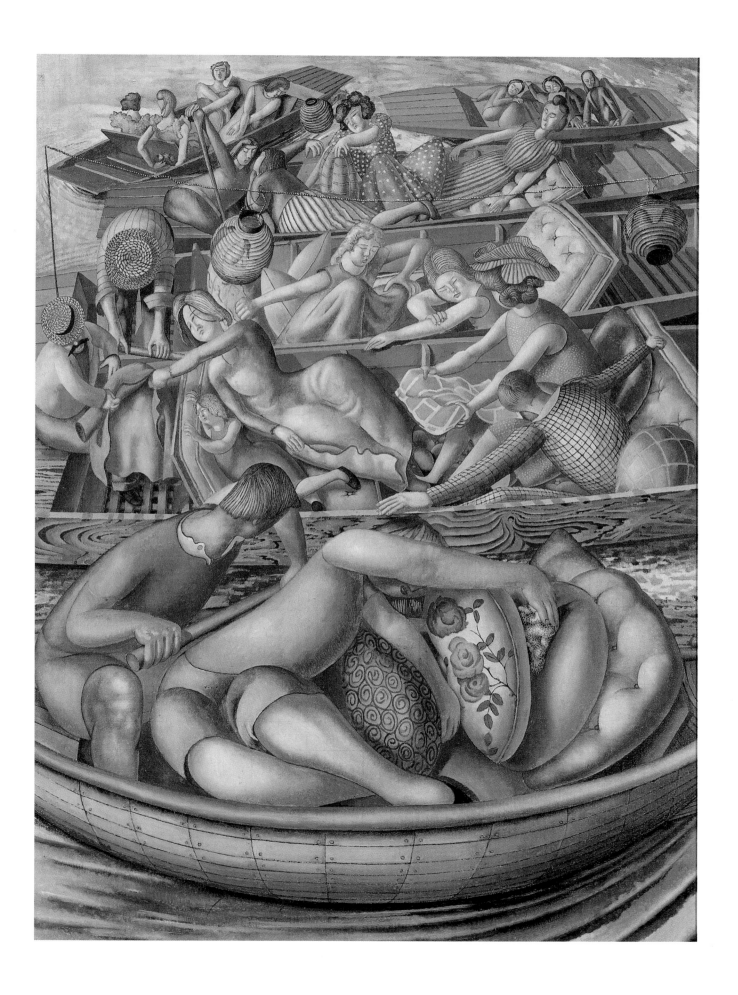

HILDA AND I AT POND STREET

1954
51.1 x 76.2 cm
Museum of Contemporary Art, Chicago;
promised gift of May and Earle Ludgin
Collection
Bell 391

Hilda lived with the Carline family at 17
Pond Street, Hampstead, following her
divorce from Spencer in 1937. The
painting commemorates the period
Spencer spent with Hilda following her
operation for cancer in 1947.

'In the drawing [on which the painting was
based] Hilda flops in her own chair [with]
plenty of cushions pushed into the hollow of
her back. Ungainly in her passionate
determination to be comfortable. Adorable to
me of course. The archangel sits sort of by
the side of her . . . and holds out over her
spread out self a long spray of lilies which
hover . . . over her. This spray has been lifted
out of a long cardboard box and lays across
Hilda's feet . . . Another cherub holds the
lid.' [Letter from Spencer to Marjorie Metz,
8 May 1953; 733.1.924]

In the painting, the archangel has been
substituted for the figure of the artist.

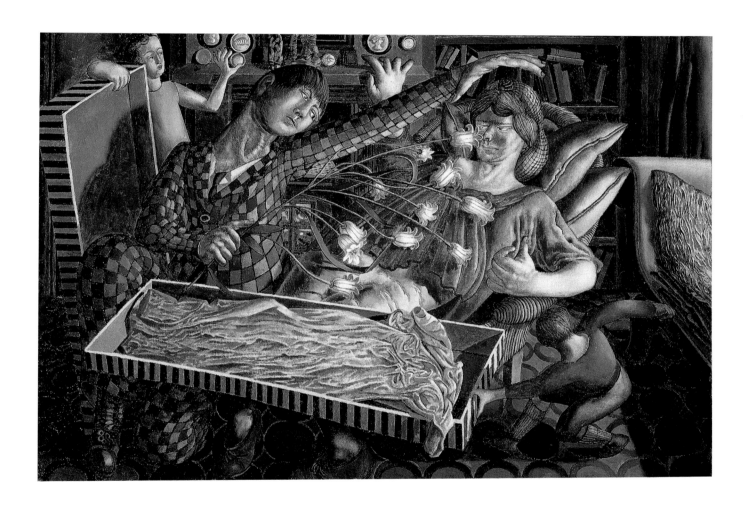

THE CRUCIFIXION

1958
216 x 216 cm
Private Collection; Melbourne, Australia;
courtesy Richard Nagy, Dover Street Gallery,
London
Bell 441

> Intended to hang together with *In Church*
> as lunette and predella, the painting was
> commissioned by J.E. Martineau, a
> brewer, for a new chapel extension at
> Aldenham School. Spencer told the boys
> at Aldenham:

'I have given the men who are nailing Christ
on the cross – and making sure that they
make a good job of it – Brewers caps,
because it is your Governors, and you who
are still nailing Christ to the cross.'
[Rothenstein p. 131]

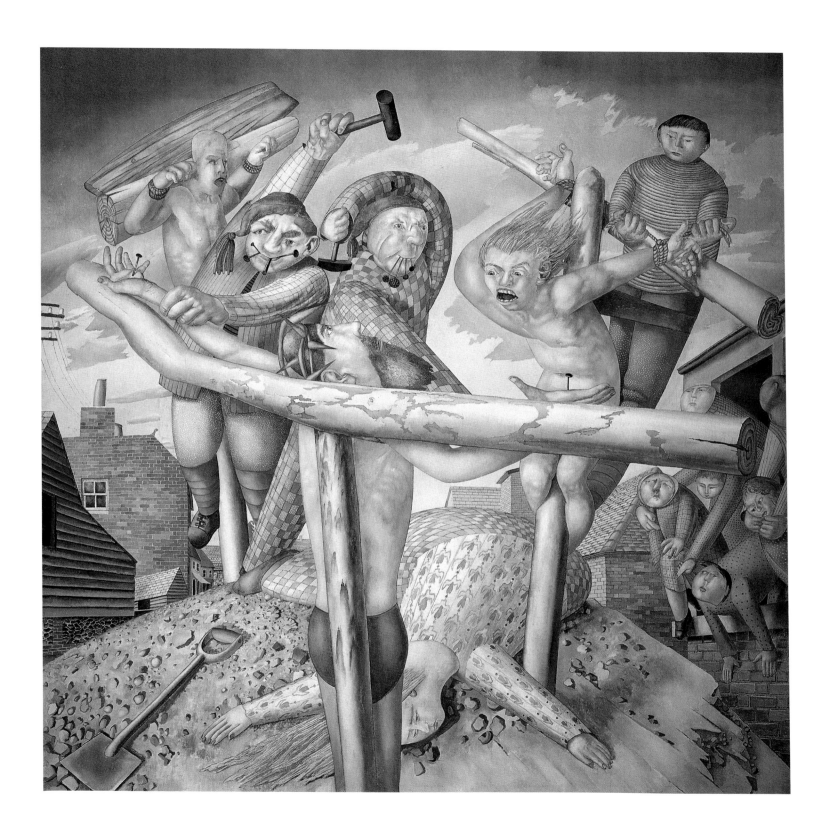

63

IN CHURCH

1958
61 x 216 cm
Private Collection; Melbourne, Australia;
courtesy Richard Nagy, Dover Street Gallery,
London
Bell 442

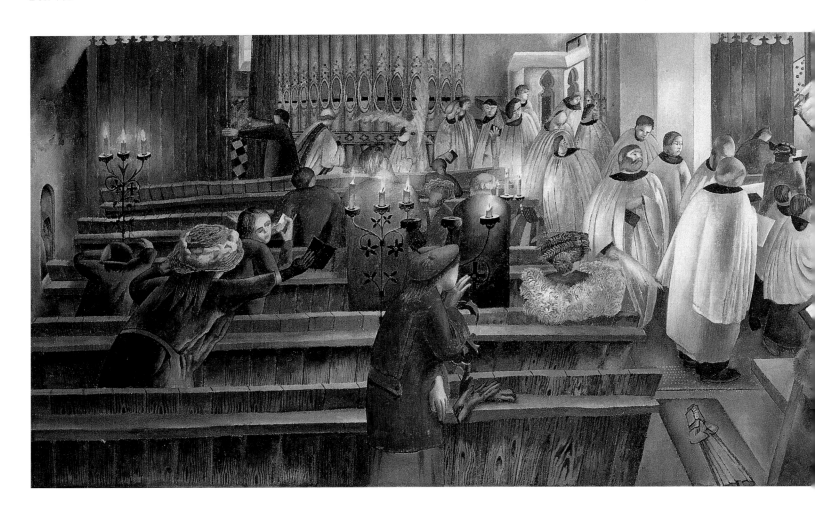

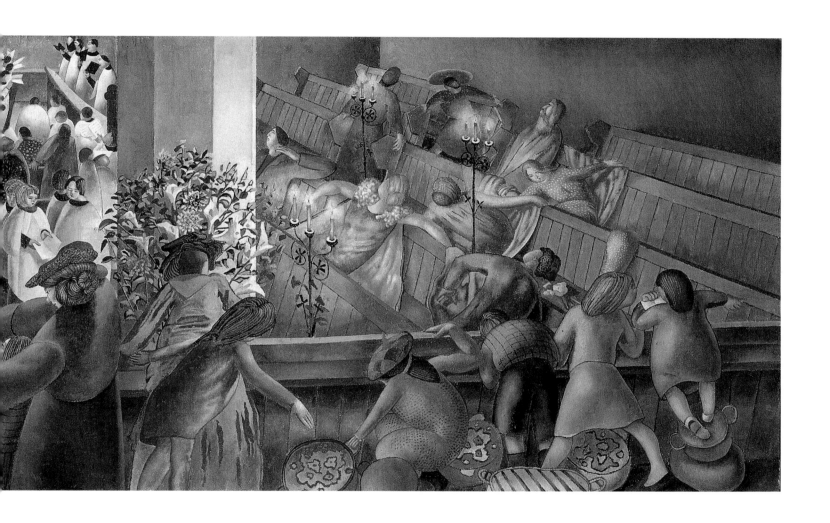

SELF-PORTRAIT

1959
51 x 40.6 cm
Tate Gallery, London; presented by the
Friends of the Tate Gallery 1982
Bell 447

Spencer's final self-portrait, painted
during July–August 1959, following
surgery for cancer earlier in the year. He
had been knighted in July, but became ill
again in November, and died at the
Canadian War Memorial Hospital on 14
December 1959.

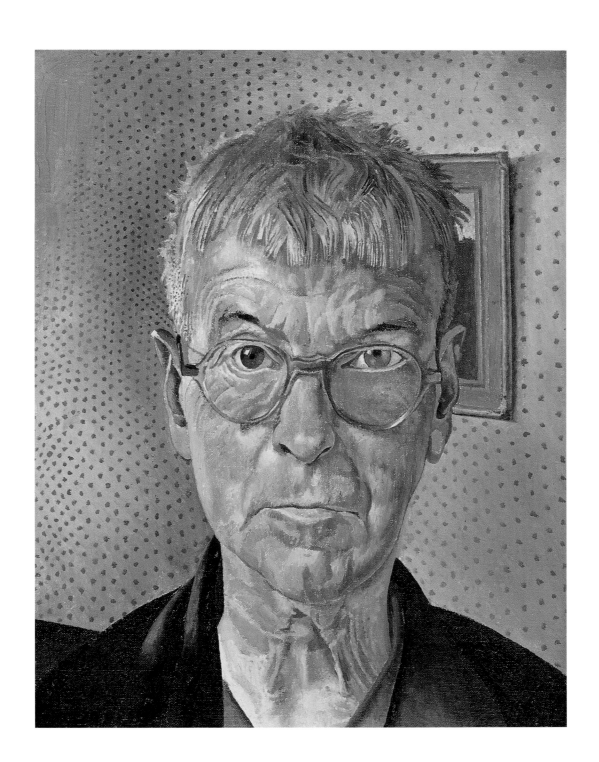

CHRONOLOGY

1891
Stanley Spencer born 30 June, Cookham-on-Thames, the eighth of nine surviving children of William Spencer and his wife Anna. The family lived in 'Fernlea' on the High Street, a house built by his grandfather. Spencer's father was the organist at the Parish Church of nearby Hedsor and also taught piano to private pupils. The house was full of music; his brother Will was something of a child prodigy and went on to become a Professor at the Bern Music Institute. Spencer was educated at home attending classes given by his sister Annie in a shed at the bottom of the garden. His mother took him to services at the Wesleyan chapel in Cookham (now the Stanley Spencer Gallery). Stanley and his younger brother Gilbert began their art studies with Dorothy Bailey, daughter of the local artist William Bailey. In this remarkable family, Gilbert also became a painter with his own place in the history of twentieth-century British art.

1907
Started training as an artist at the Technical School in Maidenhead, three miles from Cookham.

1908–12
Attended the Slade School in London, then as now one of the major London art schools. His fellow students included a whole generation of British artists: Edward Wadsworth, Paul Nash, Christopher Nevinson, David Bomberg, William Roberts and Mark Gertler. Spencer lived at home and travelled to the Slade each day.

1912–14
His work was included in the second Post-Impressionist Exhibition at the Grafton Galleries, 1912. Worked at home after leaving the Slade; *Zacharias and Elizabeth* (cat. 1) was begun on the dining-room table in December 1913. *Self-portrait*, 1914 (cat. 2) purchased by the London collector Edward Marsh.

1914–18
War declared on Germany, August 1914. In July of the following year Spencer enlisted in the Royal Medical Corps and became a hospital orderly in the Beaufort War Hospital, Bristol; his brother Gilbert was also serving there. Transferred abroad in the summer of 1916 via Salonika in Greece to Macedonia, at first serving with the field ambulance and then, in August 1917, volunteering for the infantry and ending the war as Private Spencer, 7th battalion, The Royal Berkshires. His

older brother Sydney, who had been awarded the Military Cross, was killed in France in the last months of the war. Spencer returned to Cookham in December 1918.

1919–24

Travoys Arriving with Wounded at a Dressing Station, Smol, Macedonia in 1916 (cat. 7) painted in 1919 for the Ministry of Information. Spencer was one of very few artists to work on official commissions at the time of both world wars. He lived in Cookham; nearby Bourne End; and then Hampstead in north London from December 1922; and accompanied the Carline family on a painting holiday to Yugoslavia in 1922. Spencer's mother died that year after a long illness. In 1923 Louis and Mary Behrend commissioned a cycle of paintings as a memorial to Mary Behrend's brother who had died in 1919 from an illness contracted during the war; the paintings were for a chapel which was to be specially built in the Berkshire village of Burghclere. *Resurrection, Cookham* 1924–7 (cat. 13) was painted in a Hampstead studio lent by Henry Lamb, artist, patron and friend.

1925–32

Married Hilda Carline at Wangford, near Southwold on the Suffolk coast in February 1925; daughter Shirin, born in December. First one-person exhibition at the Goupil Gallery, London, 1927; *Resurrection, Cookham* purchased by Lord Duveen and presented to the Tate Gallery. Moved to Burghclere in 1927 to work on the Memorial Chapel paintings, completed in 1932. Second daughter, Unity, born May 1930. The family moved back to Cookham in 1931, into a substantial house, 'Lindworth', off the High Street. In 1932 Spencer was elected an Associate of the Royal Academy and Dudley Tooth became his agent.

1933–38

Portrait of Patricia Preece 1933 (cat. 18); increasing involvement with Preece – 'a glamorous though impecunious artist' – who had lived in Cookham since 1927. During this period Spencer conceived the idea of 'The Church House' as a successor to the Memorial Chapel at Burghclere but this time with sacred and profane themes to the paintings; it was never to be realised but provided a framework for his painting henceforth. Two paintings, *St Francis and the Birds* and *The Dustman* or *The Lovers* (cat. 19), rejected by the Hanging Committee of the Royal Academy's Summer Exhibition in 1935; Spencer resigned in protest. Began series of 'Domestic Scenes' such as *The Nursery* (cat. 30) devoted to family life with Hilda, Shirin and Unity. The theme contrasted with a turbulent period in his own domestic life: in May 1937 he was divorced by Hilda and married Patricia Preece (at Maidenhead Registry Office on 29 May). The marriage was not a success and Spencer never lived with Preece. In 1938 Preece rented out 'Lindworth' (which Spencer had made over to her) effectively evicting him. He moved to a rented room in Hampstead, near Hilda whom he visited often. *The Beatitudes*, paintings on the theme of relationships between couples, were begun in Cookham and completed

in Hampstead. Twenty-two paintings were exhibited in the British Pavilion at the 1938 Venice Biennale.

1939–45
Christ in the Wilderness, eight small-scale canvases, begun in 1939 in his rented room in Hampstead. Britain declared war on Germany, September 1939; the following year the War Artists Advisory Committee comissioned Spencer to record shipbuilding on the Clyde, his second great public project which preoccupied him for six years from May 1940 until March 1946 when he had completed eight large canvases. Spencer worked in Lithgow's Yard, Port Glasgow, on the Firth of Clyde, spending long periods there during and immediately after the war.

1945
Returned to Cookham, to 'Cliveden View', a house which belonged to his brother Percy and had been occupied by his older and ailing sister Annie.

1950
The death of Hilda after a long period of illness; Spencer had been with her frequently during the 1940s.

1954
Visited China with a UK cultural delegation.

1955
Retrospective at the Tate Gallery, London. In the mid-fifties Spencer began another ambitious series on the subject of *Christ Preaching at Cookham Regatta*.

1959
Moved into the house of his childhood, by now re-named 'Fernley'; received a Knighthood on 7 July from HM The Queen Mother; died at the War Memorial Hospital, Cliveden, on 14 December.

SELECTED BIBLIOGRAPHY

NOTE: a full bibliography can be found in Keith Bell, *Stanley Spencer: A Complete Catalogue of the Paintings* (for details see below)

Keith Bell, *Stanley Spencer: A Complete Catalogue of the Paintings*, Phaidon Press, London 1992

Richard Carline, *Stanley Spencer at War*, Faber and Faber, London 1978

Maurice Collis, *Stanley Spencer: A Biography*, Harvill Press, London 1972

Kenneth Pople, *Stanley Spencer: A Biography*, Collins, London 1991

Duncan Robinson, *Stanley Spencer*, Phaidon, Oxford 1990

Duncan Robinson, *Stanley Spencer at Burghclere*, The National Trust, London 1991

Sir John Rothenstein (ed.), *Stanley Spencer The Man: Correspondence and Reminiscences*, Paul Elek, London 1979

Gilbert Spencer, *Stanley Spencer by his brother Gilbert*, Victor Gollancz, London 1961

EXHIBITION CATALOGUES

Stanley Spencer, introduction and notes by Stanley Spencer, Tate Gallery, London 1955

Stanley Spencer 1891–1959, Duncan Robinson (ed.), with contributions from Richard Carline, Carolyn Leder, Antony Gormley and Robin Johnson, Arts Council of Great Britain travelling exhibition 1976

Stanley Spencer RA, Keith Bell (catalogue), with contributions from Richard Carline and Andrew Causey, Royal Academy, London 1980

Stanley Spencer: A Modern Visionary, Duncan Robinson, Yale Center for British Art, New Haven, Connecticut 1981

Spencer in the Shipyard (paintings and drawings by Stanley Spencer and photographs by Cecil Beaton from the Imperial War Museum), introduction by Joseph Darracott, Arts Council of Great Britain travelling exhibition 1981-82

Stanley Spencer: The Apotheosis of Love, introduction by Jane Alison, essay by Timothy Hyman, Barbican Art Gallery, London 1991

Stanley Spencer: A Sort of Heaven, introduction and catalogue by Judith Nesbitt with a contribution from Antony Gormley, Tate Gallery Liverpool 1993

Canvassing the Clyde: Stanley Spencer and the Shipyards, Andrew Patrizio and Frank Little, Glasgow Museums: Art Gallery & Museum, Kelvingrove 1994

Stanley Spencer: Bosnian Landscapes, text by Roger Tolson, Imperial War Museum, London 1997

PHOTOGRAPHIC SOURCES

Documentary photographs have been supplied by the Estate of Stanley Spencer except where indicated otherwise in the captions. In most cases illustrations of paintings have been made from transparencies supplied by the lenders or owners of the works, with the exception of the catalogue numbers indicated below:

8, 16, 23, 39, 59 Prudence Cumming Associates
15 Christie's Images
22, 38 Phaidon Press Ltd
48, 55 Sotheby's
60 Leach Studio Ltd